INDIA

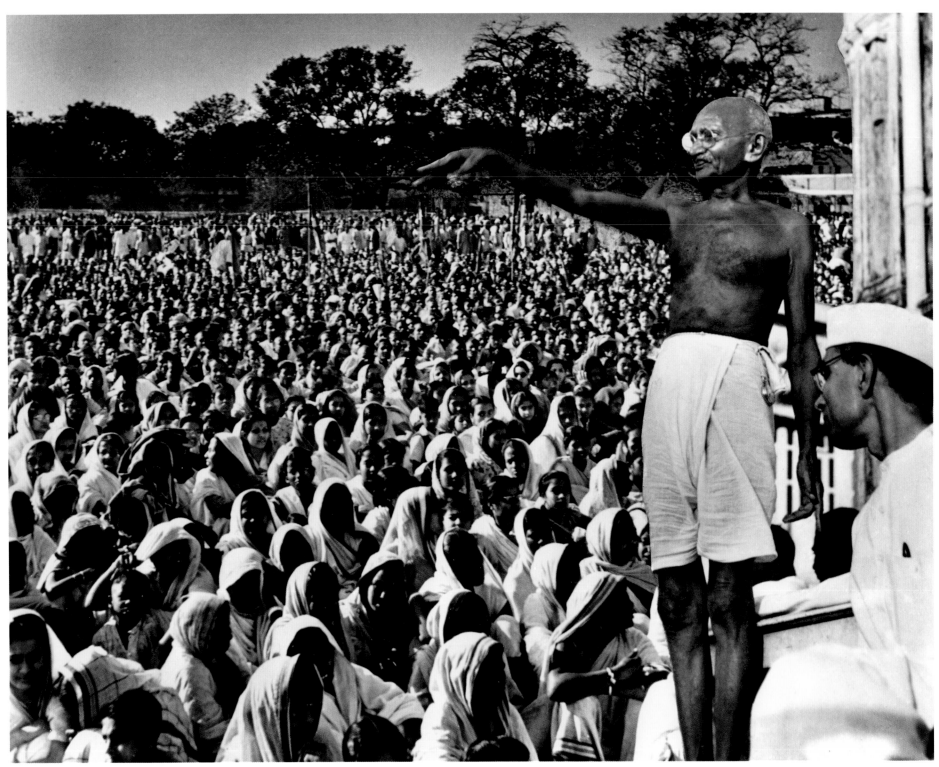

Sunil Janah, *Mahatma Gandhi at a meeting in Calcutta*, 1946

INDIA

A CELEBRATION OF INDEPENDENCE 1947 TO 1997

ESSAY BY VICTOR ANANT

APERTURE

THIS PUBLICATION IS MADE POSSIBLE BY THE GENEROUS SUPPORT OF
THE EASTMAN KODAK COMPANY,
IN KEEPING WITH THEIR COMMITMENT TO EXCELLENCE IN PHOTOGRAPHY,
AND TO THE LIFE AND CULTURE OF INDIA AND ITS PEOPLE.

CONTENTS

My optimism rests on my belief in the infinite possibilities of the individual to develop non-violence. The more you develop it in your own being, the more infectious it becomes till it overwhelms your surroundings and by and by might oversweep the world.

—MAHATMA GANDHI, 1948

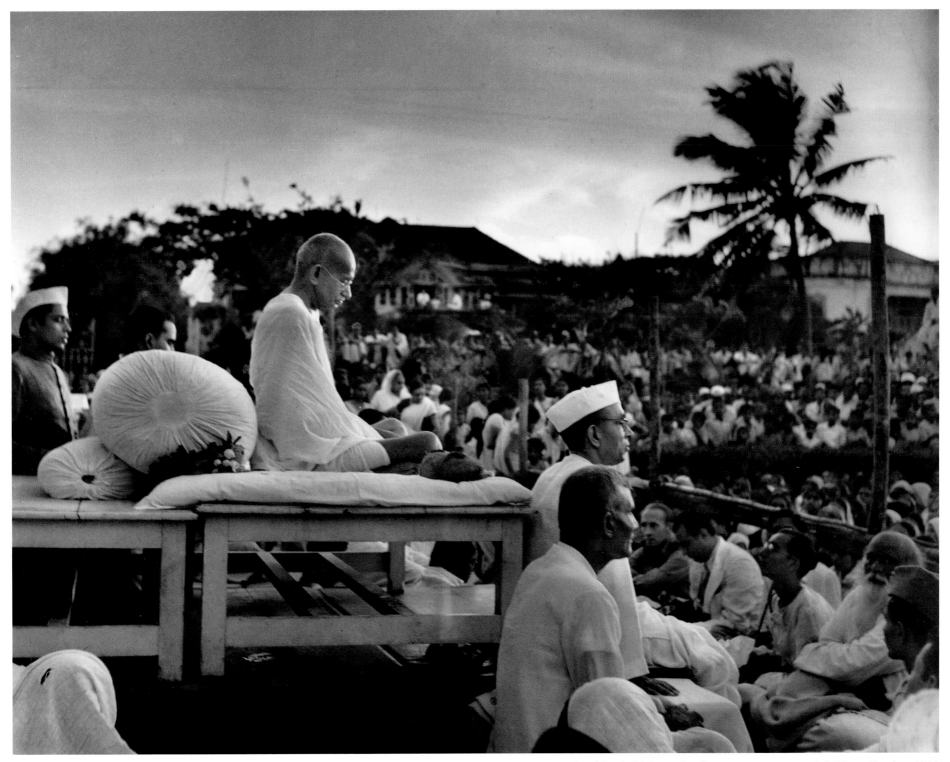

Sunil Janah, *Mahatma Gandhi at a prayer meeting at Birla House*, Bombay, 1946

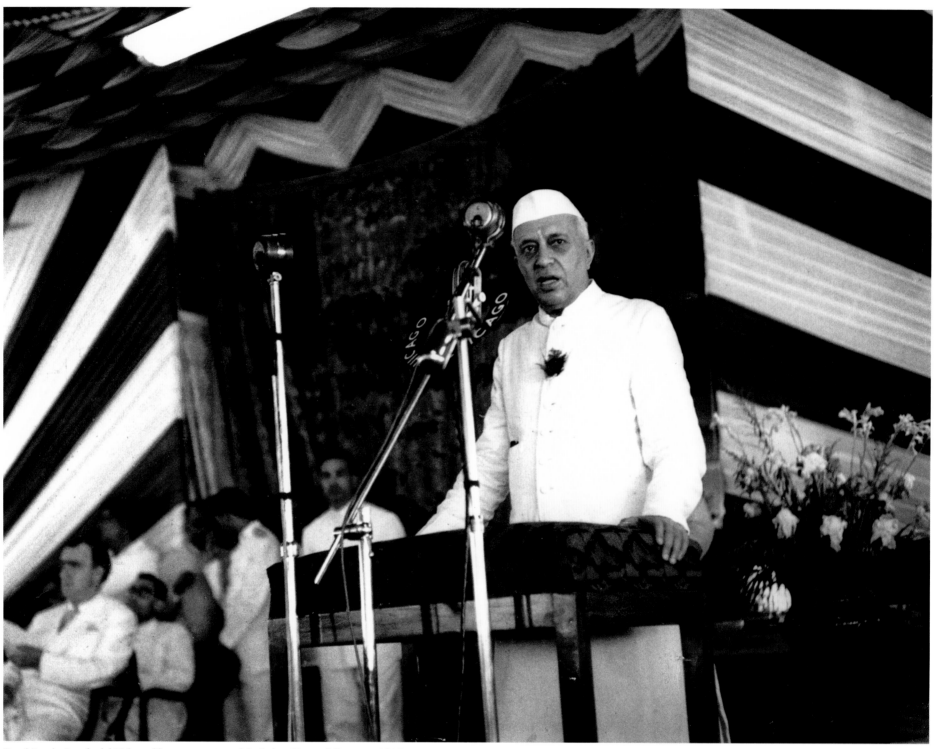

Sunil Janah, *Jawaharlal Nehru addressing a session of the Indian National Congress*, 1945

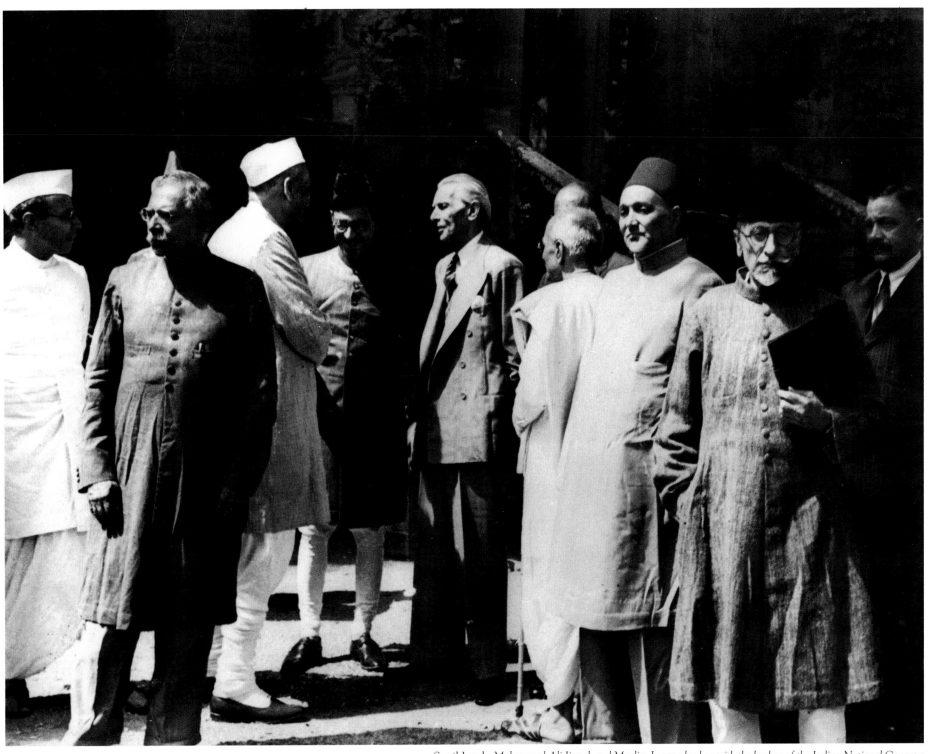

Sunil Janah, *Mohammed Ali Jinnah and Muslim League leaders with the leaders of the Indian National Congress on the lawn of the Viceregal Lodge in Simla during the Viceroy Lord Wavell's conference with them, 1945–46*

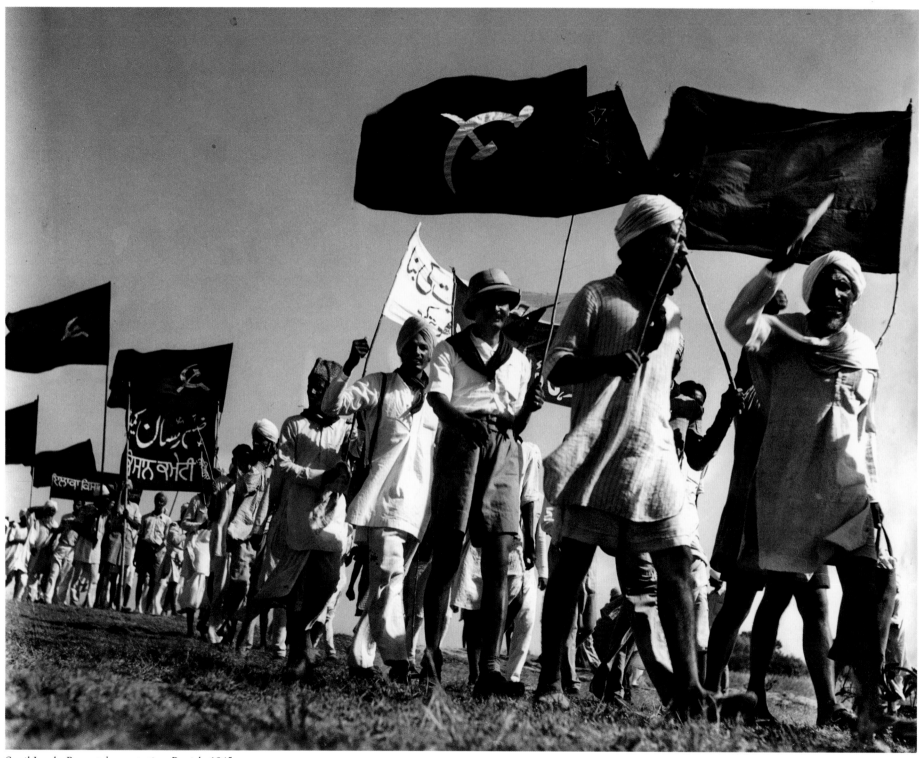

Sunil Janah, *Peasant demonstration*, Punjab, 1945

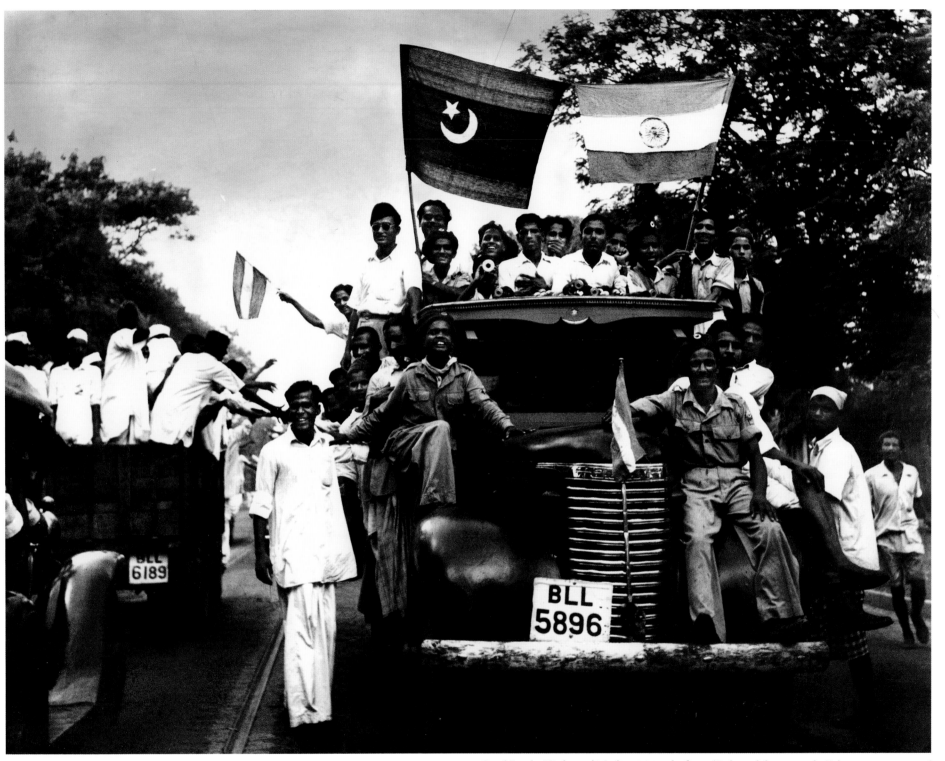

Sunil Janah, *Hindus and Muslims joining the flags of India and the soon-to-be Pakistan, in a gesture of friendship during the peace procession in Calcutta at the end of the communal riots*, 1947

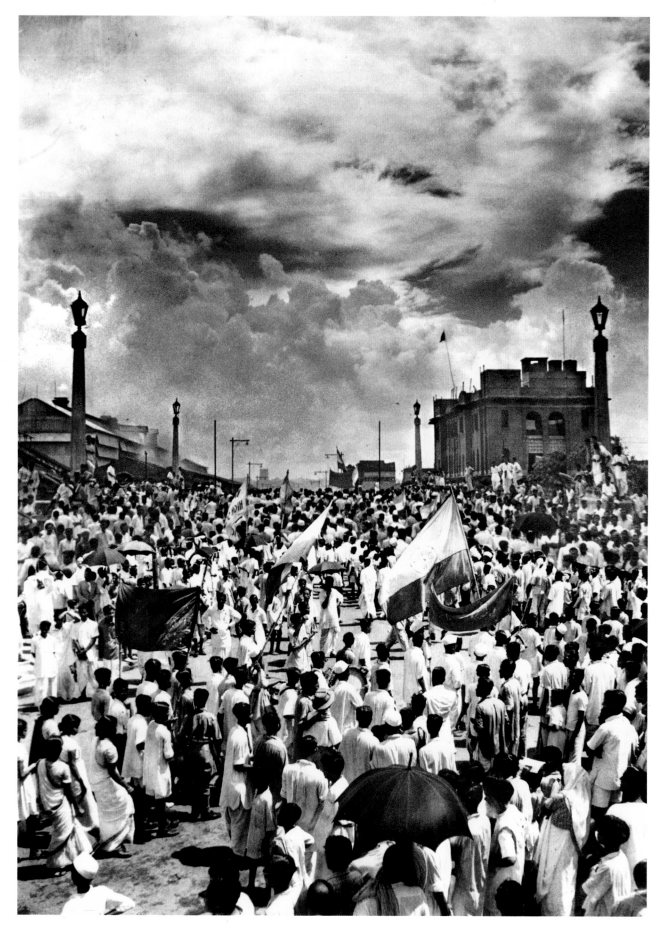

Photography became my profession quite fortuitously. I used to work for a political paper, and gradually I found that my photographs were attracting more attention than my stories.

It was a time of great excitement in India, but also a time of turmoil and tragedy—and I simply documented life around me. When I saw people dying of starvation or marching through the streets shouting slogans, I photographed them. Of course, I never attributed to myself any solemn task of recording history, although some of my pictures have now become such records.

India is one of the most populous countries in the world. Within the vast numbers of her peoples, there are primitive tribals in the forests, peasants who grow and harvest their crops today even as they did in the Middle Ages, and modern industrial workers and commuters in her great cities. Nowhere else, perhaps, can one find such a diversity of people, land-scapes, climates, and cultures. Some aspects of life in India remain unchanged, while many others have changed considerably since 1942–60, the years shortly before and after Independence, when these pictures were taken.

—SUNIL JANAH

Sunil Janah, *Peace procession in a Calcutta street, joined in by both Hindus and Muslims, after Gandhi's appeal and fasting had quelled riots in the city,* 1946

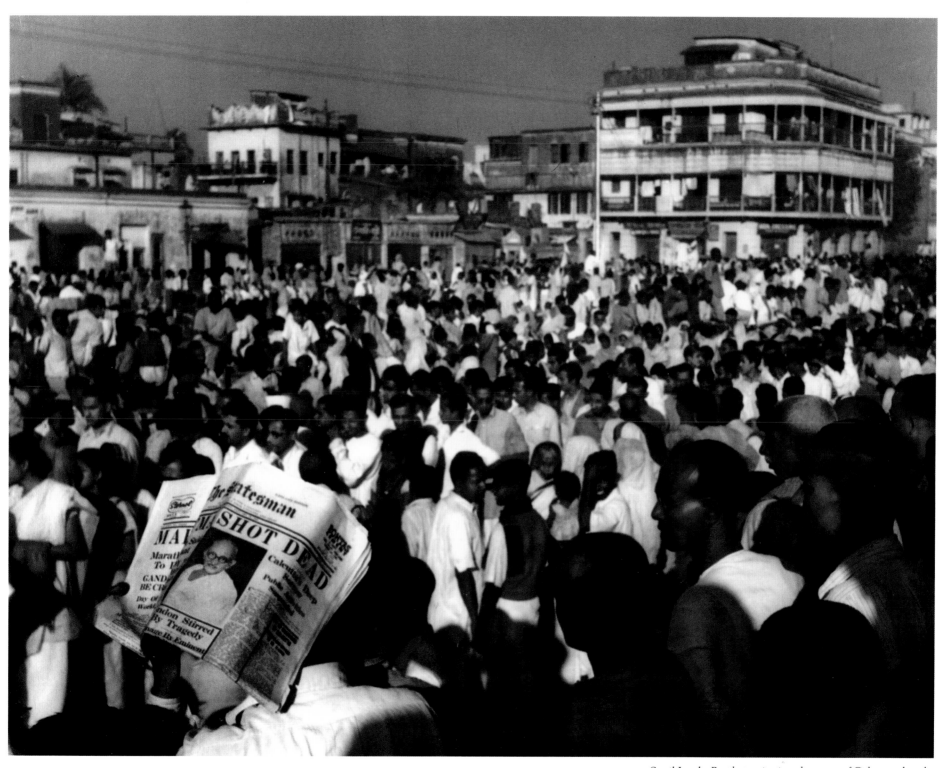

Sunil Janah, *People pouring into the streets of Calcutta when the news of Gandhi's assassination reached the city,* 1948

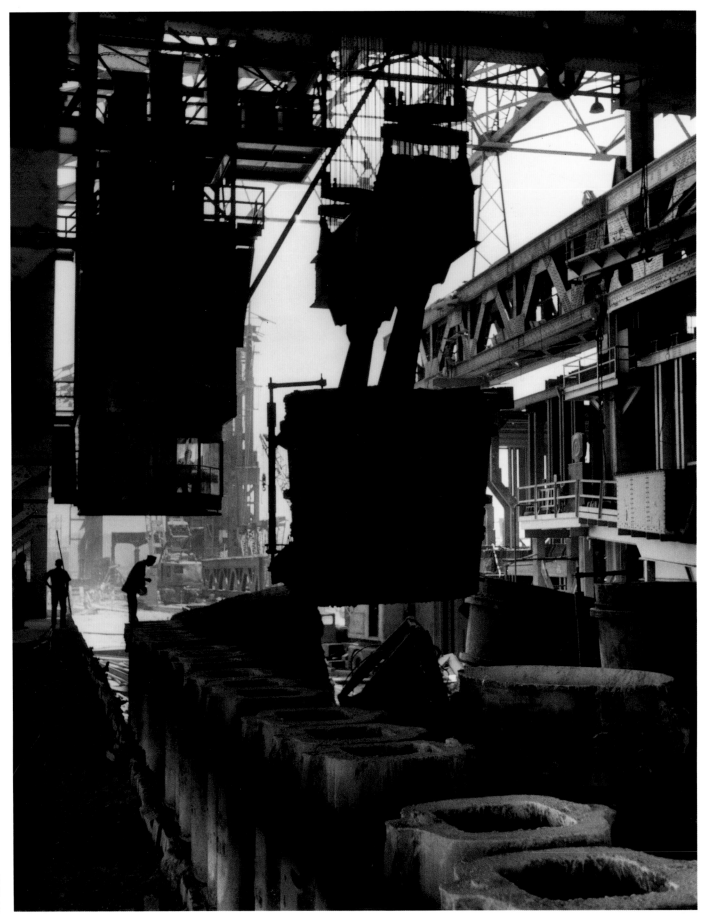

Sunil Janah, *Steel melting
shop, Tata Iron and Steel
Works*, Jamshedpur, 1954

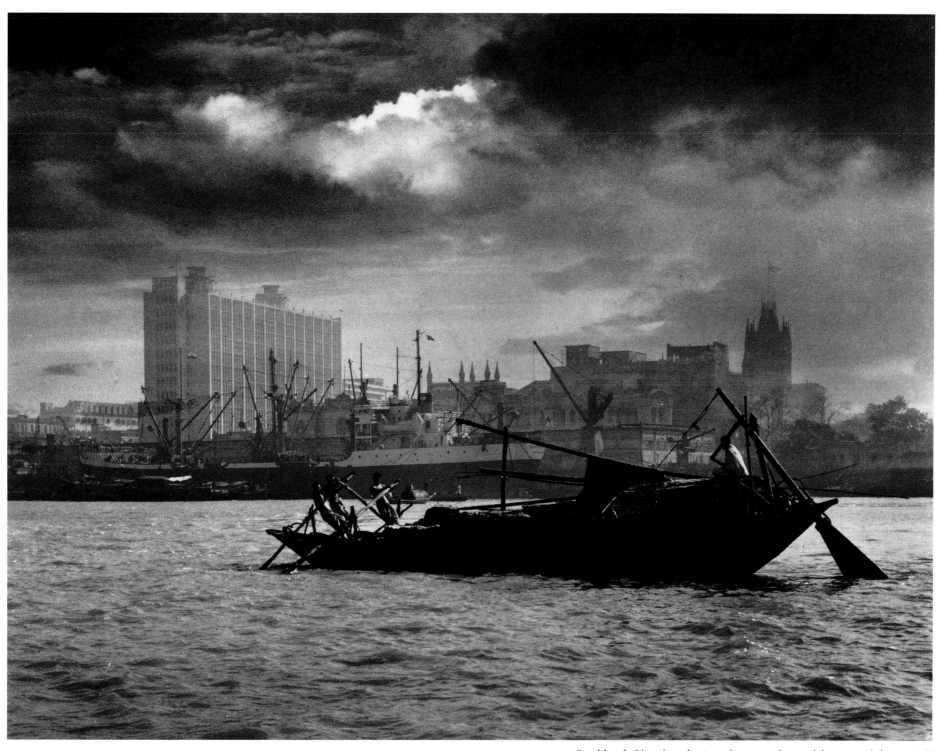

Sunil Janah, *View from the river of a country boat and downtown Calcutta*, 1952

We are a free and sovereign people today and we have rid ourselves of the burden of the past. We look at the world with clear and friendly eyes and at the future with faith and confidence.

The burden of foreign domination is done away with, but freedom brings its own responsibilities and burdens, and they can only be shouldered in the spirit of a free people, self-disciplined, and determined to preserve and enlarge that freedom.

—JAWAHARLAL NEHRU, AUGUST 15, 1947

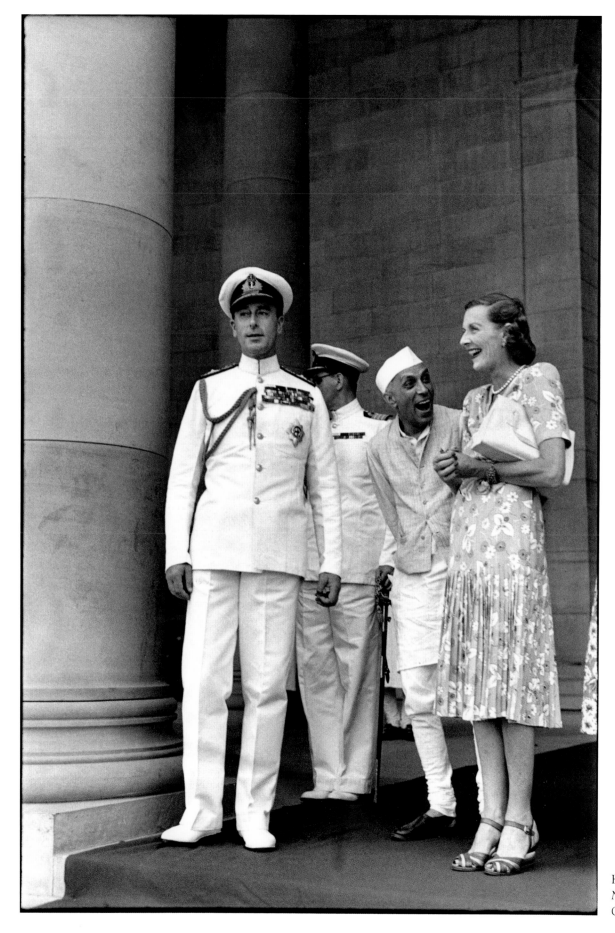

Henri Cartier-Bresson, *Pandit
Nehru with the Mountbattens outside
Government House*, Delhi, 1948

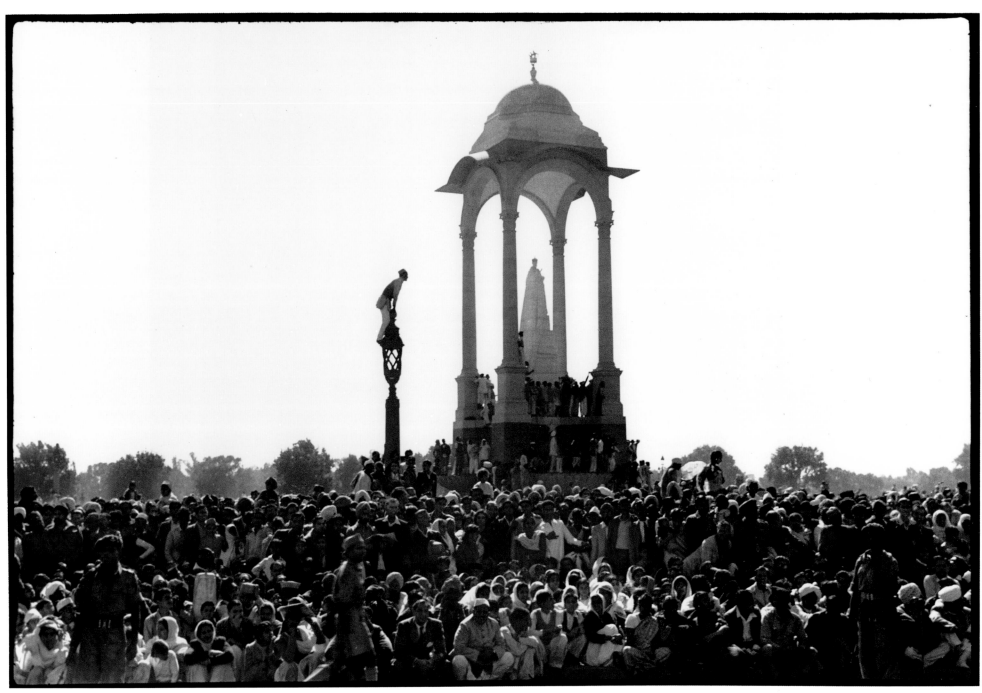

Henri Cartier-Bresson, *Statue of Queen Victoria, Mahatma Gandhi's funeral*, Delhi, 1948

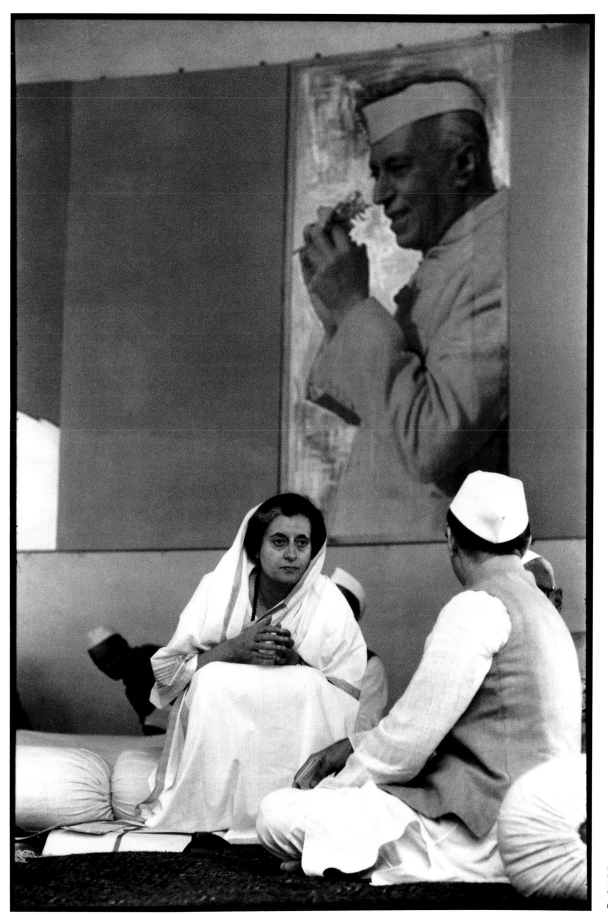

Henri Cartier-Bresson,
*Indira Gandhi at a Session
of Congress*, Jaipur, 1966

Henri Cartier-Bresson, *The Bhagwan Maharishi, dying of cancer at his ashram*. "One night,
at exactly 8:47 P.M., *we saw a huge ball of fire slowly cross the sky and fall at the foot of the ashram.*
At that precise moment the Bhagwan breathed his last." Tiruvannamalai, South India, 1950

Henri Cartier-Bresson,
Sardar Vallabhai Patel,
the minister who presided
over the momentous and
sudden end to the political
power of the maharajas, at
Birla House, Delhi, 1948

When I was seventeen, I was
brought to Hinduism through
reading the work of Romain Rolland,
and I was profoundly influenced
by the *Baghavad Gita*, as I was later
by Buddhism.

For me, India, along with Mexico,
is one of two havens for my heart.

—Henri Cartier-Bresson

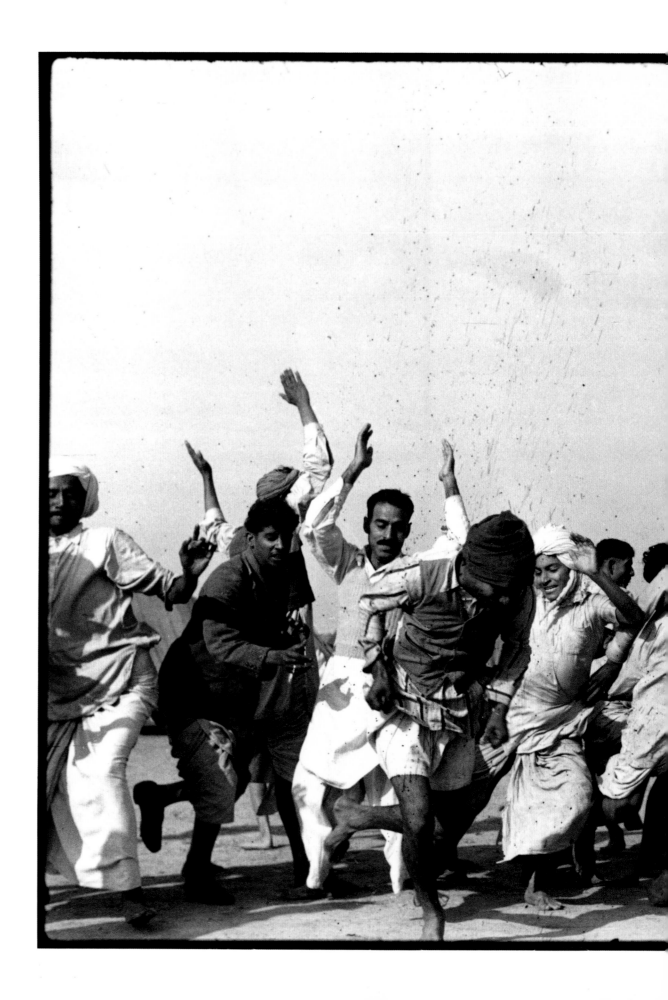

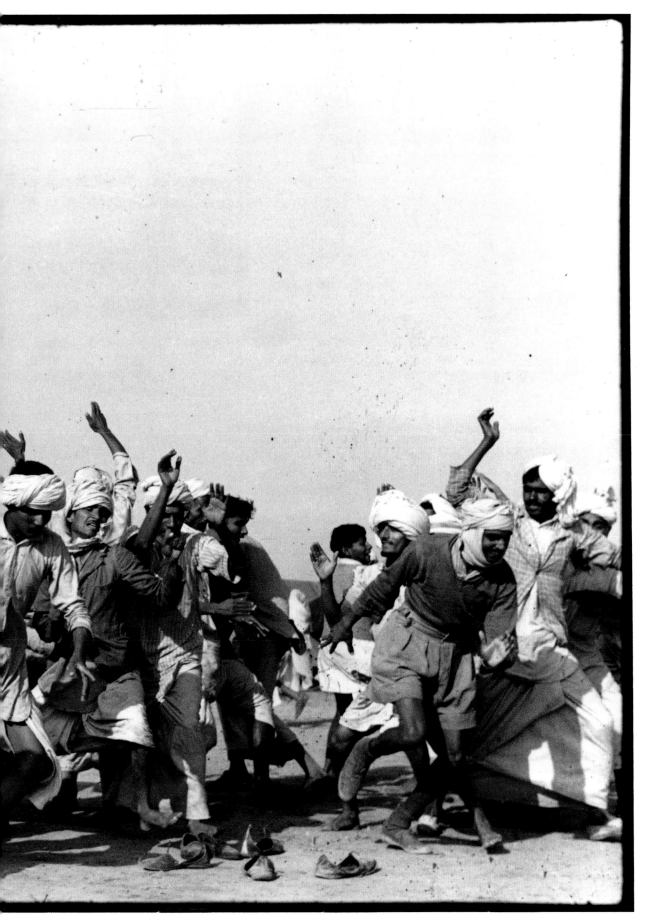

Henri Cartier-Bresson,
*At Kurukshetra Camp, refugees
doing simple exercises to
try to drive away lethargy
and despair,* Punjab, 1947

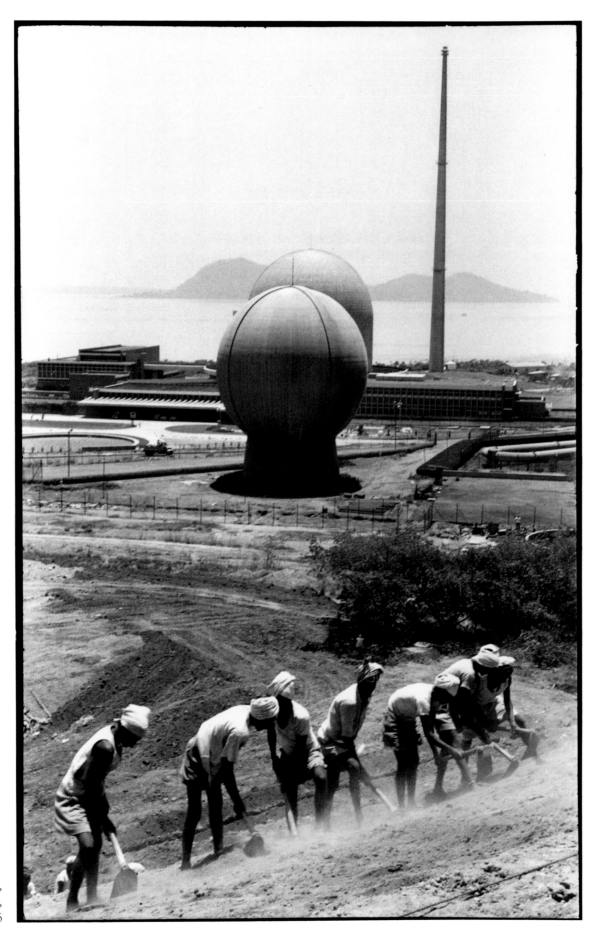

Henri Cartier-Bresson,
Atomic energy plant, Trombay,
near Bombay, 1966

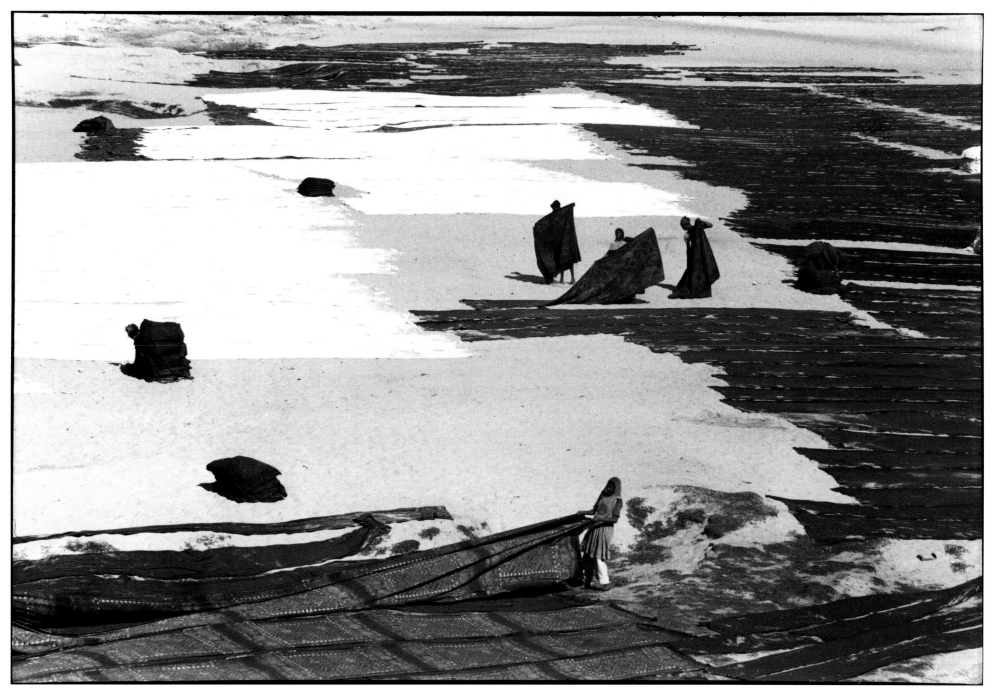

Henri Cartier-Bresson, *Women drying saris*, Ahmedabad, 1966

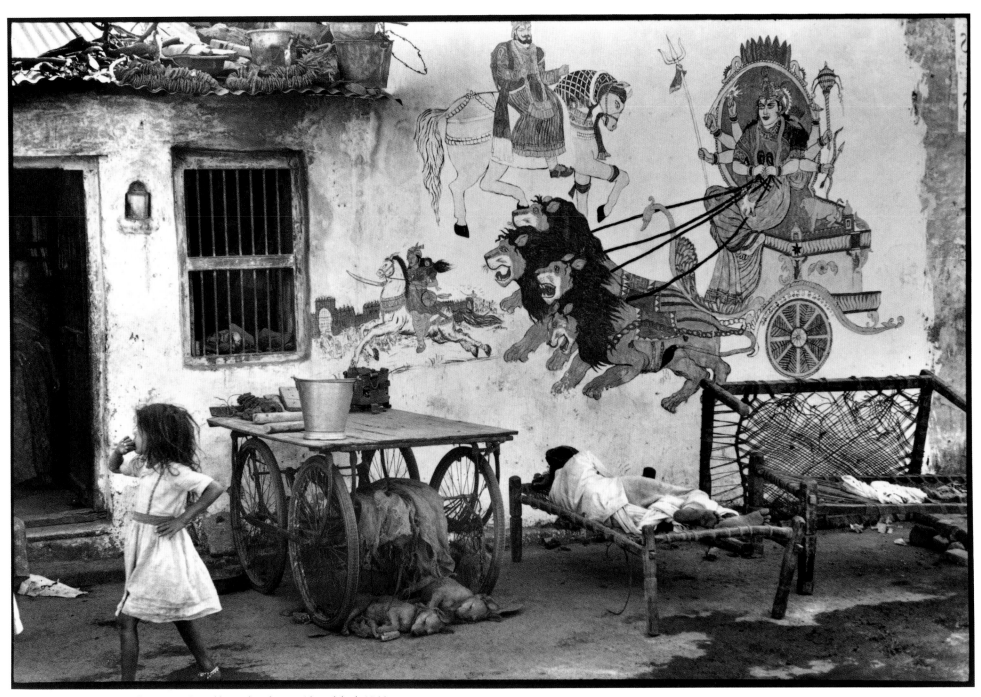

Henri Cartier-Bresson, *Wall-painting of a goddess in her chariot*, Ahmedabad, 1966

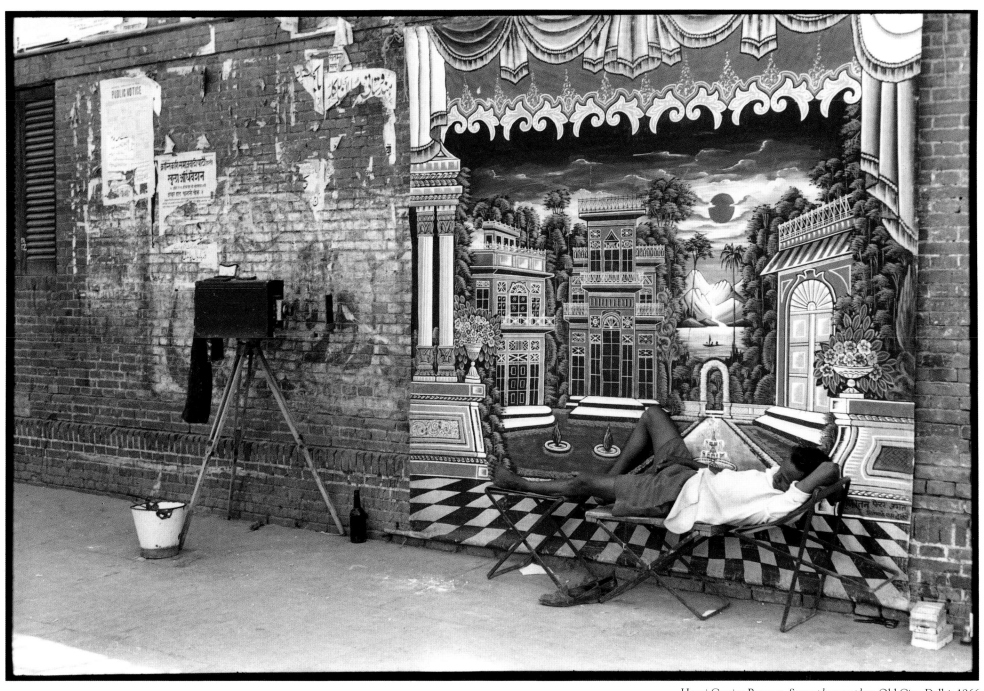

Henri Cartier-Bresson, *Street photographer*, Old City, Delhi, 1966

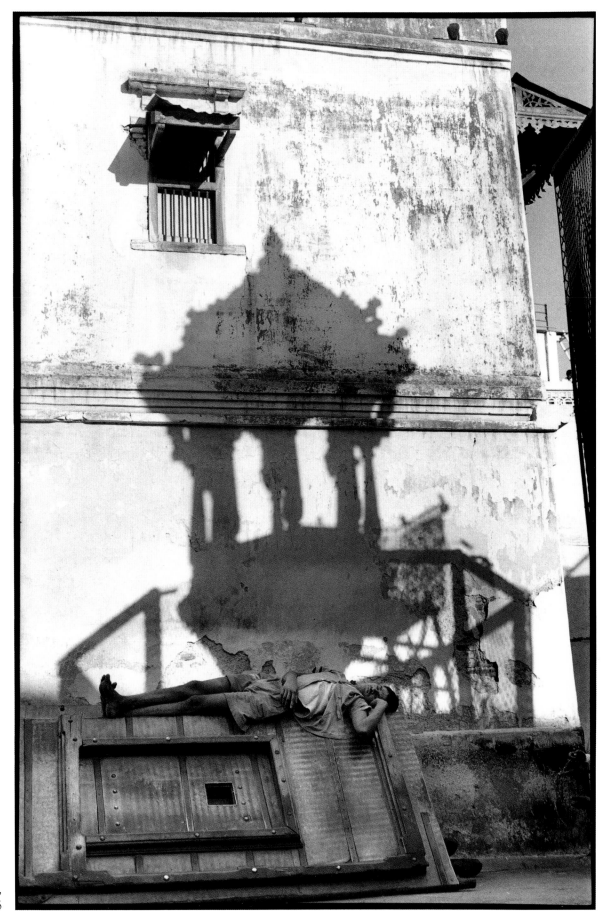

Henri Cartier-Bresson,
Old City, Ahmedabad, 1966

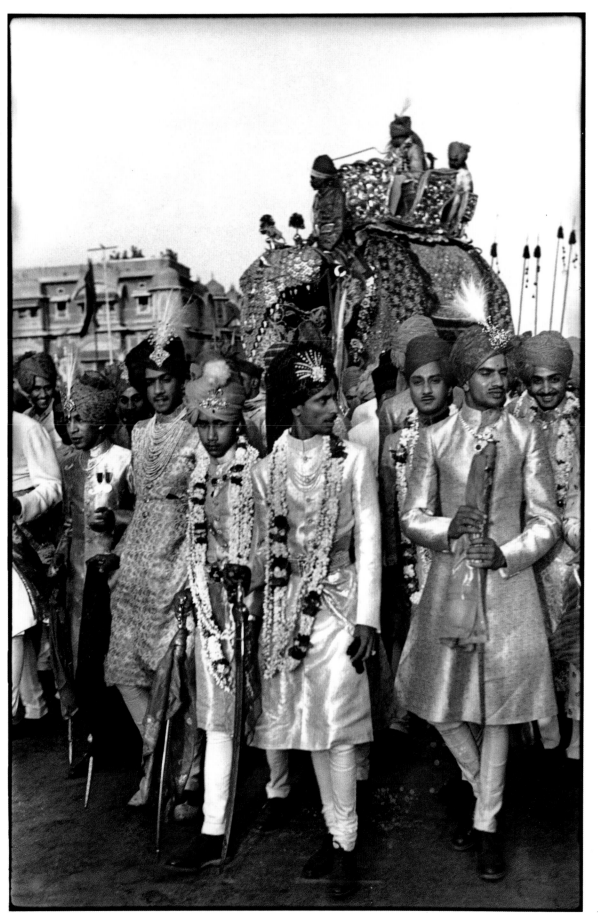

Henri Cartier-Bresson,
*The Maharaja of Baria arriving on
an elephant, escorted by his cousins,
to marry the Maharaja of
Jaipur's daughter*, Jaipur, 1948

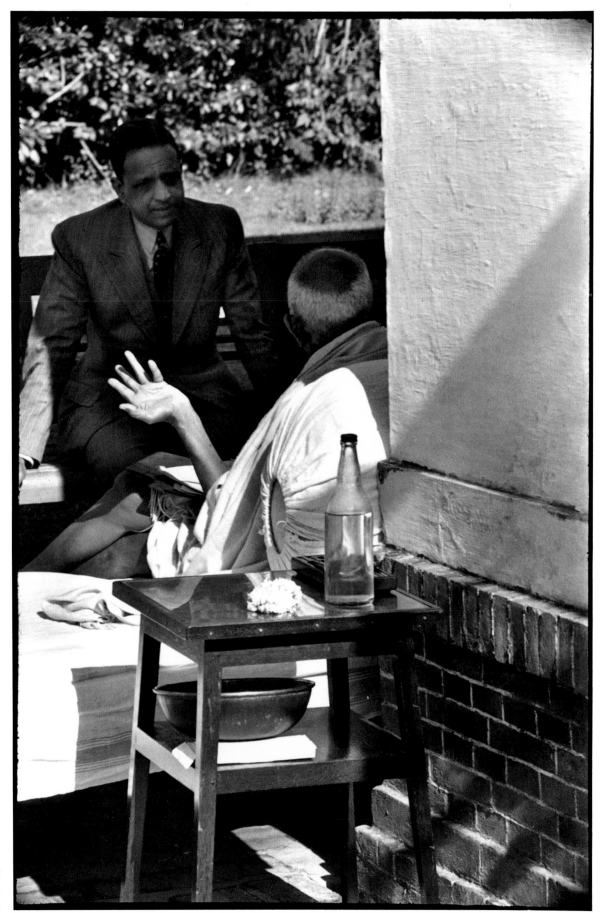

Henri Cartier-Bresson, *Gandhi
at Birla House, the day before his
assassination*, Delhi, 1948

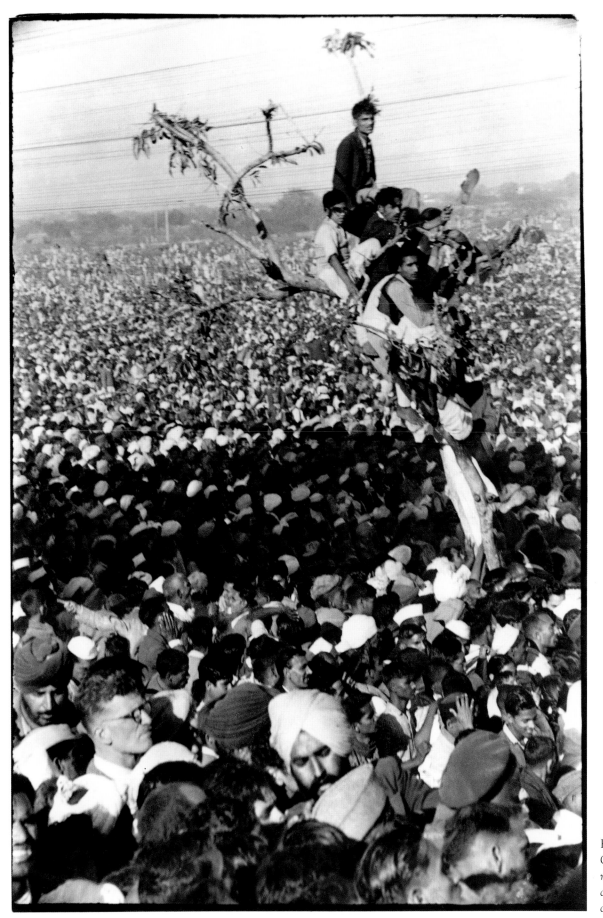

Henri Cartier-Bresson,
*Crowds waiting to pay their last
respects as the Gandhi funeral
cortège approaches the
cremation ground*, Delhi, 1948

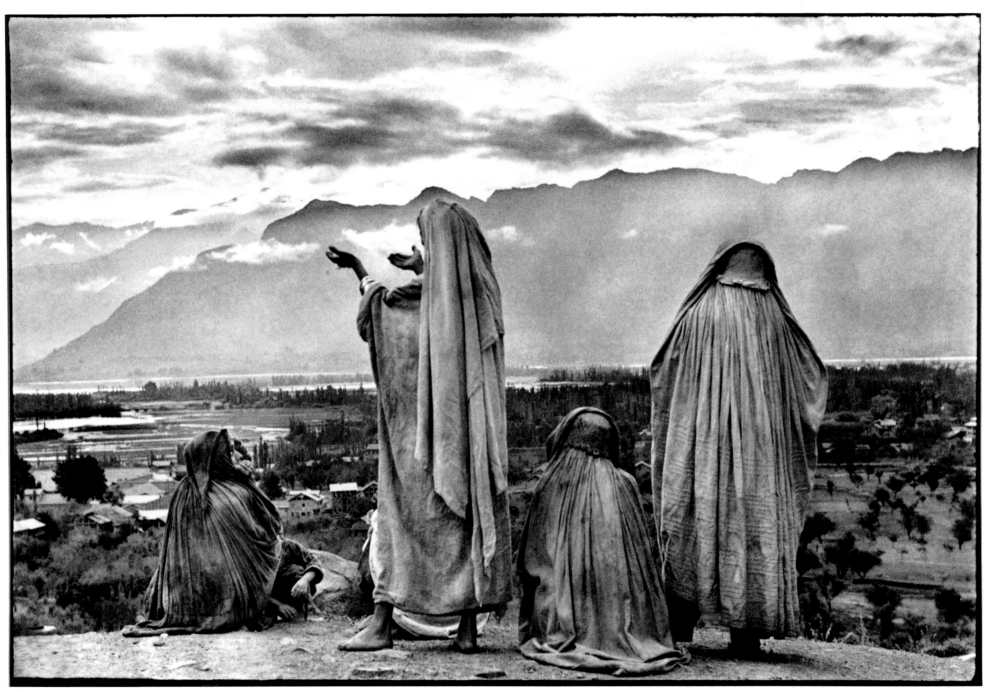

Henri Cartier-Bresson, *Muslim women praying at dawn in Srinagar*, Kashmir, 1948

THE SACRED AND THE SECULAR

VICTOR ANANT

As India prepares to reinvent its five thousand years of civilization as fifty years in the life of a modern, independent nation on August 15, 1997, there is one image that once again, as always, appears to me as the metaphor of its greatness. It bursts through the shower of rose petals, unfurled tricolor flags, the spellbinding displays of jet-fighters in the skies, the fireworks, and the waves of celebratory faces.

It is the matrix of some of the collective memories, dreams, visions, which I hope will give a participant, storyteller's meaning, on this festive day, to all that abides and surfaces as the Indianness of its 900 million citizens. Plate after plate in this golden jubilee banquet honors the gigantic scale, the sheer audacity, of this experiment in democratic nation building. And the drama of the last fifty years, whether seen through the wondering eyes of enchanted foreigners or the eyes of a generation of Indians, inside the whale, refers me constantly to that one image, which to me has become the Logos of the spirit of the land. It appears now, as it did on the morning of that first day of freedom, August 15, 1947.

The skin is black and cracked, the hair in henna-colored braids, like the gnarled roots of an ancient banyan tree. A saffron loincloth is tucked through a leather girdle around the hip. A hollow coconut shell dangles from one side.

Holy person? Or beggar? In India presences such as this stand taller, straighter, than the average human form. It is as if their humanity has been disciplined, emptied of all that is superfluous to their existence, honed down to minimal skin and bone to preserve a tin morsel of truth.

Only one phrase escapes from the lips: "*Dharam karo.*" Do your duty, your dharma. It is a voice that does not exhort, does not whine, does not intimidate. The words have the mesmerizing sim-

plicity of an algebraic formula. Like $E = MC^2$. These are the essential and only sounds permitted, like a mantra revealed by a guru, the only words by which he is bound to his own dharma, to make sense of his own life. *Dharam karo.* He is doing his duty. He bestows on me the right—the task—to tell the story of that morning in the metalanguage of my ancestors.

And these words reinstate my memory of freedom where it belongs, in the oceans from which a terrible beauty was born, and all changed, changed utterly. Fish and tortoise and wild boar and *nara-simha* (half-human, half-lion), and then the first dwarf, evolved; and in cycles of creation sages grasped the universe as organized by Brahma, Vishnu, and Shiva, and their female counterparts, Saraswathi, Lakshmi, and Parvathi. Creation, preservation, destruction. Each represented by a male-female dyad. And in times to come, poets sang into existence legends of godlike heroes, Rama and Krishna—and the Buddha.

All that is consciously Indian in me, my sense of ancestry, my awareness of the time and space allotted to me, my understanding of the people and events we celebrate today, are conditioned by my Brahmin upbringing. "We Brahmins are born old, like the Jews," my father used to say. "Knowledge is not wisdom: knowledge can be acquired. Wisdom is secreted, rubs off on you."

The role of the Brahmin in the traditional caste structure of India is paradoxical, if not ironical. Historically, the Brahmins have always been a tiny minority. They occupy the high moral ground, and appear in history as ascetics and sages, teachers, interpreters of change—what we might term today "critical-path" analysts, keepers of the national conscience. "The world is divided into givers and grabbers," my father taught me. "We who have been given so much can only live as givers." On festive days, sitting before a sacrificial fire of grass, we repeated after him, "*Idam na mama, idam na mama*"—This is not mine—as we sprinkled the flames with grains of rice, flower petals, melted butter, incense. I was always reminded that our special status as Brahmins in the village imposed on us greater obligations to live austerely, shedding desire. The contribution of Brahmins to Indian Independence has been to articulate, endorse, encourage. They do not have power; they seek powerlessness. They are a dwindling group.

Life and death are not opposites, I was taught. Rebirth and release are the true opposites. Birth, life, and death are just three strands in the earthly wheel that turns in us. Nirvana, release from this wheel, is freedom.

Freedom. Independence Day! *Inquilab Zindabad!*—Let the revolution live! Fifty years from now, on August 15, 2047, how will the body language of the dawn of freedom be expressed? How will the life-force of a nation in the making, stored for posterity in this treasure-house of photographs, be recycled? How does the future *anticipate*—invoke—the present? How does what we are becoming appear as what we are, and, at the same time, as what we have been?

The mind's eye sees differently from the eye of a photographer. Henri Cartier-Bresson has said: "When you look through the viewfinder, whatever you see, you see naked." And also, "Nothing is lost. All that you have ever seen is with you."

What he saw in India is here to be seen again, today and fifty years from now. It's all a question of time, Cartier-Bresson says. Comparing photography to the Zen art of archery: "It's a state of being, a question of openness, of forgetting yourself." His eyes constantly moving, observing, *disconnecting*, as he positions and repositions himself to forget all that he knows already, has seen over and over again. To stop thinking. Reminding himself of what counts in a photograph, its plenitude and simplicity. Waiting, waiting for hours and days, for that split-Leica-second when the lens will spring to his touch.

Look at the image he has handed down to us of Lord and Lady Mountbatten [page 17]. "I want you to regard me not as the last Viceroy winding up the British Raj but as the first to lead the way to a new India," Mountbatten is reported as telling Nehru at the end of their first meeting in the Viceregal Palace in New Delhi, five months before the transfer of power. The Viceroy here steps out up front, in tight-necked naval white pomp, yet with a shy young seaman's smile on his face. Framed between two massive Imperial pillars. Behind him, the half-exposed face and stiff body of his aide-de-camp. Between him and Lady Mounbatten—she wears a flowery, printed dress—is the open-necked, almost street-comic, crumpled, khadi-clad, soft figure of Nehru, body bent, hands clasped behind his back, breaking into an explosive joke that he shares with her, at a slight distance from the regal viceroy. Family snapshot? Nehru's sense of humor, which never left him even on the most solemn occasion? The obvious intimacy between him and Lady Mountbatten? Or simply another truth, which Cartier-Bresson saw that second: the relief from tension that actors in a great drama need to express in the intervals, to be saved from *becoming* the roles they have to play?

Cartier-Bresson saw so much. On pages 22–23 here—a festive dance? Peasants celebrating the coming of rain? The joyous detail of a shoe kicked off a foot? All those pairs of hands raised to make thunder? Only in India can grown men dance like this, like a field of grain bursting through the earth. Only in India do male laborers tidy and clean a hillock with the tenderness of a woman massaging a baby with oil [page 24]. Only in India are all men one bridegroom and all women one bride, as the elephant slowly carries the real ones to the temple [page 29]. Only in India does a black-gowned woman stand facing a mountain in a silence that holds them together and you wonder who is praying to whom [page 32]. And only in India can you have the experience of entering another's dream in an old city like Delhi and find yourself waking up to its reality, perhaps years later, elsewhere. As I entered the India-dream in my ancestral village in the Native State of the Maharaja of Travancore, in Kerala, South India, and later found myself awake in Independent India.

I see myself standing in the flat, wet rice fields that my ancestors administered as part of the estates of the king. A coconut tree shoots up, tall and straight, with a cluster of emerald-green fruit under a crown of finely tapered, swordlike leaves. On a sheaf of such leaves my horoscope was engraved announcing my arrival in a legendary Brahmin clan. I can feel the dark vertebrae of the coconut tree straighten in my own spine as memory bubbles buzz in my head. Up there, the leaves become steel fan-blades. A helicopter lifts me above the flat, alluvial land, the lazy backwaters. Whirring eyes, looking and retrieving.

Below me the trees are assembled. Tamarind, mango, jackfruit. Flesh tree, juice tree, untouchable tree. We gave the trees caste names to distinguish their functions: warrior tree, with thick armor and bitter-sharp flesh for battle; trader tree, with sweet juices made for bargaining, the fruit of which could be squeezed and dried and stored for the lean months; and spiky, untouchable jackfruit. Brahmins were speaking trees, a caste apart, given the grain of language—Sanskrit—by which all things were named, and through which all things spoke; and the word, after being employed and tested for two thousand years in the service of Brahma, the creator, grew into flesh, acquired grammar and syntax, and a script, *deva-nagari*, the script of gods.

The *deva-nagari* script is unique because every word dangles from a line above it, as fruit dangles from the branch of a tree. The word was not made to fly above that bar, it obeys the first

law of gravity: it must fall. As I write today, illuminated words on a sky-blue screen of a computer, which millions of Indians now use as they develop into global citizens, I realize that it was the women of my childhood who fed my dreams of stories and song flying beyond the reach of the written word.

Grandmother, her amethyst beads whispering to me in the dark, putting me to sleep with *nama-Shivayah, nama-Shivayah.* Grandmother, *kunjamma*, little mother to the whole village, who lived to see eleven of the seventeen children she bore die, and who reeled off their deaths as she uttered the name of Shiva, the god of death: "snake-bite, plague, drowning. . . ."

I slept next to her on a straw mat as many Indian children still do with their grandmothers. Sometimes, she would wake me up. "Listen." "Listen to what?" "A ripe mango has fallen from the honey-mango tree. Come with me. If we wait till the morning the birds will have pecked at it." And slowly, as if measuring each step, she would lead me in the dark, through the sand courtyard and the vegetable patches, skirting the water-tank, to the exact spot in the mango grove where the fruit lay. They still talk in the village of how she tamed a young temple-elephant that had run amok. While the peasants fled, she walked down the path to the temple, stood in front of it, and said, "Go back to your mother. Temple elephants don't behave like this." And the wild one meekly turned back. In Kerala, when people part, they still say, shaking their heads, "All right then, go and come." The night she died, grandmother said to me, "Go, go and sleep." The rays of the morning sun through the slatted wooden frame of the house seemed to pick her out and turn her over like a twig. She had not gone. She had just failed to come back.

Mother. She with the fish-eyes. She would read stories from the *Mahabharat* and the *Ramayan.* As she read, she would be Draupadi, wife of the Pandavas, the five heroes of the *Mahabharat*, of whom I was Arjun. Or turn into their mother Yashodha, mother of me. Or she would be Sita of the *Ramayan*, crying in the garden of the demon-king who had snatched her away from the forest. Or Savitri, following Yama, the death-god carrying away her husband, and she would sing me, the husband, back to her bosom.

We would sit in the kitchen, together churning buttermilk in a pot, with thick rope around a wooden stick, and swaying to a gramophone record. In the morning, after she had bathed, she would wash the entrance to our one-room flat in Bombay, and, with rice flour, orange, turmeric powder, green paste of corian-der, she would draw fish, stars, squares, and other images on the threshold. They would not only ward off evil spirits, they would remind visitors to take off their shoes before entering her home.

Nehru, in *The Discovery of India*, perceives that it is women who have made myth and legend "a living force." "Among the earliest memories of my childhood are the stories from these epics told to me by my mother or the older ladies of the house." Lakshmi Bai, the twenty-year-old heroine of the Indian Mutiny, who died fighting, and is known as the Rani of Jhansi, was described by a British general as "the best and the bravest." The Independence movement was literally led by women—I remember protest marches in which we always placed them in front, daring the police to break their ranks! Poets of freedom like Sarojini Naidu; the dazzling escape from jail of Aruna Asaf Ali, a Socialist leader during the Quit India movement; Vijaylaksmi Pandit, Nehru's sister, who charmed London and then Washington as India's envoy; and, of course, his daughter, Indira Gandhi, first woman prime minister. Mother Teresa.

There were, and are, thousands of others. I saw some of them in a television documentary on Republic Day in New Delhi, gray and some toothless, lisping, still speaking with maternal pride about a nation as young as their dreams. Most Indians today know that if population growth has to be controlled it will be women who have done the job. The women of India are modestly contributing to the global liberation of women.

Some of the more vivid freedoms we celebrate today, nonpolitical, freedom of perception, instinct, memory, imagination, have been received from women. There is a photograph by Mary Ellen Mark [page 97] which could be of mother giving me wings. She used to say, "You kicked in my womb, all the time, asking questions with your feet, restless to come out." Me, dying to be released from her womb.

She said it was Garuda, the eagle of the *Ramayan*, who was killed in the skies trying to rescue Sita as she was being abducted. She was afraid I would try to fly before my wings had been developed. Perhaps she knew even then that I wanted to be a poet or a storyteller. Mother-tongue, for me, is the language she gave me. For example, she said, "You speak like the crackling of mustard seeds in hot oil." Or, "You are like an ocean wave which has just had its first glimpse of land." And so, she said, she suckled me longer than any of her other children. Until one day I pulled a face, spat, and said I wanted coconut water, not her milk!

In the morning, at breakfast, as we sat around the coal fire on which she fried rice pancakes, she would ask what we had dreamed. Her own dreams were always funny. "I dreamt I was a coconut," she said. "You are making that up," I said, looking at her with pity, "only because I asked for coconut water." She ignored my rebuke. "And I dreamt that like a coconut I had six sides, a this side and a that side, an inside and an outside, a shell side and a flesh side. And then I dreamt that you came to me, and gave me another side, an eye side, and that is why I could see my dream." We roared with laughter.

I stopped dreaming in color when I left my mother's home.

Until then I used to have many dreams, flights into space as a pilot in a coconut tree. I rose above the other trees. I could hear them talk.

Tamarind tree: "You won't go far. I am the flesh you need. I am bittersweet. Without me no food can be preserved. On my branches cheetahs hide, and leap. They leap only at virgins. I fruit in the driest seasons. I camouflage in green. Inside me, a black nut. Hard. Ruthless. Cold. As cold as my blood is warm."

Mango tree: "Ah, sweet, sweet me. I am the slave of the sun. I make juice of its gold. Everyone needs me on their tongue. If I lose a bargain I turn sour. If you pluck me when I am still unripe I burn you with my sap. I graft well. Robber birds peck at me. I grow in groves. I am best preserved in teak chests, in dark, cold cellars."

Jackfruit tree: "I know I'm ugly. Spiky like a hedgehog. I persevere. I stay head bowed as long as I can. I bleed inside myself. My sap protects me. You need oil on your palms to touch me. My fruit stands in rows. I smell of sperm. I cook raw. I am best eaten ripe. My nuts roast like meat."

So, the coconut tree said to itself, Shall I answer them?

And thunder answered: "Yes, teach them, educate them. They have to serve man. You have to serve god through them."

"And what I say, shall it be written?"

Thunder replied: "On your own leaves it will be written, when dried by the sun, with lightning tips. Speak, your words will dance in the air long after they have been spoken."

Coconut tree came down to ground. Hovered a little.

It said: "I am like the earth itself, not round, nor square. I was shaped to hurtle through space, like a rocket. I have as many layers as the earth. Outside I am green and yellow, changing with the seasons. Then fiber, protective armor, woven into a shield, impenetrable and yet so pliable it can be twisted into rope, to hang, to pull weights, to make baskets, to anchor boats or tie around an elephant's foot. Then I am shell. To burn or to make cups for drinking or painting, or to be carved into masks, or for begging. Then comes my flesh, the nut, wet and white, drenched with oil, firm yet flaky, multipurpose food for both humans and animals. And then again, inside the flesh, covered by the flesh, I am milk, oceans, sweet, ever-fresh. I do not grow from seed. I am planted whole. Horoscopes are written on my leaves. Homes are thatched with my leaves. Fires are lit with my stalk. When I am old and die I am carried to be planted as a telegraph pole. I am rolled between bride and bridegroom at weddings. No one climbs me except the untouchables. Yet I am the Brahmin of trees. I serve all the castes equally. I teach, I bring justice, I heal, and I burn the dead. I have three eyes, one more than is given to man."

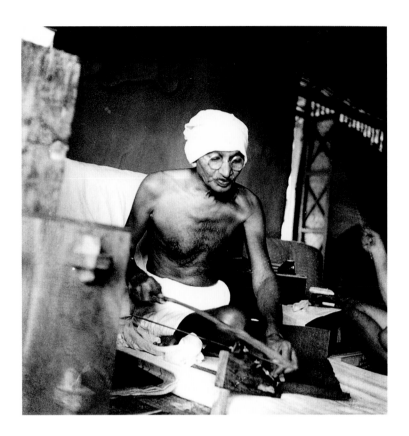

Kanu Gandhi, *Mahatma Gandhi at Sevagram Ashram*, Wardha, 1940

> When you learn to swim
> do not enter a river that has no ocean
> to flow into . . .

Kamala Das advises fellow-swimmers,

> . . . go, swim in the great blue sea.

A unique characteristic of India's freedom is the pervasive mother-nature, the feminine principle, of its creative energies. It manifests itself in its bewildering variety of its cultures. It breathes in the astonishing inventiveness of some of its earliest political figures. For example, Aurobindo Ghose (1872–1950), whose life and work embody the peace he found through the violent contradictions of his time. His father was a doctor, a Bengali educated in Britain. He sent his son to a convent

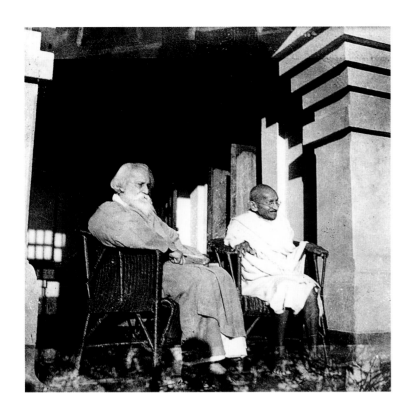

Kanu Gandhi, *Mahatma Gandhi with Rabindranath Tagore*, Santiniketan, West Bengal, February 18, 1940

school at the age of five, and then to England when he was seven. Aurobindo was twenty when he left Cambridge University. He came back to India and was recruited into the prestigious Indian Civil Service. He felt "denationalized" by his foreign education and began to look for his Indianness in the teachings of the Bengal "mystic" Ramakrishna (1836–1886), and his disciple, Vivekananda (1863–1902), the first to preach Vedantic Hinduism to audiences in England and America. Aurobindo left the Indian Civil Service to participate in the agitation against the partition of Bengal, was arrested for inciting people to violent action against the Raj, and was sent to prison. After his release in 1910 he left Bengal (and his wife) and withdrew to practice yoga and meditation in an ashram in Pondicherry, a former French enclave in South India. From all over the world the ashram still attracts pilgrims in search of spiritual comfort. Aurobindo wrote: "Whereas others regard the country as an inert object, and know it as the plains, the fields, the forests, the mountains and rivers, I look upon my country as the mother, I worship and adore her as the mother."

Reverence for the mother-spirit is one special meaning of India's freedom. It appears as the enduring source of its artistic heritage, in the vitality of its folklore, and, of course, even in the originality of its food and clothing. It is the secular force through which India apprehends the sacred universe. Indians call this force *leela*—play.

Let it play here now, in the words and images that celebrate fifty years of independence.

My freedom began with a realization of my obligations to the peasants in my village. My father was a practicing Brahmin who, like many of the English-educated generation of Brahmins at the turn of the century, could no longer bear the indignity of being a second-class citizen of his own soil. He saw himself as being descended from the *gotram*, or lineage, of Kaundinya, the sage to whom was given one of the three earliest Vedas. The essence of his Sama Veda is that the Self must live anonymously, without egotism, like Kaundinya himself, about whose personal life nothing is known.

There is in this book a photograph by Robert Nickelsberg [page 62] that could be a portrait of my father bathing in a river. He would enter the water very slowly, as if with each step he was shedding the load of land-time. Then, as river-time came up to his waist, and his sacred thread began to float in the water, he would fold his hands in prayer. Sprinkling his face and body seven times, each with a prayer, he would hold his nose with two fingers. And only after that, hand covering mouth, because speech itself had to be thrown off as body melted into water, he would immerse himself and emerge purified. "Just as you must throw off your clothes before you go to sleep," he taught us, "you must throw off your words if you want to go to God."

I think it explains why he chose to leave our village and the "Native State" in Kerala for Bombay, commercial capital of British India. He worked as a postman to study electrical engineering, and later became what he called "a railway servant." In all his ritual he remained a true Brahmin, yet he left the village to be "converted" by Gandhi, who was born in the *vaishya* (or merchant) caste.

In those early days of the Independence movement many Brahmins like my father redefined their sense of belonging to the "upper caste." There are two words in our native language, Malayalam, for labor. One is *joh-lee*, or "work," employment; the other is *vey-lai*, or "service." My father chose to leave the village because his Vedic ethic of "service" had to be modernized. Our clan had served the King: it was time now to serve Mother India.

"It is not by birth that you become a Brahmin," he used to say, echoing the words of Buddha. "It is by your deeds." At home, we ate off banana leaves, sitting on the floor, first sprinkling water around the leaf. Then saying grace with seven morsels of rice, for the spirit residing in our flesh, for Brahma, for our ancestors, elders, kith and kin, and so on. Mother always ate last, from the same leaf on which she had served our father. We cleaned our teeth with salt and the husk of grain. We scraped our tongue with the rib of mango or coconut leaf, and smeared our bodies with sandalwood paste. On Saturday—the day of Saturn—we mas-

saged ourselves with warmed sesame oil. We wore loincloths, and the infants stayed naked. We prayed around a brass lamp at night. And observed "auspicious" holy days, according to the Vedic calendar.

As a follower of Gandhi, father added new rituals. We sat at a spinning wheel a few hours every week. He read from Gandhi's articles in the weekly newsletter *Harijan*. "*Eashwar—Allah théra naam*," said Gandhi, seeing no difference between Hindu and Muslim god. And so, my father asked a breadseller who was a Muslim congressman to read to me from the Koran and tell me stories of his prophet Mohammed.

Even though he enrolled me in a suburban British school, and began reading to me from Shakespeare and Dickens, Father took me one afternoon, when Gandhi's train was stopped at our local station, to get *darshan*—to have a vision of him. It is a word that does not translate easily. Many have tried to convey, as some of the photographs in this celebration do, the presence of Gandhi. As we walked along the platform, my father stopped at a first-class carriage for me to see the poet Sarojini Naidu. I remember her telling me with a chuckle, "Don't forget to ask him to show you his teeth." The joke was that Gandhi had only a few left. He was sitting on a wooden seat in what was then known as the "servant's compartment" of a first-class ticket holder. My father had to lift me to look at him through the iron grilles of the small window. Gandhi's gaze rested on me. I felt that India would never be an unfriendly place. It would be open. It would always be open. I had been "opened."

As my father put me down I heard Gandhi say, "He is ready now to become a Youth Congress volunteer." Like many Indians of those days my father was being asked to contribute one of his sons to the cause. Later, as a volunteer, one of the many who attended to the needs of senior leaders of the All-India Congress Committee, I could feel the power of his presence hovering above the hustle and bustle, the pettiness and vanities, the bickering and intrigue of ordinary politicians. Even the words *power* and *presence* do no justice to Gandhi. Perhaps *shakti*, aura, is closer. His compassion forgave everyone in advance, as he forgave me years after, one Monday, his day of silence. That story comes later, after I joined the Socialist group in the party, before it launched the 1942 Quit India movement to sabotage the British war effort, and I was arrested and detained in prison.

"There is no prison like the prison of the self," my father said,

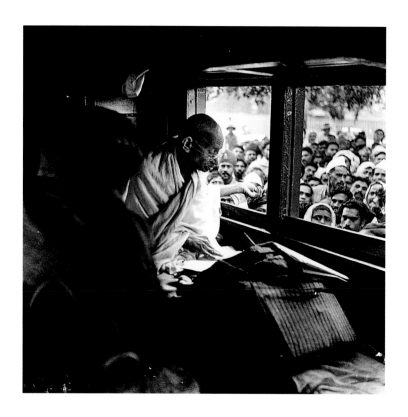

Kanu Gandhi, *Mahatma Gandhi on a fund-raising journey for Harigans*, Bombay, September 8, 1944

translating from the *Upanishads*. Most of us in those pre-Independence days sensed freedom as the expression of a collective consciousness. India was a geophysical form, its head draped in snow, its arms spread and fingers becoming the tributaries of the Ganges and the Indus, the bare midriff of the central Vindhya range, its thighs the eastern and western ghats, its toes dipping into the Indian ocean.

As I write now I feel again that sense of collective experience, as if nothing that happened to me or is recalled now is personal to me alone. Albert Einstein says it is "a feeling of solidarity with everything alive that it doesn't seem to me important to know where the individual ends or begins." Nehru writes: "Though outwardly there was diversity and an infinite variety among our people, everywhere there was that tremendous impress of oneness, which had held all of us together for ages past whatever political fate or misfortune had befallen us." A Karnatak poet, Karanth, declaimed in Whitmanesque terms, "Hear in me 350 million voices speak."

A young Congress volunteer had no time for private pleasure or anxieties. After school hours there were regular study groups, meetings, sporadic *hartals* (strikes) to organize, flag-raising cere-

monies on days of special significance, walking miles to Chow-pathi beach for political rallies, pamphlets to sell.

Thrown into life on the city streets we began to grasp the real significance of colonial rule, its economic penetration, the reach of its exploitation. The British had their exclusive preserves, gymkhanas, boat clubs, race courses, bars, and residential areas. Rich Indian toadies. In Bombay we learned three or four languages, Marathi, Gujerati, Hindi, and, of course, English. We also learned instinctively how to recognize the phony from the real, the con man from the honest rogue and the simpleton saint from the poseur.

One of the reasons my father chose to become a "railway servant" was that it gave us certain privileges: free education and medical services, and, much more important, free second-class travel. Once a year, during the winter school holidays, he took us to a new part of India. Delhi in the north; Lahore and Lucknow; Amritsar in the Punjab; Calcutta in the east; central India, Poona; Ahmedabad in Gujerat; Baroda, Mysore, Bangalore; Benares and other places of pilgrimage; centers of Muslim culture like Aligarh and Hyderabad; and, of course, Madras and the southern tip of India, Cape Comorin (Kanyakumari), where my mother said three seas "converge to wash our feet."

We saw jute mills and ancient temples; went down coal mines and into Elephanta caves; Howrah bridge and the legendary rivers; Moghul architecture and the Imperial sweep of Lutyens's New Delhi. The old observatory, great mosques like the Jumma Musjid; the Red Fort; climbed up the Qutb Minar; saw palaces of the Maharajas, in Gwalior, Patiala; Saint Thomas's church in Madras; the synagogue in Cochin. Prisons, too, where Gandhi and other leaders had been put away.

Everywhere we lived in simple ashrams. Everywhere we thrilled to the excitement of local delicacies and fruit, apricots, dates, walnuts in the north; Bengali sweets; the large, shawl-sized, thin *roomali* chappaties of Lucknow; milk warmed in huge, earthenware pots and with a thick layer of cream, drunk from clay cups in Hardiwar; red watermelons and fleshy tangerines; roasted gram and sweet potatoes; the oysterlike fruit of palm trees; mangoes; succulent custard apple; pickles and chutneys; sweet *lassi* and fresh lime juice. Monkeys snatched food from our dried-leaf plates; parrots screeched. We saw the *gulmohar* tree, flaming red in the heart of a dry field; violet *jambul* fruit dangling in bunches. Everywhere mother braided her hair and wore a bun of jasmine buds.

We saw fakirs walk on burning embers, put a skewer through their cheeks; snake charmers make the cobra rise from a basket, sway its head and show its fangs to the tune of a bagpipe; we saw bears tango to the rat-a-tat of drums; acrobats balance on top of a greased pole; magicians sawing a girl in half in a cane basket and then bringing her out alive; peacocks that spread their feathers and shook to announce the coming of the monsoon; elephants and horses decked to carry a bride; tigers and lions in zoos; camels sauntering down a busy thoroughfare. Eunuchs and transvestites clapping and singing. Nautch girls with anklets dancing on bare feet. Roadside fortune-tellers, shrines in the hollow of massive *pipal* trees. And everywhere crowds such as can be experienced only in India, like rivers flooding, massed ranks of clouds, tidal waves, or volcanic eruptions.

This India is still there, will be there. It lives outside time, in a kind of space that has never been usurped by alien forces. It is pure because it is unashamed. It is the choreography of an archetypal innocence. And living proof that the sacred and the secular are inseparable in the celebration of Indian Independence.

In the mind's eye these early experiences of my Indianness are even now retrieved and transformed. Memory becomes dream. Once a year, during the long summer holidays, my father took us back to our ancestral home in Kerala. The village was the renewable source of spiritual energy.

A low-caste, untouchable youth was my constant companion. Keshavan was a few inches shorter than I. He had a small head, a narrow forehead. He was quick-footed, lithe, black, yet straight as a rod. He belonged to the "toddy-tapper" caste, which also had to do the job of climbing coconut trees to pluck the fruit. He climbed with a coconut-fiber ring around his ankles, soles touching, toes spread around the trunk. As he frog-hopped his way up to the top, the coconut tree no longer seemed to have its head in the sky. He seemed to make it bend to the ground.

Keshavan taught me to climb and I had many dreams of flights into space piloting the tree. I rose above the other trees. I dreamed that with a Brahmin mantra given to me by my father I had made a coconut tree so small that it didn't need climbing. So that I didn't have to fear that Keshavan would disappear one day in a whirr of leaves.

I had an exhilarating dream one year when there was no rain. My uncles sulked and brooded. My aunts hid the best tidbits, fried

banana, jackfruit, even coffee and sugar. There was no milk, they said, because the cows were dry. There simply wasn't enough to eat. One morning, I slipped away from the bickering in the kitchen, to walk across the parched fields to the cool hilltop.

As I walked with my head down I dreamed a powerful dream. "You see, Keshavan, the rains don't fall because the skies need cleaning. There is a blockage up there."

"Blockage in the sky?" he laughed.

"Cobwebs," I said.

"There are cobwebs in your head," he said.

"You peasant idiot, what do you know? You live in a hut thatched with coconut leaves, not like me, in a house of wood and stone, with a slate roof, and strong beams which are covered with spider's webs. You have never seen cobwebs."

"That's true, swami," he said, addressing me in a tone of deference that is used with the Brahmin caste. "There are no cobwebs in my hut. Rain and sun pour through the dried crackling leaves, swami. No cobwebs."

I loved Keshavan too much to let him wallow in his peasant deprivation of cobwebs. "You get a cool breeze. In our house we have cobwebs, in the dark corners spiders, beetles, and bedbugs. And even in our heads insects crawl." So I told Keshavan my coconut dream.

I told him that I had put all the coconut trees together, end to end, and tied them with a pole to reach the skies. At the tip of the pole I had made a huge, round brush with bristles, and with this I would clean the skies of all their cobwebs so that the rain could come bursting through.

Keshavan was full of admiration. "You can do that?"

"Yes, Keshavan, I can do it. The Brahmin mantra is powerful."

"One day, swami, will you teach me those mantras, so that I, too, can do it? I will make it rain whenever our people want it."

"You peasant fool, son of a pig, I cannot teach you," I said sadly. "Why?"

"Because, you dung-head, because you will make it rain all the time, that's why. There's coconut water in your head."

His eyes lit up. "Yes, swami, you are right. Brahmins are wise."

The next morning as I walked alone to the temple on the hill in the market town nearby, I saw, at the foot of the hill, dozens of bare-bodied men working. Dead coconut trees were being carried and being laid flat on each side of the road, like pipes, at regular distances.

Between these poles of dead wood were small rolls of wire, almost like coconuts covered with silver polish. I knew what was going on. They were putting up the first telegraph lines for the nearby town to receive and send messages from the big world outside the village. Would the day ever come when I could write words for Keshavan, from Bombay, from the cities of the West, cities where they mint these coins called English, the new currency of thought and ideas?

That was when I decided to become a writer, when the freedom to which I already felt heir, legitimized, became an urge to share it with all the dispossessed of the earth, represented by my low-caste friend Keshavan. I told him that evening when we swam in the river, "I will write words for you to dance on telegraph wires that stretch from coconut tree to coconut tree and drop at your feet in the village."

Political education and Congress Party work in Bombay had given a modern impulse to my Brahmin sense of duty to the other castes through the example of Gandhi. Coming back to the village every year—where all Congress activity was banned—gave a special focus to revolutionary ideas, and, at the same time, a sharp, subversive flavor. When I went back to the city I was seduced by the literature of other revolutions. Bloody ones. The American Revolution against the same Crown that dared to impose its power (and taxes) from across the oceans; the French Revolution; the Russian and Chinese Communist uprisings of peasants against feudalism. We were youth of an age of violent revolution: our fathers belonged to the nonviolent Gandhian movement.

While Gandhi remained the beacon light of Congress resistance, the unchallenged exponent of a moral force against the might of the Empire, my generation looked to Nehru as the future. His words and writings had a more flamboyant, urgent, virile ring. Gandhi himself had said that Nehru was his true heir. While he kept faith with the Father of the Nation, Nehru embodied the kinetic energy of our time. Gandhi was an Old Testament patriarch, or a Vedic sage: Nehru was a swashbuckling, filmic hero. His autobiography denounced Imperialism and unmasked colonial exploitation: Gandhi rebuked it, threw it back on its own conscience. Gandhi gave us nationhood: Nehru, the world.

Soon after Britain declared war against Hitler's Germany, the mood of India changed. Nehru demanded independence, immediately, so that India could join the battle against Fascism as

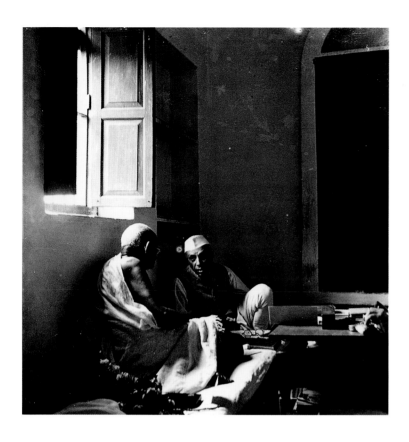

Kanu Gandhi, *Mahatma Gandhi in conversation with Pandit Jawaharlal Nehru in a low-caste house*, Bhangi Nivas, New Delhi, 1946

a free country. Churchill would have none of it. The speeches of Congress leaders became more and more virulent. There could be no compromise on either side. I had joined the Socialist group within the Congress, led by Jayaprakash Narayan. He was a peasant from Bihar who had never seen a tram until he was twelve, and who had gone to America where he paid his way through university picking fruit and working in factories—and got five Ph.Ds. The Socialists were preparing to "go underground" and sabotage the British war effort. I was studying how to make bombs and dynamite railway bridges to derail munitions trains.

Why, even Gandhi was beginning to concede that violence was unavoidable. Revolution or resolutions passed at Congress meetings? Like the historic "Quit India," *now*, demand on August 7, 1942, which said that Congress could no longer be justified in "holding the nation back." The strong man of the Congress, Sardar Vallabhai Patel, said: "If there is a choice between slavery and anarchy, I hope the people will prefer anarchy, as the latter will ultimately disappear and the people will become free."

On the night of August 9, 1942, when we learned that all our leaders had been arrested in a nationwide dawn swoop, and sent off to remote prisons, I went out and vandalized army posters at the local railway station. Sabotage. I was beaten by a British soldier. Father, realizing what might happen if I were caught in some "underground" activity, and, I suppose fearing for his own job and image as a Gandhian, decided to send me away from Bombay, back to the village in Kerala, "for a cooling-down period."

Many of the migrant Gandhians to Bombay from villages in Native States were "evacuated" during those early years. A German warship had been sighted off Bombay. No one was certain if the Allies would win the war. A fiery nationalist from Bengal,

Subhas Chandra Bose, had escaped to Germany and then to Japan, its Axis ally in the Far East, where he was recruiting an Indian National Army to "invade" India through Burma.

In the early forties, with Gandhi and all other national leaders put away in jails, it was almost as if the Gandhian phase of the Independence movement was over, and new forces were released. The war had done its wretched work. A new class had emerged, collaborators with the British, feeding the supply lines to the eastern front. Blackmarketeers, hoarding vital necessities, learning to manipulate the market. Even those who paid lip-service to the Congress were making big money. My Muslim friends, and the young Muslim girl I had fallen in love with, were dreaming of a separate nation, when, after the war, Britain realized that the age of colonial rule would inevitably have to end.

Maybe all wars create a psychic state in which aggression and violence become a virtue. Fired by Hitler's ideas of a superior Aryan race, extremist leaders were stirring up images of a militant Hinduism. When I came back to Bombay, many of the Congress youth volunteers who had been my friends, especially sons of the industrial working class, had joined the Communist Party, which had been legalized after Russia joined the Allies. We young Socialists never forgave them. It seemed an act of betrayal. It made the Communist Party a puppet of Stalinist Russia, and Communism itself as alien to India as imperialism. The Socialists were still "underground." And, although I had been "cooling down" for more than a year, my father was quite proud when I was arrested for defying the ban on political gatherings and organizing a flag-raising ceremony on Quit India day, and I was taken to prison. The police who helped me get rid of the subversive pamphlets in my pockets were very respectful when they took me away from home. They told my father, "He is a hero, your son."

Germany was defeated. In retaliation to the Japanese bombing of Pearl Harbor, America atom-bombed Hiroshima and Nagasaki, and Japan surrendered. India, until then Gandhian India, had to face a new reality when its Muslim minority began "direct action," and unleashed mob violence in Calcutta, in a desperate bid for their own homeland, Pakistan.

Independence, at any price—a dream of unity becoming the nightmare of partition, or a prolonged state of self-destruction, bloodletting, cliff-hanging instability? A million people were to die, and perhaps as many would be uprooted from their homes before the new nation was born on August 15, 1947.

History does not confess. At its most virtuous it can apologize. There is no dearth of apologists for what happened. There are encyclopedic analyses of the partition of India. Whether it was motivated by political expediency, a convergence of liberal British, steadfast Muslim and desperate Hindu interests, or whether it was inevitable, freedom came as a physical shock, almost like the first, bewildering experience of one's own sexuality. It was a physical, not psychic, tremor that ripped our bodies. What Rilke calls "the fathers resting like mountain ruins within your depths," stirring as personal geography. Until then India was a place in me kept in trust for a nation. Now it had to be re-possessed by the Self.

India's birth as a nation has been advertised in popular psychology as Freedom at Midnight, and its people as Midnight's Children. But it is not a Cinderella fairy tale for those who lived through it, and who experienced it as a saga of change and continuity. Even as the pictures in this book do, there are thousands of Indians like me, participants, whose lives bear witness to the events of the nation.

Soon after nationalist leaders were freed, and the Socialist government of postwar Britain recognized that the time had come to leave India to its own fate, negotiations began for a transfer of power and a deadline was set: 1948, not 1947. Most of us ordinary Congress workers had no illusions about what was happening. There was violence everywhere. Communal riots in Bombay reminded us of the terror being unleashed in Calcutta, and along the borders mixed populations of Hindus and Muslims were sacrificial victims of the inhuman drama of redrawing the map of a subcontinent.

The Raj had its own notion of justice: it had to be *seen* to be done. As Gladstone, a liberal British prime minister much earlier said, the British had always treated Indians as either children or dolls. Imperialism was an exercise in auto-suggestion, India a kindergarten school for lovely but unruly children. The heat was on, getting to them. The children wanted new toys to play with. So be it. Let the pandits and the half-naked fakirs and the mullahs take over. Britain had lost an empire of young lives in the war. And there was a lot of rebuilding to be done back home.

Many of us young volunteers could see that the Congress, which had developed as a service institution, was turning into a marketplace. It was the beginning of cliques, horse-trading, networking. Practicing Gandhians had put their spinning wheels away. They wore Gandhi caps and cottage-industry khadi, yet

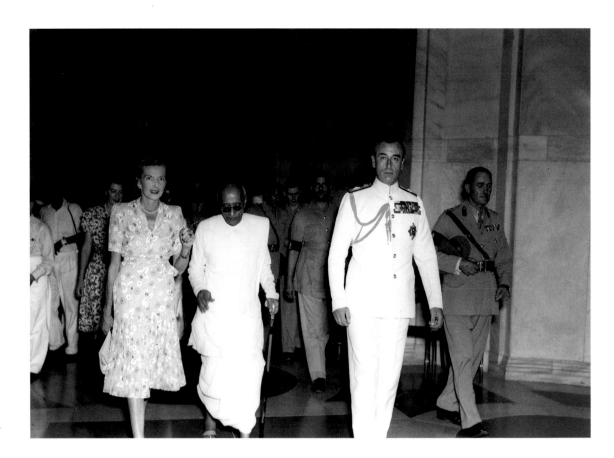

they were building up their own vote-banks, to get elected to provincial legislatures or the central Constituent Assembly, and, slowly, to gain control of a ministerial portfolio, an empire of their own. We youngsters would only be as good as the professional politicians whom we could get close to and who would use us. We began to think of survival, to reinstate our personal dream of freedom in the labor of our bodies, in the dignity of a work, as doctors, engineers, bureaucrats perhaps, technicians, professionals with skills the new nation would need. Many were withdrawing from active politics.

Gandhi himself had chosen to leave nation-building to his political heir, Nehru, and to furrow a deeper spiritual path, to tour riot-torn areas and hold prayer meetings. It can be seen in some of the Sunil Janah's photographs here where Gandhi's gaze is turned inward, as if he cannot bear to look at India anymore, even from the solitariness of a railway carriage looking out at the crowds who have gathered to get *darshan*. Or as he sits at his spinning wheel. In sharp contrast, Nehru's face is lit with a kind of heroic anger, an obstinate refusal to shirk his responsibilities and let India be dragged down.

Homai Vyarawalla,
The Mountbattens leaving Rashtrapati Bhawan accompanied by Rajagopalachari, who took over as second Governor, June 21, 1948

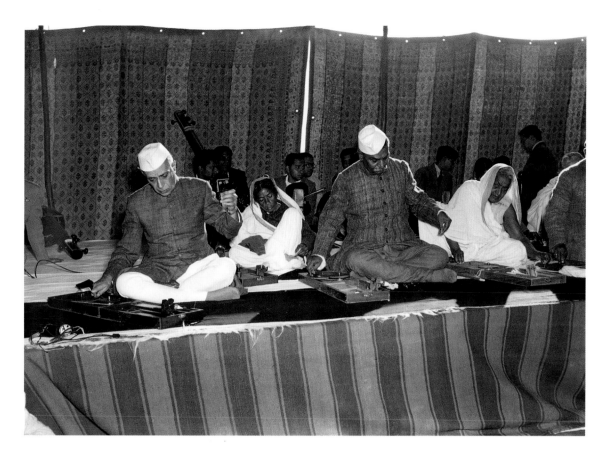

Homai Vyarawalla, *Mass spinning at Raj Ghat in Gandhi's honor— Pandit Nehru, President Rajendra Prashad with his wife and sister leading at the third anniversary of Gandhi's death*, January 30, 1951

I was to encounter both Gandhi and Nehru before I decided to stop subscribing to the Congress party and began to earn my living as an independent journalist and storyteller. This is how it happened.

I was a volunteer at the crucial Congress session in Bombay in 1946 when it became evident that Nehru, and Nehru alone, would have to decide: independent India, undivided, or India and a separate homeland for its Muslims. The Socialist faction, of course, wanted a unified India, but the decision was still to be made. It was a butcher of a night. I could not sleep. My mind was burning with rage, blind rage, driving me to some lunatic act of anarchy. In the early hours of the morning the tent in which I tossed and turned was like a cauldron. I decided to step out and "eat" (as we say) some cool air. About a hundred yards away I could see a figure, in pajamas, walking restlessly up and down, like a caged animal. Nehru. Hands clasped behind his back. Shoulder bent. Slowly, as if I was stalking a tiger I drew close to him.

In those days we volunteers had no badges. Security was unknown. Nehru himself detested being guarded.

"Traitor," I hissed to myself. I was sure he hadn't heard. Yet,

suddenly, he turned around, his drooping head whipped into caution, looking about. He spotted me. "Come here," he said. I think he recognized me as a volunteer. "What are you doing prowling around at this time of the morning, instead of getting some sleep? You know there'll be a lot of work today."

"I couldn't sleep," I replied. "Just like you."

In those days there was no generation gap between leaders and young volunteers.

He put his arm around me. "You're right. I couldn't sleep, too. What is tormenting you?"

"The same as what is tormenting you."

He burst into laughter. "Well spoken. Decisions are forged in the furnace of contradictions."

"You have decided?" I asked.

"We shall see," he said. Then he asked, in that seductive voice with which he could draw out anyone, "Tell me, you know I am now very isolated from the people on the streets, what do they say about me?"

My reply was clear. "They say, Panditji, they say that you are a good man surrounded by crooks and gangsters."

"That's what they say?" he asked incredulously. "And do you agree?"

All the anger had been drained out of me. "Yes, but I know that as long as you are there India will remain good."

"It's a heavy burden," he said. "And I can't carry it alone. Now, it's time for you to catch some sleep. I want to be alone for a while more."

My one-to-one with Gandhi came later. I had asked for an audience on behalf of the young Socialist group. It was a Monday, his day of silence, so he wrote down his answers to my questions on strips of paper that he tore from a school notebook. Sometimes he would have fits of chuckling before replying, like a child playing with marbles.

Couldn't he see that nonviolence had failed? I asked. And he smilingly wrote that sooner or later the British would quit India. His advocacy of nonviolence as the means to achieve independence was based on common sense. Arms are expensive. It meant entering into secret alliances with arms dealers in foreign countries. It would involve long training. It would open India to the risks that the arms brought might be used for nefarious ends. A nonviolent revolution was the cheapest and most economic strategy for India.

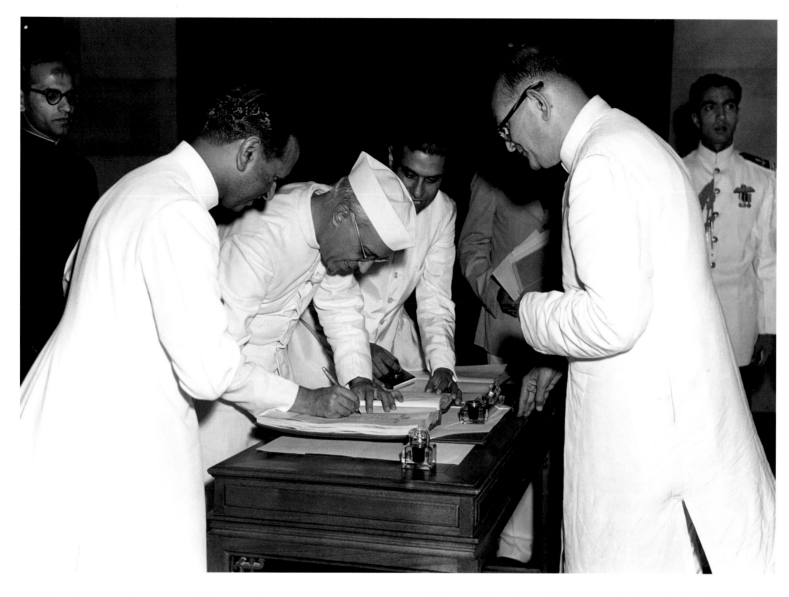

Homai Vyarawalla,
*Jawaharlal Nehru signing
after being sworn in as
Prime Minister*, 1952

"So a horizontal revolution?" I sneered.

"Down to earth," he scribbled and smiled.

I felt nauseous. I wanted to humiliate him. I said something like, "A lying-down revolution would be nice if I could sleep next to nice girls."

I shall never forget the look on his face. God forgive you because you know not what you say, it said. He started spinning, retreating into silence. The spindle rose in his left hand like a young dove learning to fly. The wheel turned gently. I rose to leave. Gandhiji paused.

He tore another strip of paper from the school notebook. He wrote with a fine nib in his lacelike handwriting. A blotting pad floated over the words. He handed me the strip of paper. He had written one word: *Baba*. Son. And he had signed it: *Bapu*. Father.

The spindle in his left hand soared above his head like a dove in full flight. White wings spread. I had been branded into bondage. After he was shot dead, on January 30, 1948, many of the Socialist leaders withdrew from politics. Jayaprakash Narayan and Vinobha Bhave began a *bhoodan* to persuade the big *zamindars*—landlords—to give land voluntarily to peasants.

Gandhi's death, like his life, has mythic density. As Einstein wrote: "Generations to come, it may be, will scarce believe that such a one as this ever in flesh and blood walked the earth." As India and the world prepare for the third millennium, this one will be remembered for ever as the Gandhian era.

Even as I write these words there is a report in the London *Times*, from India. Half a century after Independence, Gandhi's unspoken thoughts before his death, scribbled in English on the

backs of old letters, envelopes, or school notebooks, are made public again. They had been preserved by his secretary, V. Kalyanam, during his last years. Gandhi writes about himself: "He had made his final choice. He had no desire to see the ruin of India through fratricide. His incessant prayer was that God would remove him from any such calamity descended upon their land." We stayed awake until midnight before August 15 to listen to Nehru on the radio describe the moment of Independence as a "tryst with destiny." Our minds had been brutalized. As a working journalist in Bombay, I kept moving around the poorer areas of the city witnessing and reporting on the senseless killings and street violence in areas where Hindus and Muslims lived together. The father of the Muslim girl I was in love with had decided to opt for Pakistan. My own father was talking about retirement and going back to our village, to live his last phase of a Brahmin life in an ashram.

Fate, kismet, had become destiny. Until then it was fate which had ruled our lives, fate in the shape of a Crown studded with our stolen jewels. A horizontal people had overnight been stood on its feet and made vertical. To be lying down was a form of death. Yet, in what form would destiny appear if I woke up?

My head was full of noises. I heard the Crown jewels that night banqueting drunkenly in Buckingham Palace.

The most priceless of them, the rarest diamond in the world, Kohinoor, raised a toast and said, "We have the last laugh."

"Tell us how," said the rubies and the emeralds.

"It's all there, faithfully recorded in the archives of the Empire.

"We went in as honest traders. We were asked to stay on by the natives to protect them against tribal hordes invading through the northern mountain passes, and foreigners secretly entering through the western ports. So we signed honorable treaties with the local rulers, and offered them the services of our soldiers, the bravest in the world. More, we taught them to dig deeper into their land for metals, gold, iron ore, copper, and coal. We cleaned the waste lands and set up plantations, sugarcane and jute, and cotton where once there was desert. We cleared the hills of forests and planted tea and coffee. Our mills in Manchester gave them back fine cloth to cover their bare bodies. We spread reason and science through the language of the Empire. We bred good polo horses and fine cricketers. We opened our schools and universities to the sons of the rich. Thousands of our sons died of malaria and plague to bring them justice, railways, electricity."

"Greed and whisky," whispered some breadcrumbs on the banquet table. The pearls ordered them to be swept off.

"And then?"

"Ah, there came along this voodoo man, from a respectable merchant family in a village on the west coast, who was sent to England to study our law. He couldn't get a job when he went back, and so a Muslim family offered him employment in South Africa. At first we thought he was just a crank. But he knew his onions, and he played his cards well to free indentured Indian labor in South Africa. He went back to India where he had already gathered followers—even some woolly ones among our own countrymen. We thought he was harmless, and that a stint behind bars would cure him of his fantasies. It didn't work. He had woven a spell around the natives. They didn't rise. He organized the lazy bastards just to lie down in the streets, on railway lines, put them back to sleep, so to speak, in the voodoo-land to which they were born."

"Tell us more."

"This is not the night to speak of him," said Kohinoor, flaring up. "If you want to know it's all there, in his own words, *My Experiments with Truth*. The real truth is that he conned us, this half-naked fakir. But we had the last laugh. There were others in the land to whom we had given our word, our trust. Minorities, princes! They had equal rights to what we were to leave behind. We had to do a quick scissors-and-paste job. Of course we knew that the blood of a few million buggers would be spilt. We would have the last laugh. They wanted one free country: we gave them two!"

Just then the lights went out, and the jewels fell asleep.

August 15, 1947. Fifty years from now the children of India will want to know what happened to us that day, not how or why. I could not tell whether it was night or day, my eyes were bloodshot. My father kindly said at breakfast, "It is not the fact that it is morning that says you are awake. It is the fact that you are awake that tells you it is another morning."

There was work to do. A huge celebration meeting on the seashore. Perhaps the whole day reporting on mob violence in the city. Until that morning I paid little attention to the beggar sitting on the railway bridge I crossed to take the local train to Victoria Terminus. He would sit motionless, silent, with a bowl by his side in which a passerby would sometimes fling a coin. That

morning he was standing upright! Index finger erect. He was saying, *Dharam karo*. Do your duty. In doing my duty I would see my destiny. It is the image that appears again as I write today about the years that followed.

"The light has gone out of our lives," Nehru mourned, when Gandhi was shot dead on January 30, 1948. Ten days earlier a crude bomb had disturbed his prayer meeting, after he had ended a fast to beg Indians to live together like brothers. Gandhi had taken it calmly. The next day he only quietly rebuked the young Hindu arrested. Nehru wanted stringent police guard at Gandhi's next prayer meetings. Gandhi refused.

"If I am to die by the bullet of a madman I must do so smiling. There must be no anger within me. God must be in my heart and on my lips." He had done his duty: he had firmly seized his destiny. Perhaps he had even willed it.

What we are celebrating today is the way in which this will was given as a legacy to Nehru and has been handed down through his daughter, Indira, his grandson, Rajiv, and even bequeathed to the later leaders, Lal Bahadur Shastri, Narasimha Rao, and chief ministers of provinces, as well as thousands of nameless heroes, scientists, researchers, technicians, and rural workers, who daily give themselves to what they see as the destiny of India.

Nehru's vision of India, fed by that will, was of strength—"big" things to be done. A constitution had to be framed: the foundation for a secular, democratic republic. How many constitutions are there in the world that have a preamble beginning with the word *justice*? I know of only this one. The map had to be redrawn, princely states incorporated, and the maharajas given a decent pension (privy purse) to readjust to life as common citizens. Linguistic continuity was to become the basis for provincial autonomy. Hindi was the national language, but English was not discarded. There were built-in safeguards for the "scheduled castes." The country needed a sound defense potential, and an honest and efficient bureaucracy. India had to be taken out of "the bullock-cart age" and, at the very least, be placed in the bicycle age. Much of this has taken fifty years to happen, and is taken for granted by young men who ply scooter rickshaws in the cities where once their parents might have pulled rickshaws.

Compared with other third-world countries that were decolonized during the same period, India's development as a nation, and its global status today, are undeniably the result of the uncanny instinct with which Nehru, Indira Gandhi, and, for a brief period,

Rajiv Gandhi, steered the country through the last five decades. I believe that they all built and sustained stability by grasping one secret: the survival of such a complex and diverse conglomeration of people must be based on *simplification*. "We must make a strength of our weaknesses," Indira Gandhi said to me during an off-the-record interview in 1965, when she was Information Minister under Shastri. "We must simplify."

There are many photographs in these pages which still give the feel of drive and energy with which Nehru first shaped the nation. For example, the street scene captured by Raghu Rai, a Nehru-generation photographer [page 106]. It epitomizes the vertical leap India made during the Nehru years. Look at it carefully: are there any bullock carts? Is there one sleeping figure? Can you feel the verve of a nation on the move? Wheels, wheels, going in all directions. And men loading steel tubes onto a handbarrow. The new temples that Nehru saw are also there, steel mills, power plants, hydroelectric projects, vast projections against an image of ancient Indian faces and bodies.

India's five-year plans fell short of Nehru's targets, yet he relentlessly pressed on with his vision of modernizing. Meanwhile, he visualized this young nation playing a dignified role in a postwar world that was being polarized into free enterprise and Communist nations.

After I set sail from Bombay, in 1953, I was aware of both the tremendous suspicion and the awesome respect that Nehru's India inspired, ploughing a lone furrow with its policy of nonalignment during the Cold War decades. I went back to India every five years or so. I could see the will of Nehru battling daily with regressive forces. Twice during the fifties and sixties I had one-to-one meetings with him. He raged at me, on both occasions, when I dared to accuse him of "double-think." Yet he gave me a generous hearing. I saw his face change—not age, he never aged. I had gone back as a "foreign correspondent," reporting for British newspapers, but trying to give an Indian-eye picture of the Nehru period. He gave me the affection that he always gave to youngsters who stood up to him, and which I had sensed he gave to me as a Congress volunteer.

He had begun to brood more and more after the 1962 border-clash with China. When I asked Krishna Menon, then a close confidante and his External Affairs Minister, what the border dispute with China was about, at the bottom line, Menon replied: "Where the chopsticks end and the fingers begin, that is where

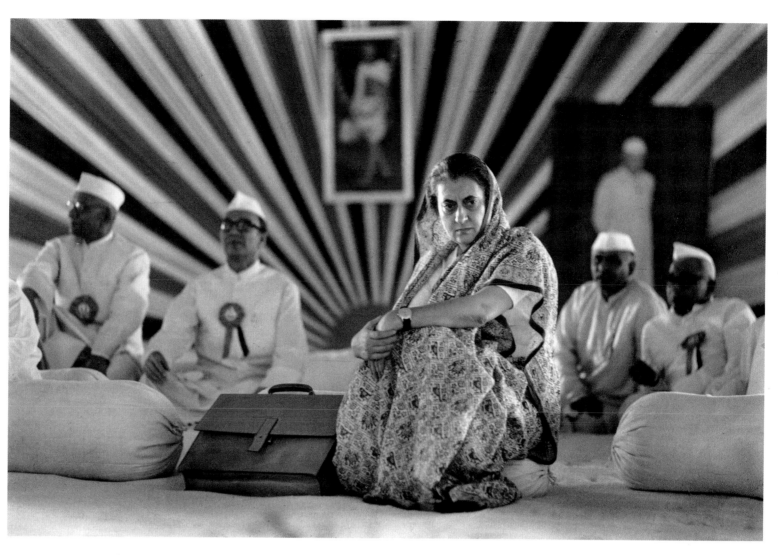

Raghu Rai, *Indira Gandhi with politicians*, 1977

China ends and India begins." A blistering simplification? Not if you think of it carefully, not when you see that the hand, in these photographs, is the measure of all things Indian.

I was in Delhi on the day Nehru died in 1964. I went to pay my last respects to him in the room of his prime minister's residence where his body lay before the state funeral the next day. Outside the room there was a heap of slippers and shoes which had been removed before entering. As if a whole nation had promised to follow his path, barefoot. A symbolic tribute to a man who forged a nation on the anvil of his mind? I don't know. All I remember now is that in the "off-the-record" interview in the spring of 1958, when I questioned his Kashmir policy and said it was at the core of all Indo-Pakistan enmity—draining both countries of their goodwill as neighbors and real resources in defense expenditure—he put his arm around me and held nothing back.

To this day I have not betrayed his confidence, although I have interpreted the spirit of what he said. I think I understood then what made Nehru tick: there was not an iota of hatred in his makeup. He himself was the repository of the love of a nation, and the nation itself was a love-child of nature. In time would come trust and respect. Love, trust, and respect, in that order—not authority, discipline and efficiency—would build India.

I went back in 1965, after Nehru's death to be with Prime Minister Lal Bahadur Shastri. I went to Benares, where he used to swim across the river every day with a satchel on his back to go to school. Shastri belonged to the Servants of India Society, a unique institution whose members give all that they earned or possessed to the society, which, in turn assured them and their dependents of all basic necessities. A kind of political "insurance" society. I went with Shastri on an election tour to Allahabad and

nearby villages. From Pakistan and in India, I reported on the two nations heading for a mighty clash, and on the 1965 war. "Partition, partition," Shastri murmured almost to himself when I asked him if India had reconciled itself to the creation of a Muslim nation. "Partition? I wonder how many more partitions we will have to see?"

Every time I go back to India I go back to my village. If I can, I also go back to Bombay. Every time I am amazed at one reaction from friends whom I have not seen for years: they greet me as if I had never left, as if it were only the day before that they had last been talking to me. Bombay becomes more unrecognizable every time. The trams have long disappeared. Planes are parked at the airport three in a row, as in an open-air car park. In fifty years of independence a city that not long ago held less than a million people has become a megalopolis of nearly ten million. They still keep pouring in. They live in luxurious high-rise apartments or sleep inside municipal "water pipes" in shanty slums.

It is the village, however, which remains my real index of change. The old ancestral Brahmin house built on stilts with strong teak wood has been demolished. In its place is a new house of cement and brick, and the new owners are of the untouchable caste! In the estate, still surrounded by the old wall, the vegetable patches that supported the families of five uncles and their six children each with eggplants, lady fingers, tapioca, yams, and spinach, are overgrown. The banana groves have withered. A few desultory coconut trees still sway around the stagnant pool. There is no trace either of the boathouse at the far end along the sluggish green inlet from the river or of the two cow sheds.

The new lady of the house invited me to look around. There is running water, a lavatory inside, modern furnishings, grocery shop calendars with garishly painted goddesses. Electricity! The old well at the back of the house remains.

From the commanding heights of the steps around the well my grandmother alone had authority to draw water. She was there before sunrise as the first logs were lit for coffee. Water was plentiful in the village, but the four pots she drew were used strictly under her surveillance. One for the kitchen, one for household ablutions, one for drinking and cooking, and one kept at the far end of the courtyard for the peasants who sat in a line for their morning *kanjee*, rice broth.

Only one cousin remains of the clan. He lives in a hut across

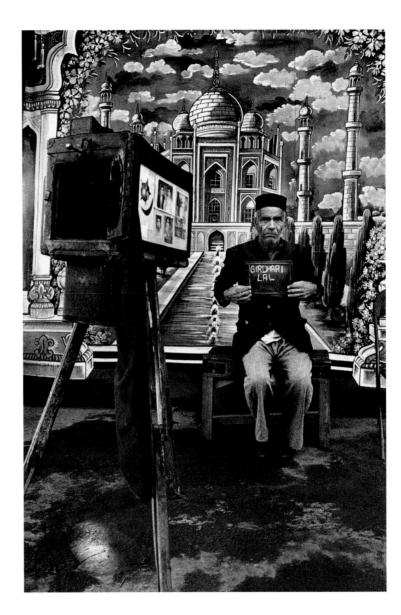

Raghu Rai, *Girdhari Lal Being Photographed*, Old Delhi, 1982

the inlet on the road. There is a regular bus service now from the market town up the hill. The bus stops here. My cousin's wife runs a small eating room for locals, and sells betel nut, cigarettes, chewing gum, school notebooks, and small groceries. The eating room is the "guest house" of the ancestral home, and one has to crouch as one enters the kitchen, where she cooks over an open fire with coconut stalk and other pieces of wood. She and my cousin stoop and touch my feet when I arrive or depart.

There is a television repairer. A bank. A lawyer. A doctor and a nurse. A community worker's office. A modern grocery store with Coca-Cola posters. And a shop selling jeans, Big Apple T-shirts, and dhotis and saris and cloth.

There are few bare bodies to be seen.

I walk the narrow path from the old house to the riverside and temple. It is deserted. The one old temple-hand says he will light the lamps on the outside walls of the temple for me to have "the blessing of the lights." The lamps are still small clay cups, but instead of holding oil-wicks they have tiny electric bulbs. Though the temple has been open since Independence to all castes, no one comes to pray. One man walking around the outer courtyard smells of local liquor. The temple-hand tells me he is a retired policeman.

The village is represented in the town council by a Communist. He is the son of Keshavan, the low-caste companion of my childhood. Kerala was the first state in India (and in the world) in which the Communists came to power through the ballot box, renouncing the orthodox line of seizing power by violence. Its leader came from a caste that considers itself higher than the Brahmins, the *namboodiri* caste, which maintained all the temples in the state. The literacy rate in Kerala is the highest in India—nearly ninety percent—and the birth rate the lowest. Up to high school education is free, and the State offers free medical services. The Brahmin caste has nearly disappeared. Syrian Christians, Muslims, Hindus, the majority of old low castes, eat the same kind of spicy, rice-and-coconut-based food, and still use banana leaves for plates. More and more tourists looking for sun and sea go to Kerala now rather than Goa, and there are direct flights from Southeast Asia, Europe and the Middle East to Trivandrum, the capital. There is a new red-brick provincial legislature and secretariat building in the center of Trivandrum. I do not see a beggar on the streets anywhere.

When I was in the village in the spring of 1996 I called on the old Communist Chief Minister, E.M.S. Namdoodiripad, or "EMS," as he is affectionately known. He lives in a rented, two-room house in one of the small winding lanes off the beaten track.

EMS has known me since 1957, when I was the first "foreign correspondent" to report from Kerala about the remarkable election victory of his Communist Party and the defeat of the Congress. He began his political life as a Gandhian, and made nonviolence a cardinal precept of Kerala Communism.

He was slouched in an old cane rocking chair with leg- and armrests when I last saw him. He was wearing a sleeveless vest and a dhoti. He is hard of hearing now and so I wrote my questions on paper that his granddaughter tore from her school note-book. I wanted to know the main change in India during the last fifty years of independence, as he saw it. And whether he had failed to lift the peasants of Kerala from their poverty. His reply sums up, truthfully, both what we are celebrating today and what could happen in another fifty years.

Slowly, speaking as those do who are hard of hearing, he said: "Since Independence, Kerala has been more and more incorporated into the total economic system of India. And India itself is being incorporated into the global economy. We cannot change anything in isolation any more. I don't think we have failed our peasants. I think peasantry itself as we have known it, as a way of life, will disappear within the next fifty years."

Last night Gandhi came to me in a dream, as he often does. He appeared in the unforgettable form that opens this panoramic celebration of fifty years in the life of India.

I was not alone in my dream. At first, I couldn't understand what he was trying to say with his hand stretched and hovering over the vast crowd of which I was a part. Was he blessing us? Was he sending us away? Was he beckoning us to enter his being?

Then we heard him. "If I call you now will you follow me?"
The crowd silently asked: "What action do you propose?"
"Resistance."
Bapu said it softly. And the figure slipped away.
The sound of a Vedic chant embraced the crowd.

Om, poornamadah, poornamidam
(Om, that is the whole, this is the whole)

Poornaath poornamudachyate
(From the wholeness emanates this wholeness)

Poornasyah poornamaadaya
(Take from the whole its wholeness)

Poornameva ashishyateh
(And the whole abides as wholeness)

At marriage or death anniversaries or other worshipful ceremonies, this Vedic hymn restores, locates, all human existence and the events that dramatize its mysteries within a boundless cosmic order.

It echoes now in the hollow of my ears.

It is a beautiful country, my country. Never has nature manifested herself with such abandoned pride, never has the earth borne the traces of passionate love with such splendor. Caressed, repudiated, and loved in turn, my country stands: lushly verdant, heart-breakingly arid, and awesomely majestic. Many-hued is my country, and many-hued are my people. Creamy white, honey skinned, ebony black, and golden brown are my people, and the earth is alive with echoes of their many moods. It echoes their gaiety, their sorrow, their anger, their restraint. Lush green vines with sombre brown, awesome white towers above the rush of blue waters. It is a beautiful country, my country.

—SALONI NARANG, 1984

THOMAS L. KELLY
India Gate, New Delhi, February 1995

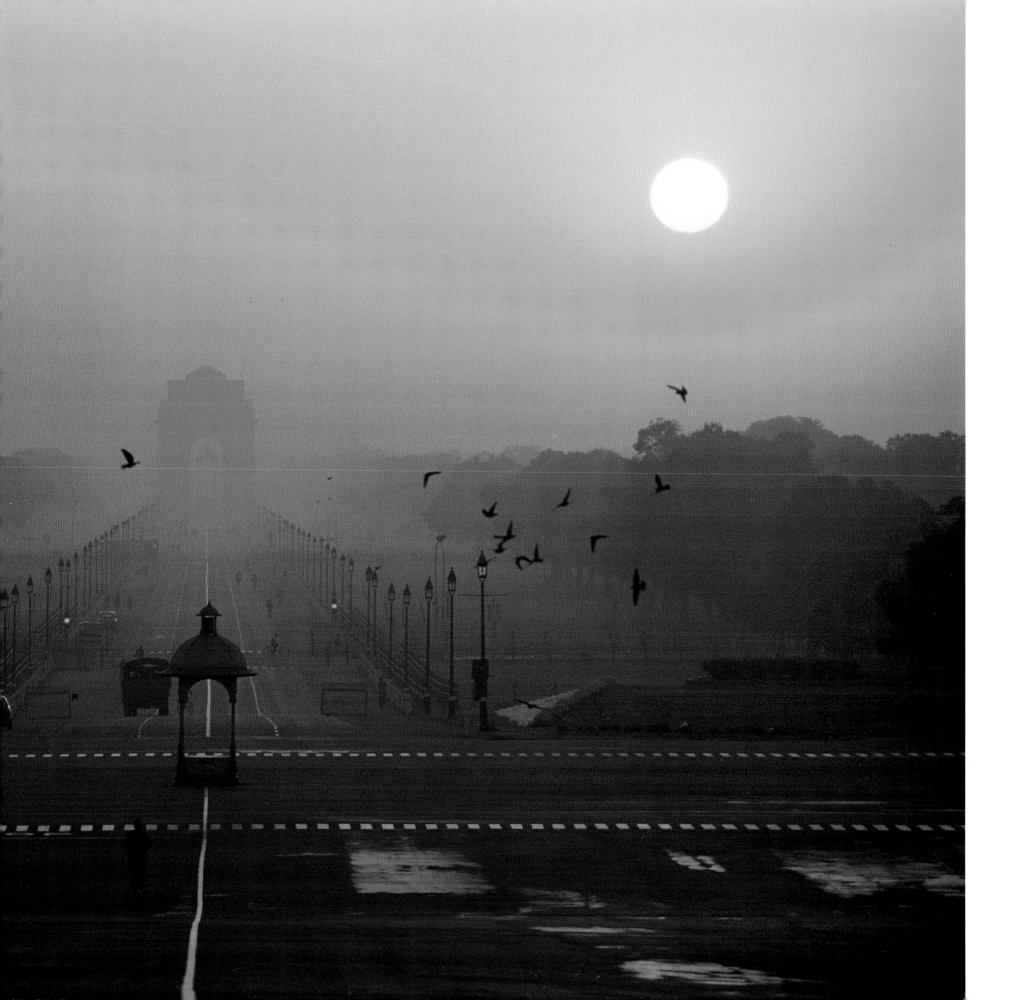

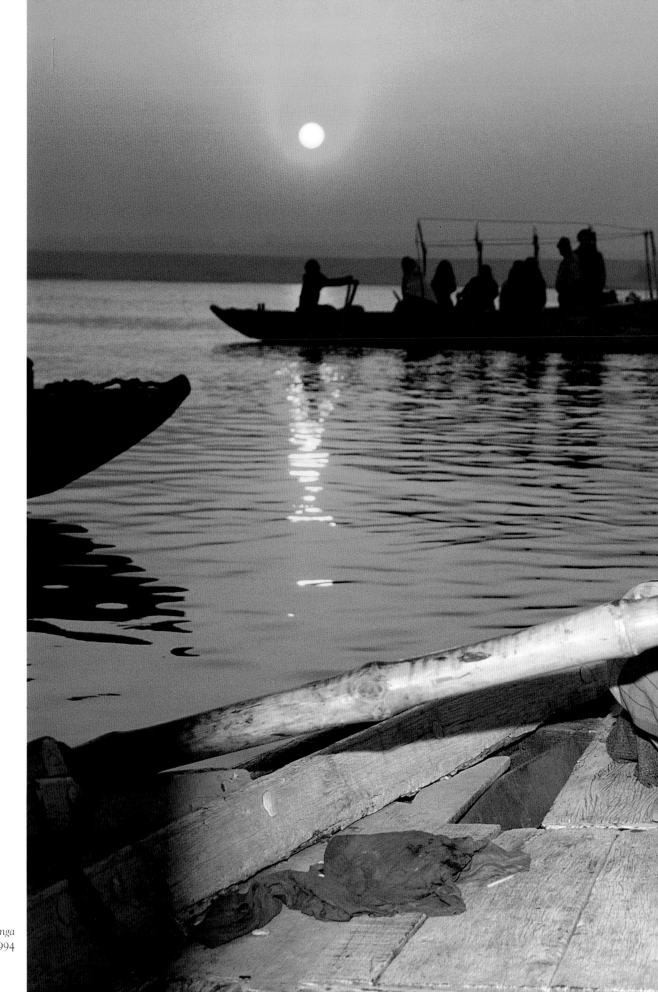

Thomas L. Kelly, *Boats on the Ganga River*, Varanasi, April 1994

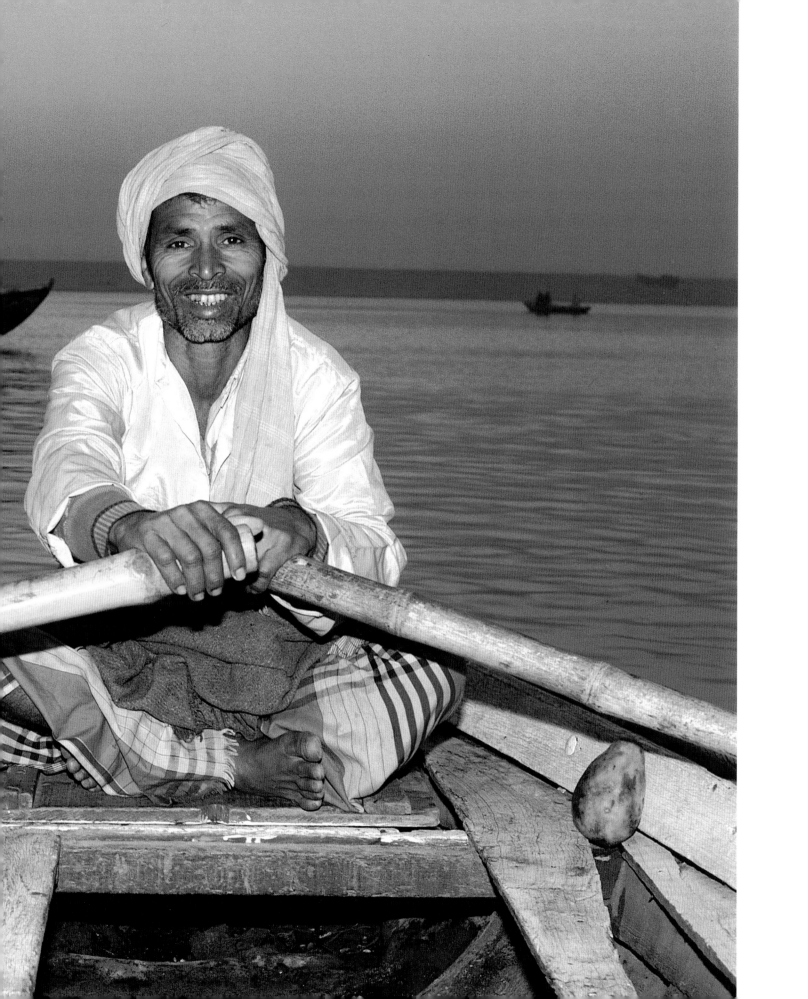

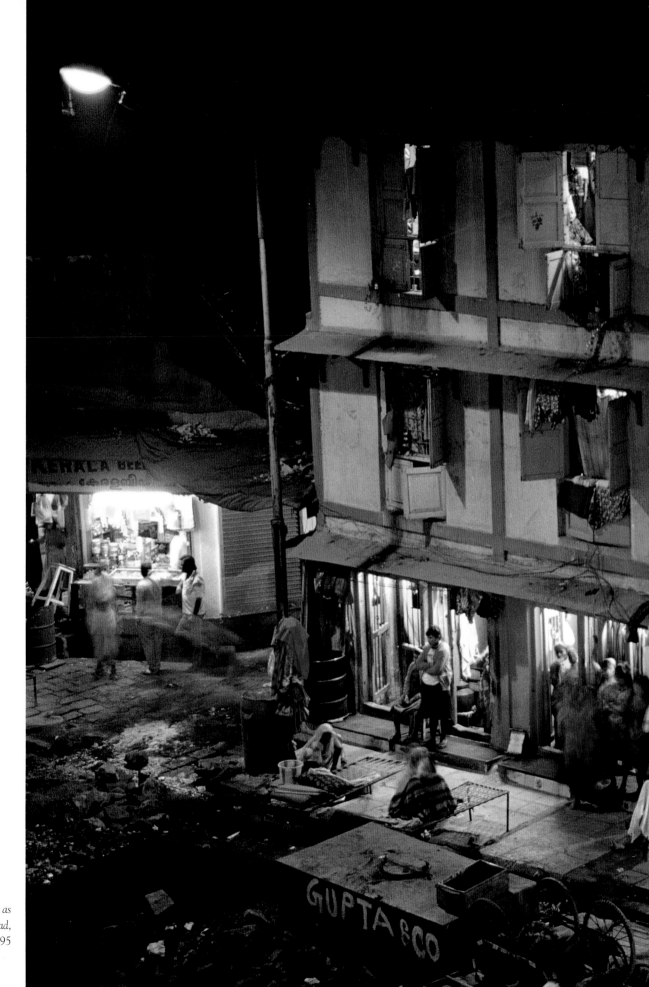

Thomas L. Kelly, *Business as Usual on Falkland Road*, Kamathipura, Bombay, May 1995

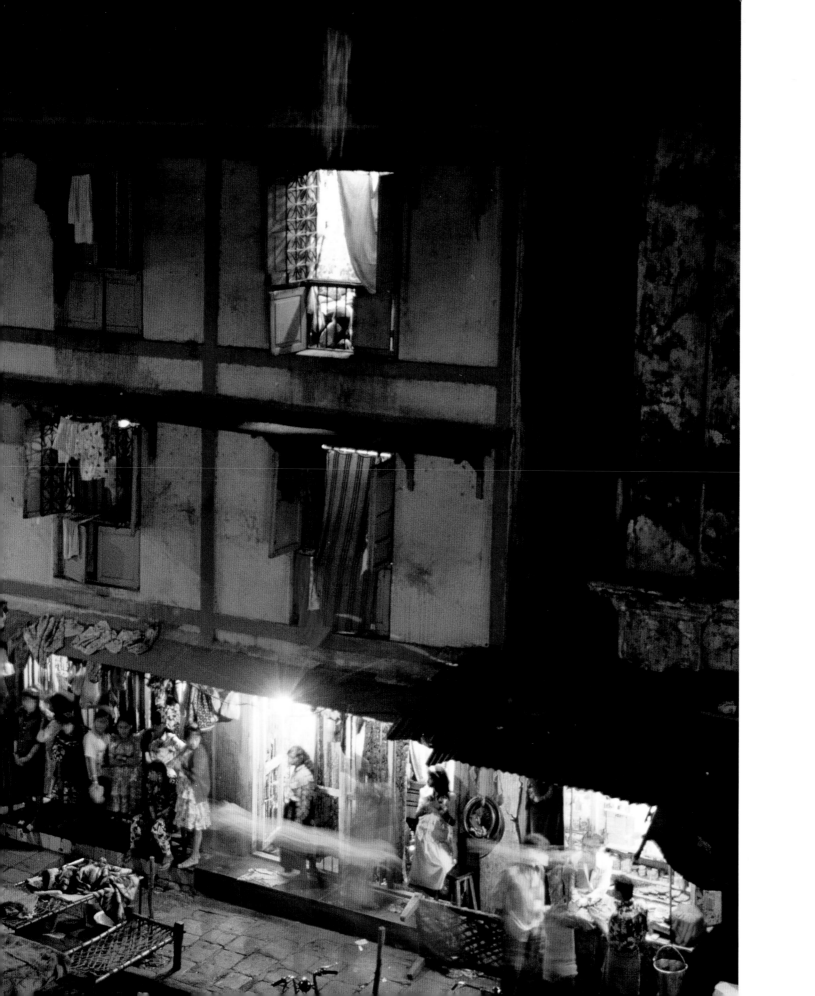

The history of India has been the history of a struggle between the mechanical spirit of cadence and conformity to social organization, and the creative spirit of man, which seeks freedom and love in self-expression. We must watch and see if the latter is still alive in India, and if the former can offer service and hospitality to man.

—RABINDRANATH TAGORE

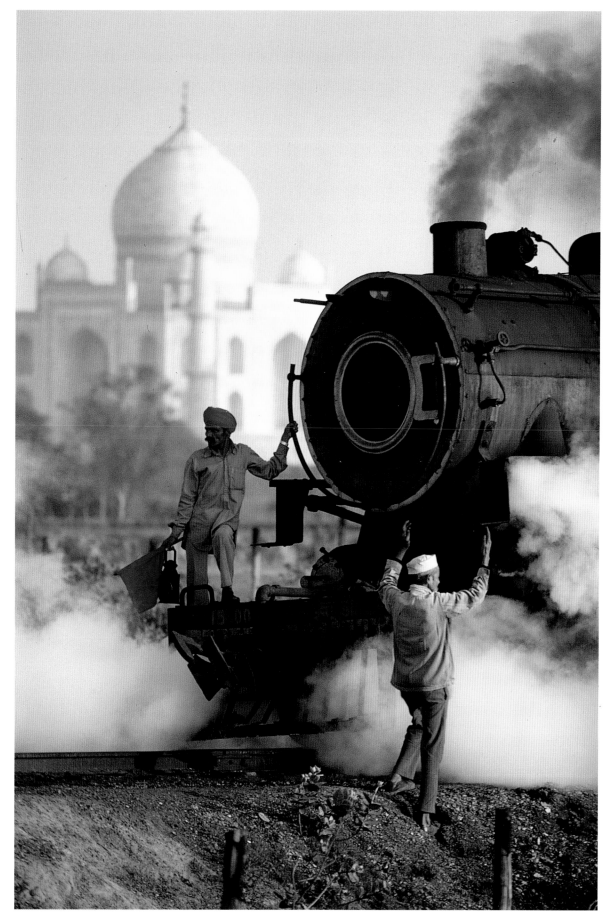

STEVE McCURRY

Steve McCurry, *Locomotive
Rolls by the Taj Mahal*, 1983

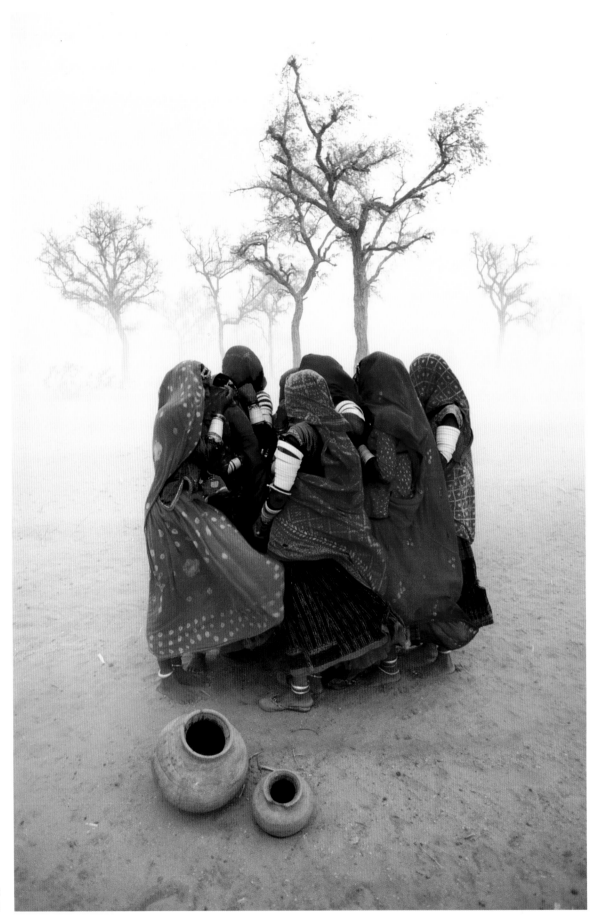

Steve McCurry, *Women in
Rajasthan Dust Storm*, 1983

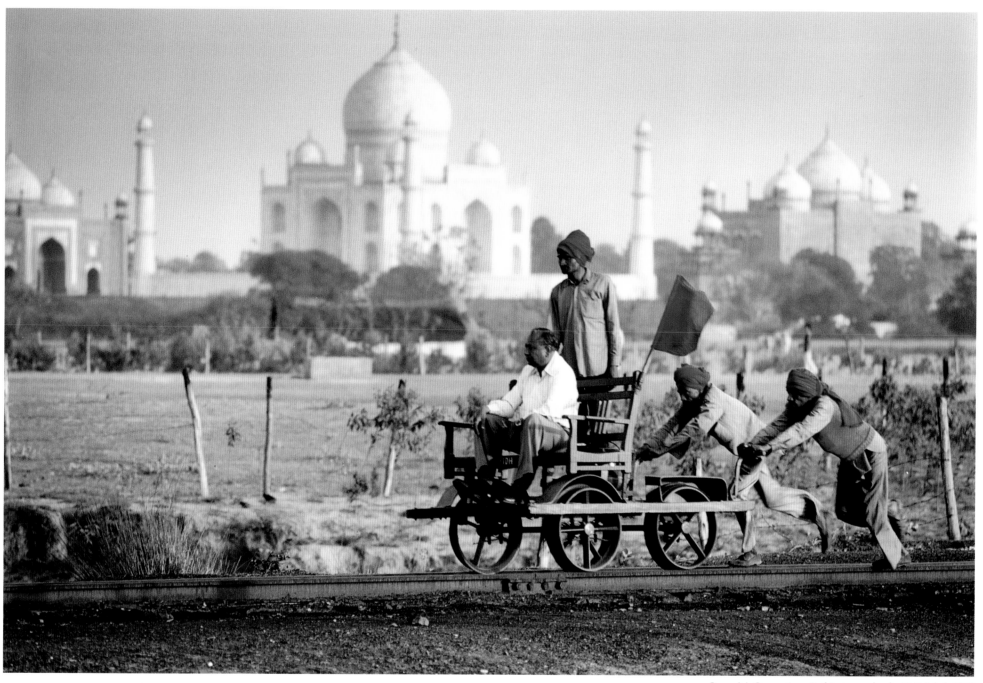

Steve McCurry, *Agra Rail Inspector by the Taj Mahal*, 1983

Above: *Prince Anjum Quder, Descendant of Wajid Ali Shah, the Nawab of Oudh, 1992*

Prince Anjum Quder, seventy years old, great-grandson of Wajid Ali Shah, the last Nawab of Oudh, lives on the first floor of Wajid Ali's mausoleum at Metia Bruz, Calcutta. The mausoleum also houses the offices of the King of Oudh's Trust, of which Prince Anjum is the chairman. He wears a number of other designations, including President of All India Shia Conference, Member All India Muslim Personal Law Board, etc. etc. The British annexed Oudh and sent Wajid Ali Shah into exile in Calcutta. They set him up in Metia Bruz, gave him palaces, allowed him to keep his concubines and gave him a general allowance. This was the usual practice adopted by the British in dealing with powerful dynasties—exile, isolate, corrupt, and thereby neutralize.

Above: *Narendra Singh Rathore of Bikaner, Rajasthan, 1990*

Dwarfed by the stature of his forefathers, Narendra Singh Rathore lives in a large red house (he is obsessed with the color red) with his Great Dane bitches and a menagerie of other animals. He was exiled from his family's palace when he was twenty-one, for which he holds his mother responsible. Until recently, he was living on an allowance of a few thousand rupees per month, which his mother continued to give him after his father's death in 1988. After his father's will was probated, he finally inherited one wing of the palace—which he planned to give to a hotel chain on lease, some say primarily to spite his mother, who, as a trustee of the 50-crore, is running a section of the palace as the Lalghar Palace Hotel.

Left: *Fatheyab Ali Meerza, the Nawab of Bengal, 1992*

The Nawab, Fatheyab Ali Meerza, ninety-two, and his brother Sajjid Ali, forty-seven, live in the dilapidated Murshidabad Haveli mansion on Park Street in Calcutta. They are direct descendants of Siraj-ud-daulah, the Nawab of Bengal, whom the British crushed to establish their rule in India. Fatheyab Ali's allowance of 19,000 rupees per month, awarded by the British to sucessors of the Nawab, was stopped by the government in 1969 when his succession came into question. He has been fighting this case in the Supreme Court. In the meantime, he has had to rent out twenty of his twenty-five rooms, and parts of the mansion look like a slum. The Nawab now lives in decrepit surroundings; Sajjid is more realistic, and is involved in land-brokering. The state government tried to take over about half an acre of the mansion's frontage, but the brothers managed to get a stay order from the court.

Top left: *Arvind Singh, the Maharaja of Mewar*, Udaipur, Rajasthan, 1994

Arvind Singh is a pioneer among the maharajas who made good by entering the tourism industry. Almost all his palaces are converted into hotels, and he has been able to market his royal personage quite successfully. Paying tourists are allowed to film him during festivals such as Holi and Gangaur, where he puts in a royal appearance, performing the traditional prayers or going in a procession through the town.

Below: *Nawab Sajid Ali Khan of Malerkotla*, Punjab, 1994

The present Begum of Malerkotla, Sajida Begum, is a politician with a long association with the Congress party. She is a widow with no children of her own. In a bid to carry on the lineage of the Malerkotla family, she has recently adopted this boy, Sajid Ali Kahn, a nephew, as her own son.

As with most other royal families, her properties are also disputed, and the palace she lives in is almost in ruins.

Above right: *Nawab Masoom Ali of Tonk*, Rajasthan, 1990

Masoom Ali, who was declared the Nawab of Tonk in 1974, never even stepped inside the Nawab's palace, which is now in the custody of his nephew Aziz Ali, along with all the other properties. In fact, Masoom Ali was never meant to be the Nawab. His oldest brother Sadaat Ali ascended the throne when his father, Aminuddaulah Ibrahim Ali Khan, died in 1930. Sadaat Ali died without any issue, and so, according to the Muslim law of primogeniture, the next brother was made the Nawab. In the same way, all of Masoom Ali's brothers died without issue until he was made Nawab in 1974—long after the abolition of the so-called privy purse. In the meantime, the last begum had adopted her sister's son, and was able to keep all the property, because after the abolition of the privy purse, the law of primogeniture no longer applied.

Over the years, the family's wealth had been considerably depleted, and Masoom Ali, living in the modest Mubarak Mahal with a few acres of land, was quite badly off. Ironically, it is only after his sons have grown up and are now in government service that the family's economic situation has improved.

The highpoint of Masoom Ali's life is the annual camel sacrifice, which he performs every year at Bakr-id (July), when he gets to be "Nawab" and some of the older citizens come to pay respects to their "ex-ruler."

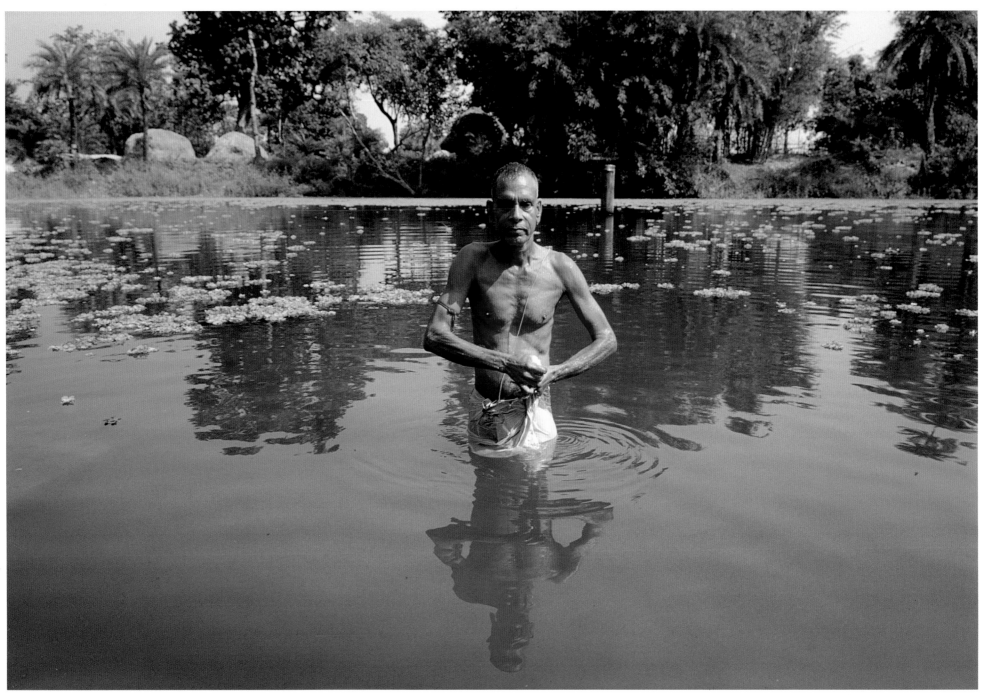

Robert Nickelsberg, *Brahmin man wearing Hindu upper caste's "sacred thread" over shoulder, bathing in river*, Bihar State, 1991

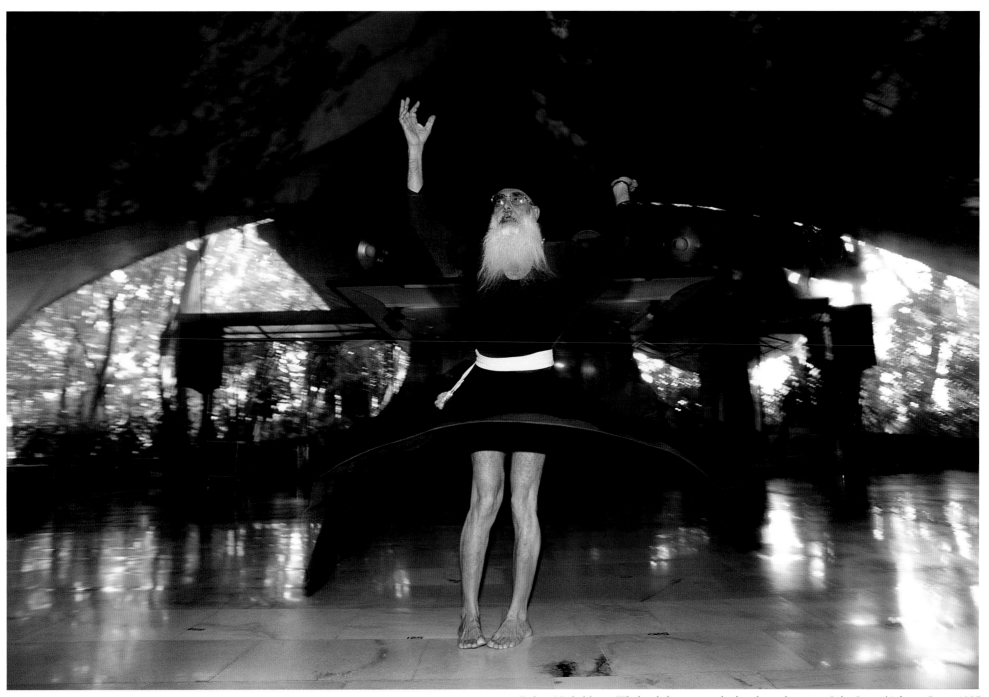

Robert Nickelsberg, *Whirling holy-type man leading dance therapy at Osho Center/Ashram, Pune, 1995*

India is a nation of extremes, its often violent political and ethnic sentiments—easily charged and never far from erupting—play off the country's somber, thoughtful, and contemplative moods. The spectrum of extravagant colors viewed with crisp light in a village or city are contrasted with bleached landscapes and the pallor, dust, and impermanence of urban sprawl. India's disparate millions move one foot cautiously into the modern world, keeping the other firmly stuck in a variety of pasts.

—ROBERT NICKELSBERG

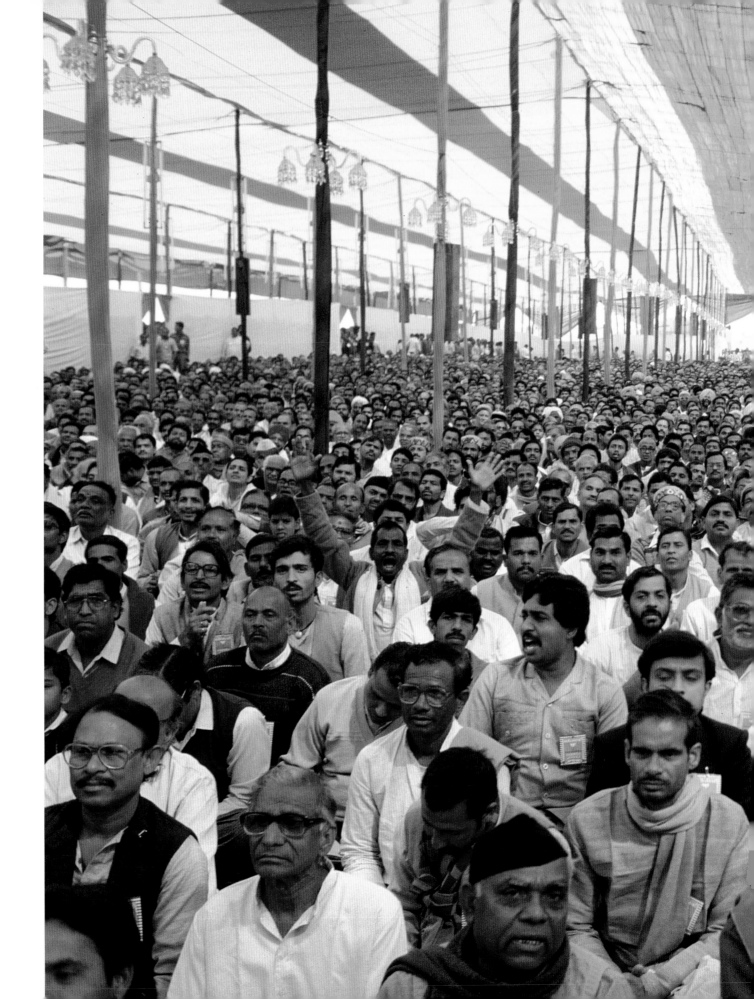

Robert Nickelsberg, *Crowd of Hindu Nationalist Bharatiya Janata supporters attending BJP convention in tent of party colors*, Jaipur, Rajasthan, 1991

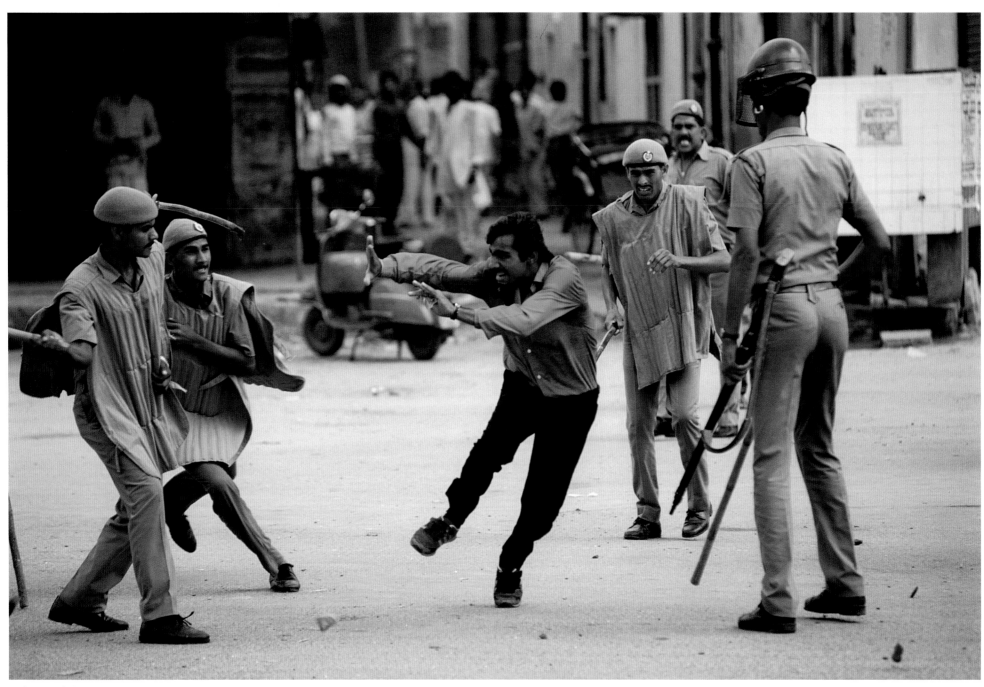

Robert Nickelsberg, *Youth battling with riot police during wave of violence surrounding a proposed government quota giving 27 percent of government jobs to backward castes*, New Delhi, 1990

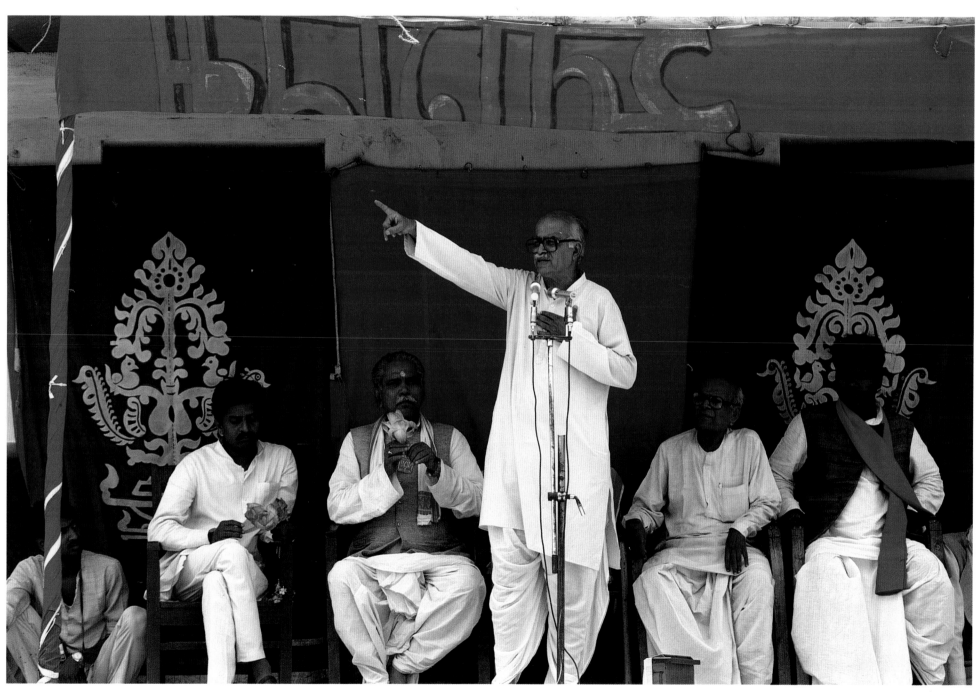

Robert Nickelsberg, *Hindu nationalist Bharatiya Janata Party leader L. K. Advani addressing rally, on the road campaigning for BJP in May parliamentary elections*, Bihar State, 1991

Sanjeev Saith, *Pa*, New Delhi, 1993

SANJEEV SAITH

68

Sanjeev Saith, *Between Houses*, Ranikhet, 1992

Sanjeev Saith, *Ma*, New Delhi, 1992

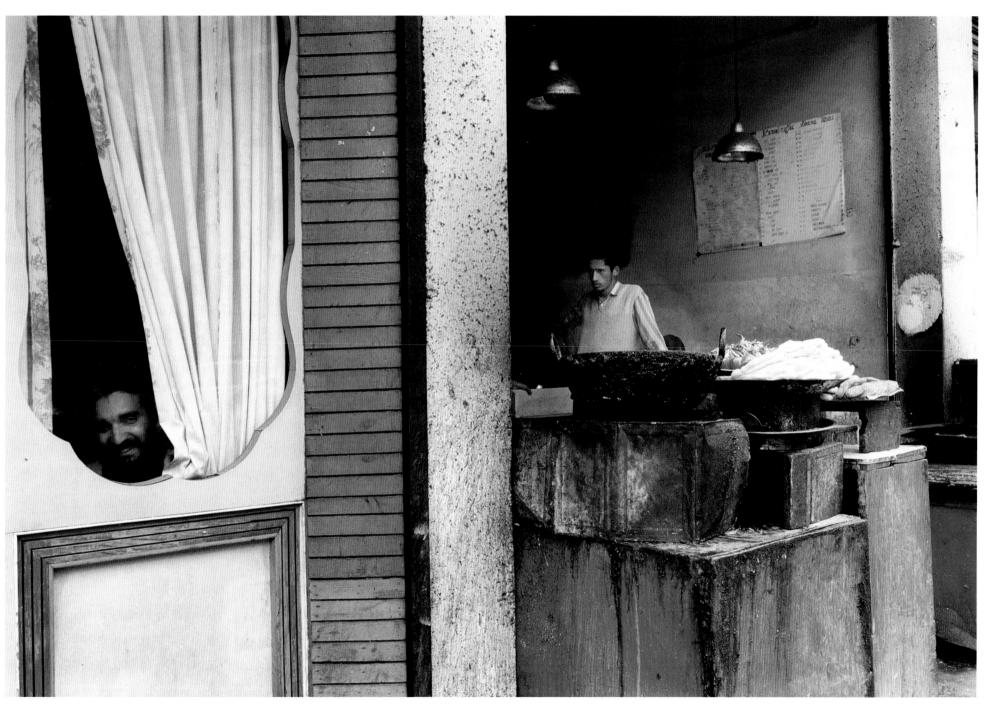

Sanjeev Saith, *Two Restaurants*, Manali, 1992

A TWILIGHT POEM

Indian dusk: cool half-lit eyes
stir the troubled soul to design.

A needed belief,
in the sullen throat of ruins.

If now, an old man's face
appears on the darkened ledge,
the whewing of the wind
fills one with dense exile.

You know of night, and what a seed,
a dead grandfather's face is like.

Across the shadows,
a water-buffalo wallows in the marsh's ooze;
a naked boy calls:
his voice stumbling on his own body
drowsy with the day-long cries of forbidding crows.

—JAYANTA MAHAPATRA, 1976

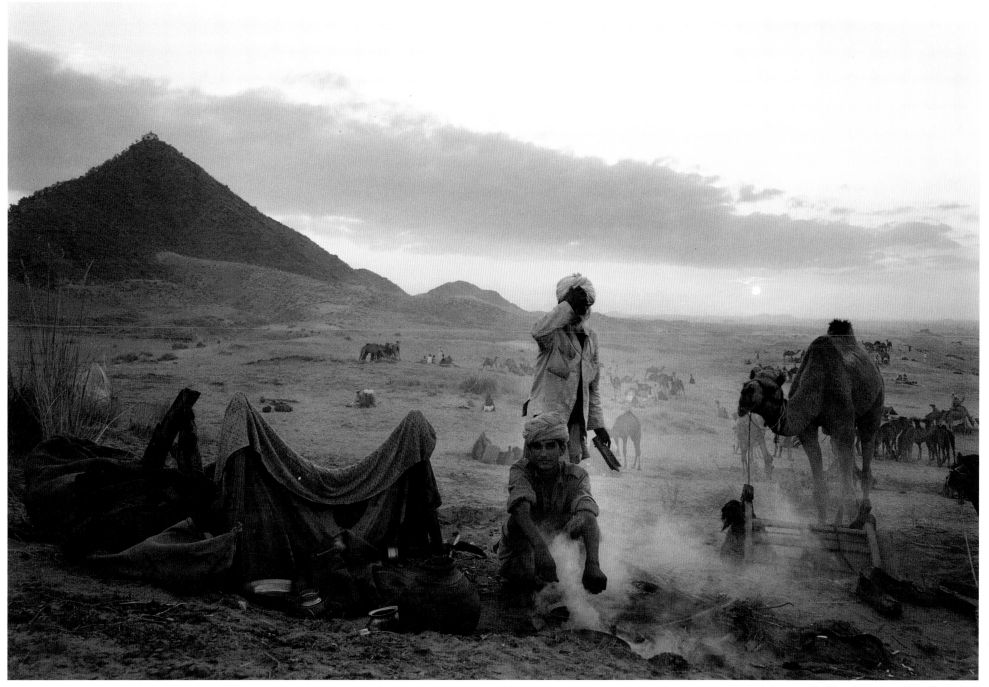

Mitch Epstein, *Pushkar Camel Fair*, Rajasthan, 1978

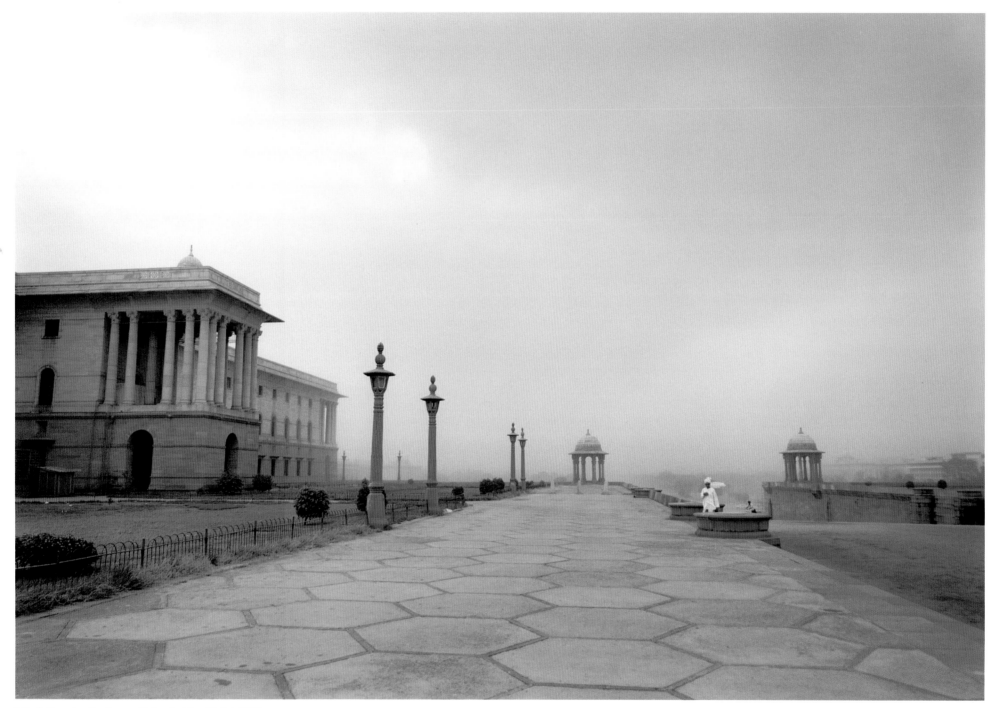

Mitch Epstein, *Sandstorm*, Rajpath, New Delhi, 1978

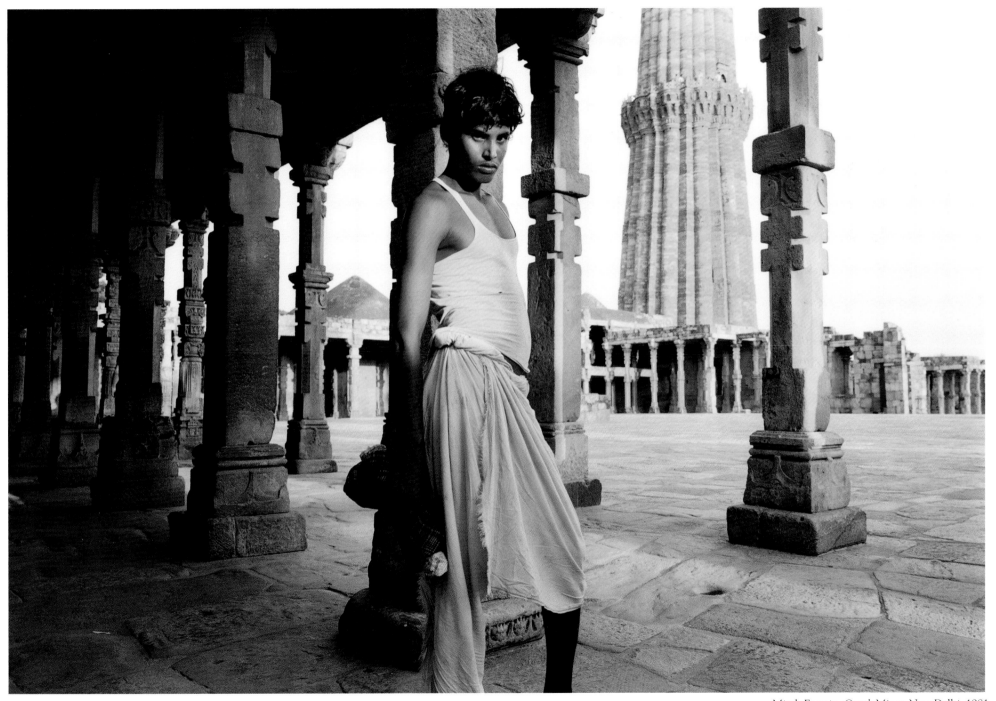

Mitch Epstein, *Qutab Minar*, New Delhi, 1981

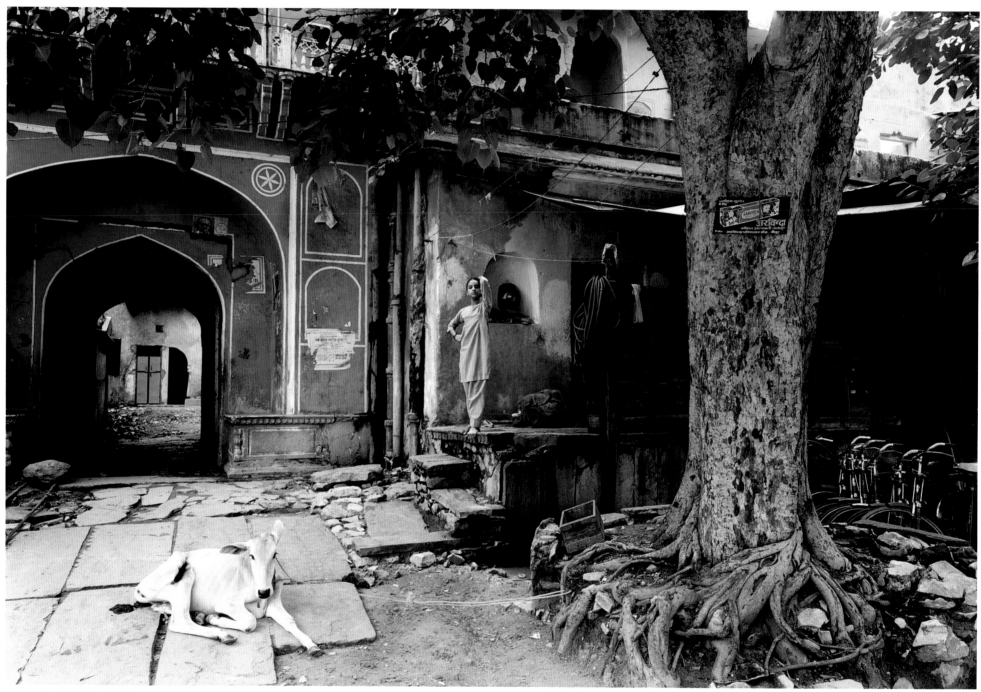

Mitch Epstein, *Jaipur*, 1985

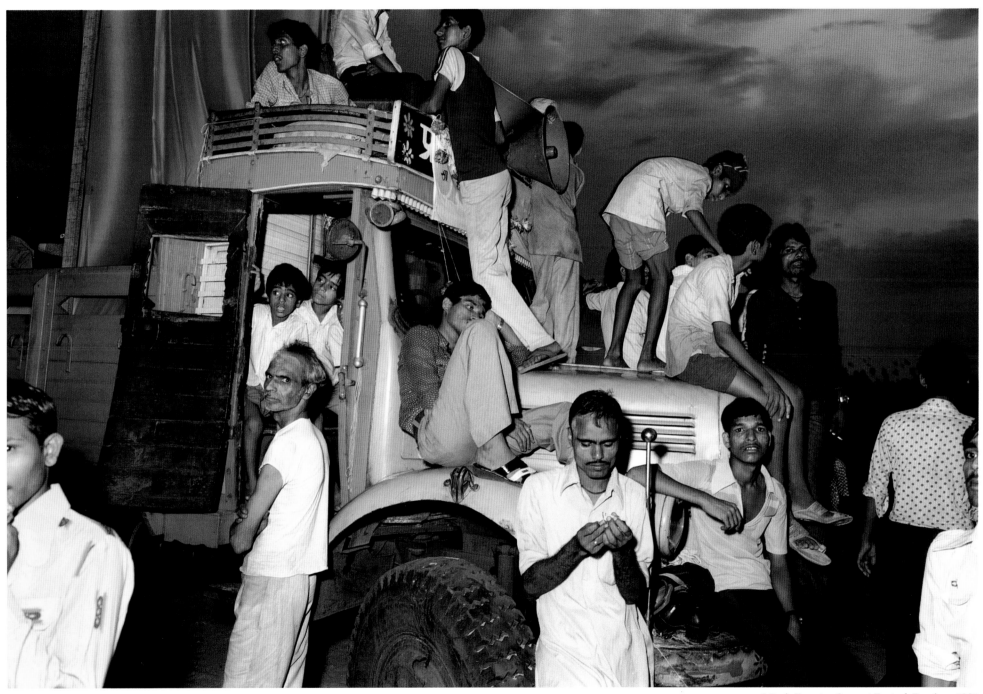

Mitch Epstein, *Ganpati Festival*, Bombay, 1981

HARRY GRUYAERT

Jaipur, Rajasthan, 1976

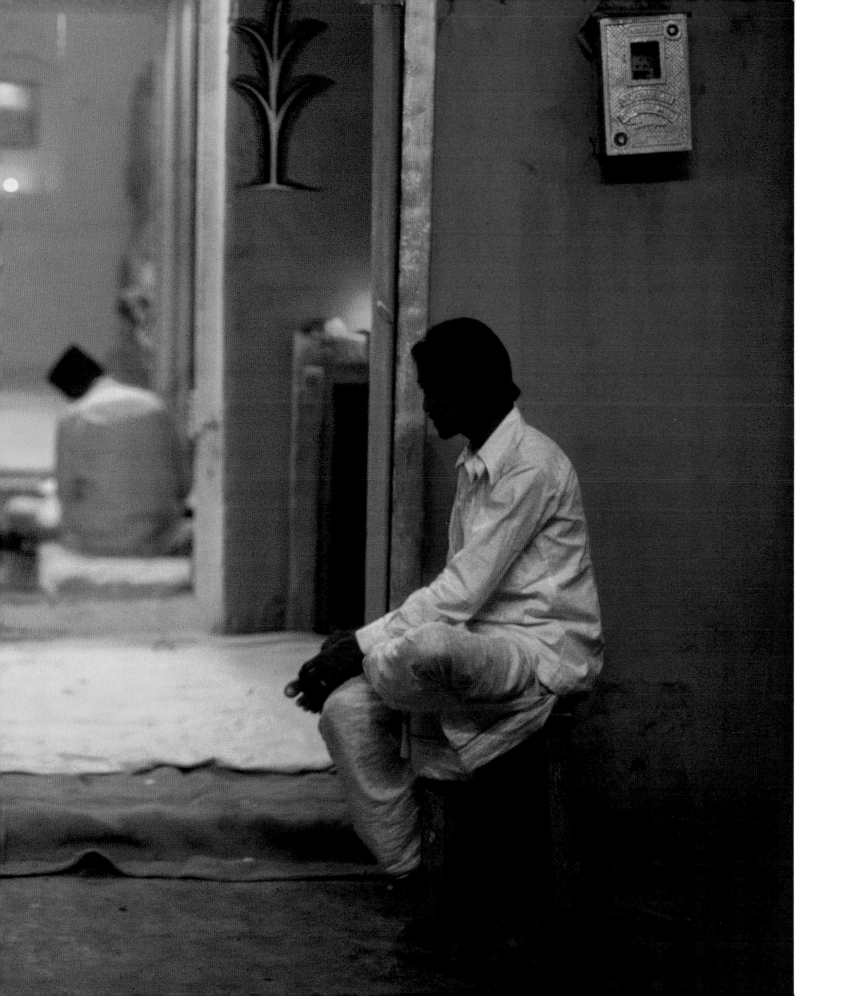

Harry Gruyaert, *Morning Mist in Pushkar*, 1976

Swallow this summer street,
then wait for the monsoon.
Needles of rain

—Agha Shahid Ali, 1987

Harry Gruyaert,
*Gymnast at
Benares,* 1976

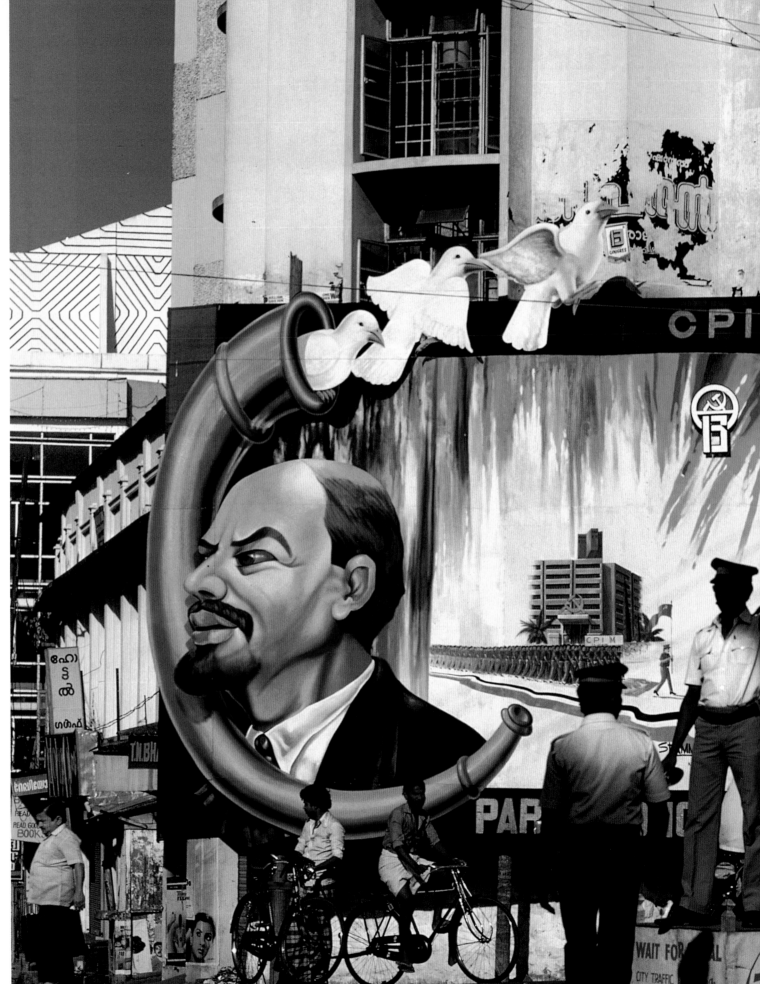

Harry Gruyaert, *The Annual Communist Party Meeting*, Trivandrum, Kerala State, 1989

ALEX WEBB
Bazaar Store, Bombay, 1981

Alex Webb,
Wrestling poster,
Bombay, 1981

Alex Webb,
Movie Poster with
Street Sleeper,
Bombay, 1981

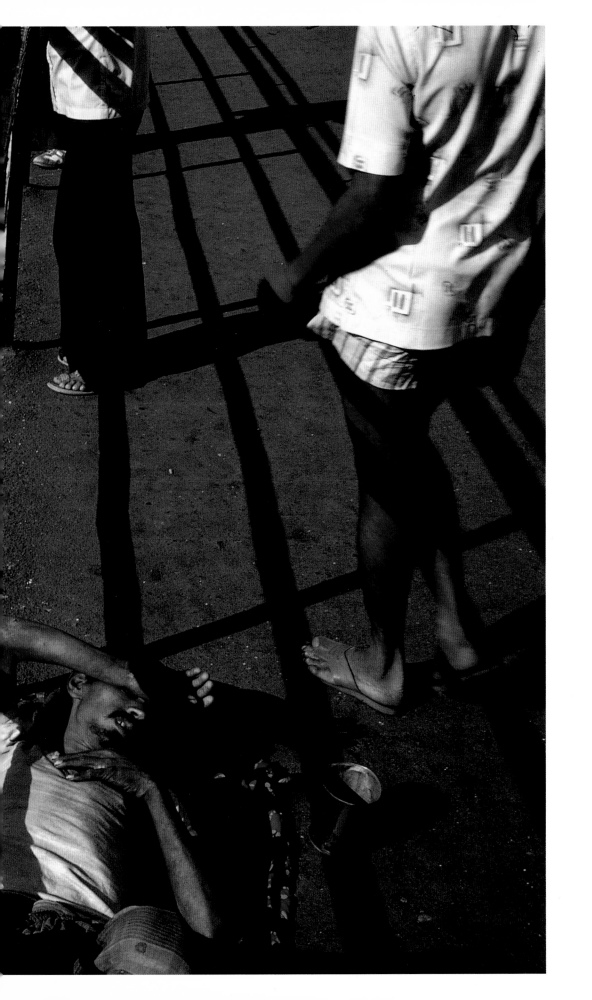

The wise old men
 of India say
there are certain rules.
For example, if you loved
your dog too much,
in your next life you'll be a dog
yet full of human memories.
And if the King's favourite daughter
loved the low-caste palace gardener
who drowned while crossing the river
in a small boat during the great floods,
they'll be reborn, giving a second chance.
The wise old men of India say
one often dreams
of the life one led before.

—SUJATA BHATT, 1983

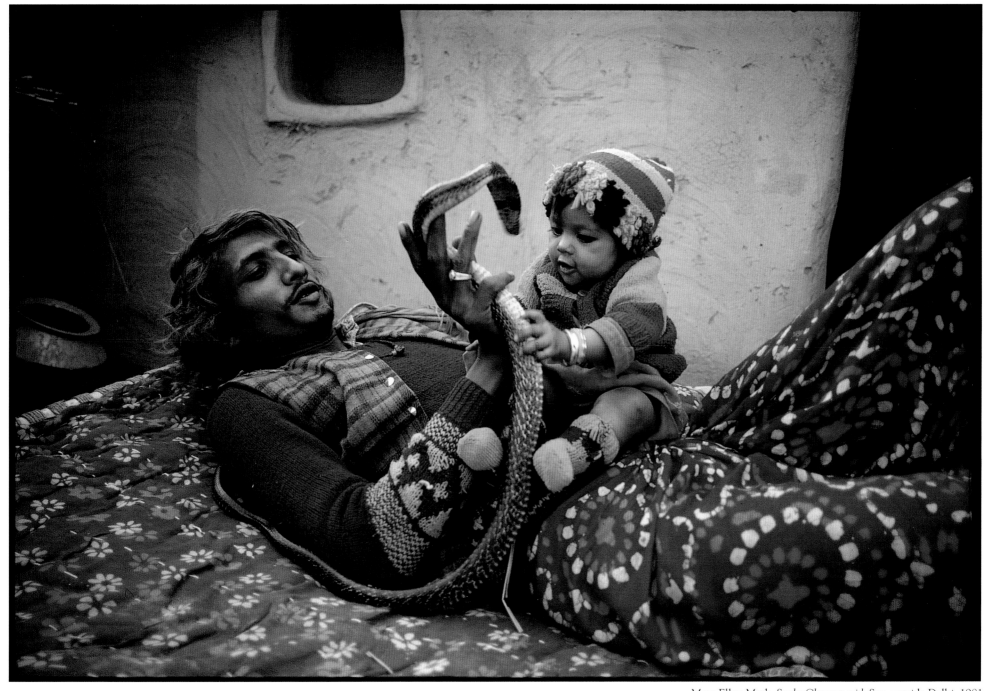

Mary Ellen Mark, *Snake Charmer with Son*, outside Delhi, 1981

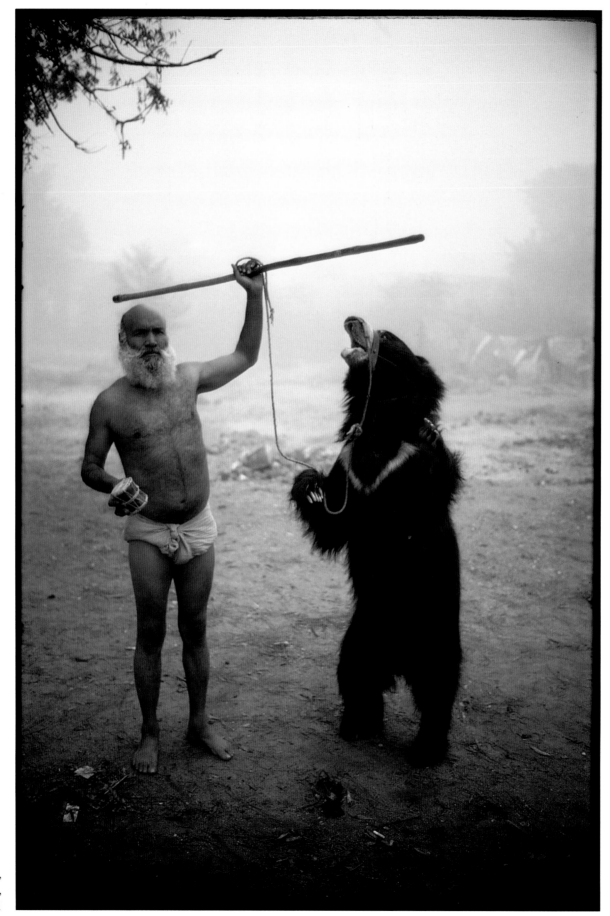

Mary Ellen Mark,
Street-Performing Bear-Trainer,
Delhi, 1981

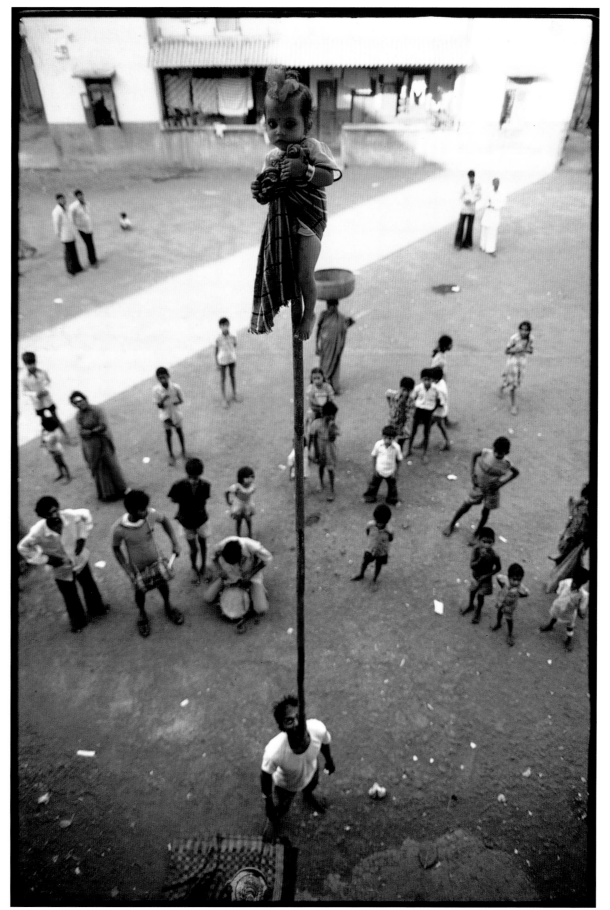

Mary Ellen Mark,
Street Acrobats,
Bombay, 1981

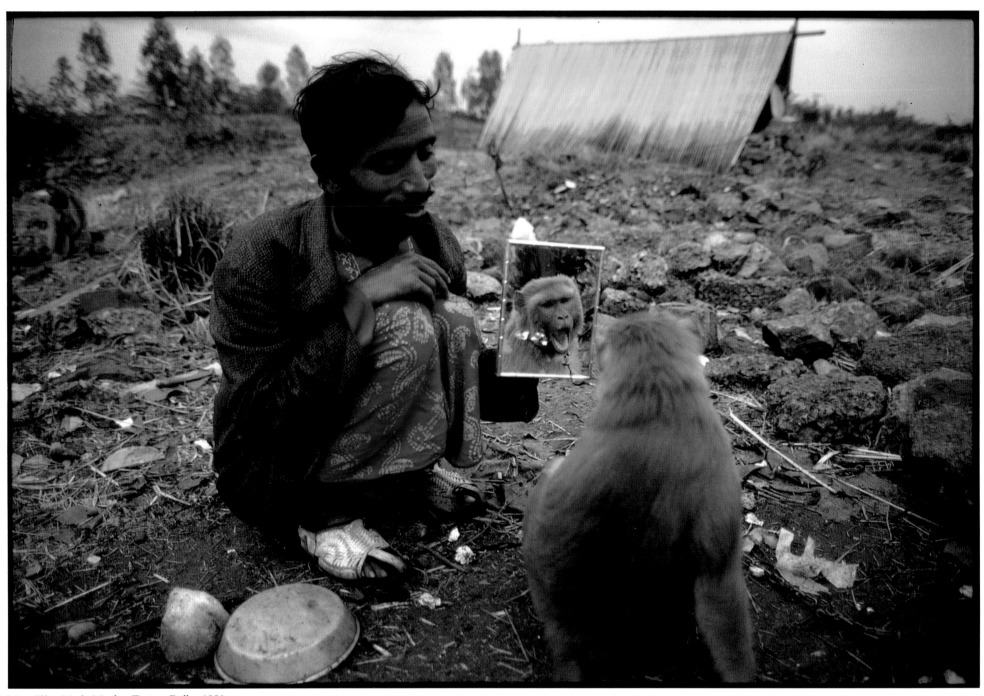

Mary Ellen Mark, *Monkey Trainer*, Delhi, 1981

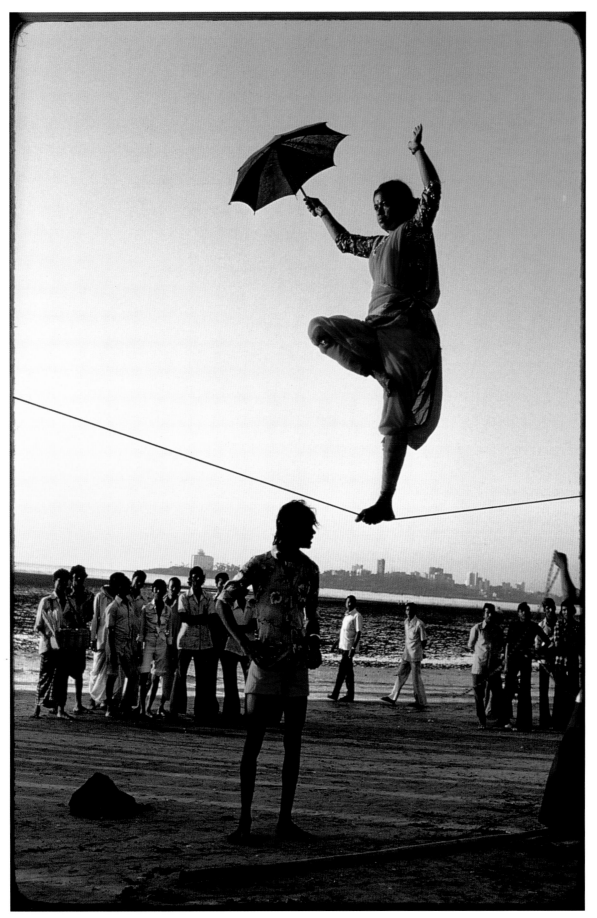

Mary Ellen Mark,
Street Acrobats,
Bombay, 1981

When you learn to swim
do not enter a river that has no ocean
to flow into, one ignorant of destinations
and knowing only the flowing as its destiny,
like the weary rivers of the blood
that bear the scum of ancient memories,
but go swim in the sea,
go swim in the great blue sea.

—KAMALA DAS, 1974

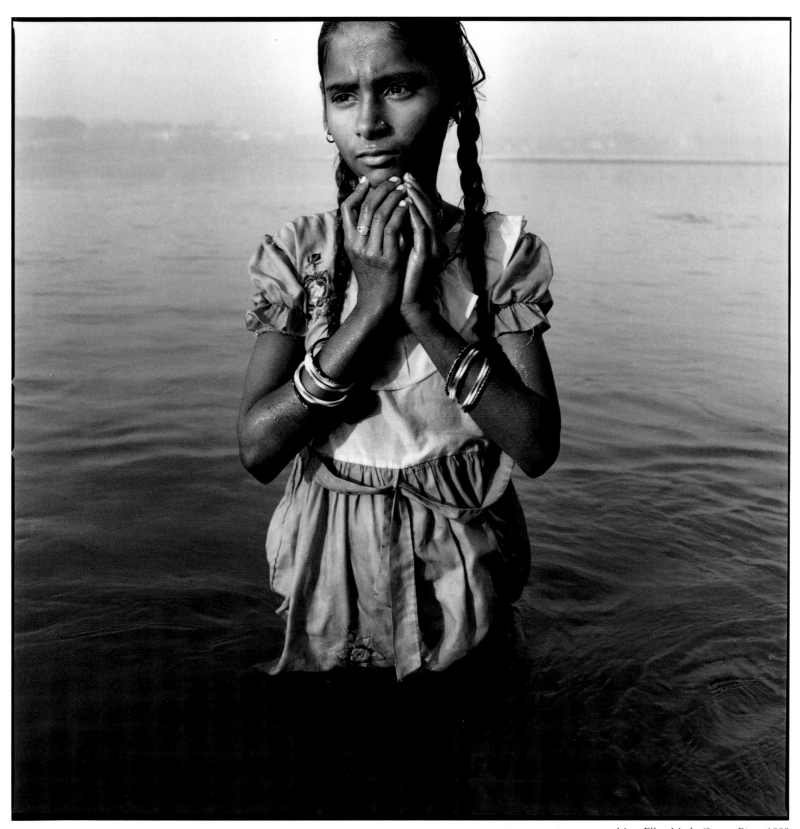

Mary Ellen Mark, *Ganges River*, 1989

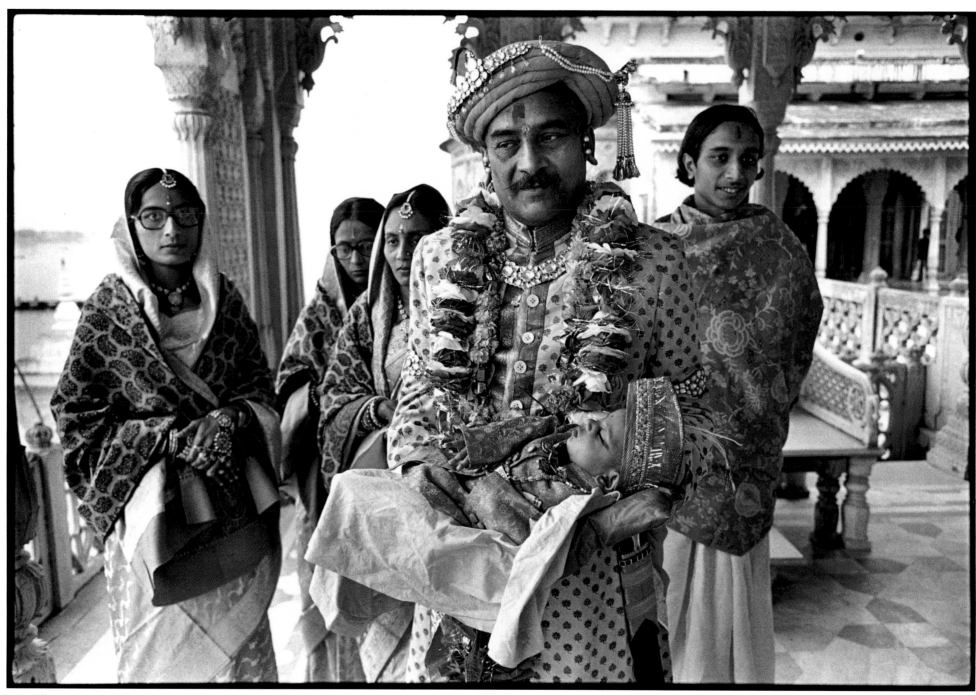

Mary Ellen Mark, *Maharaja of Benares*, 1981

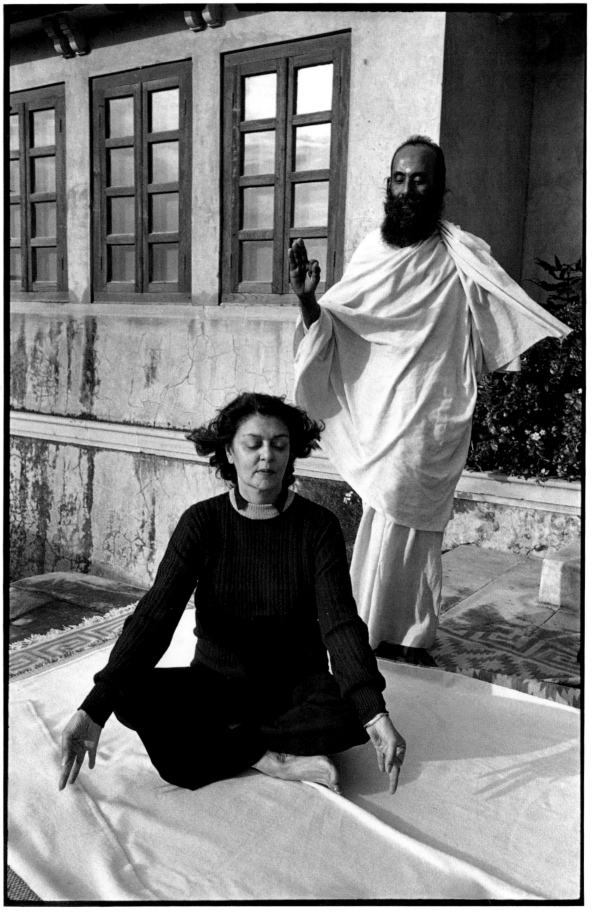

Mary Ellen Mark,
Maharani of Jaipur, 1975

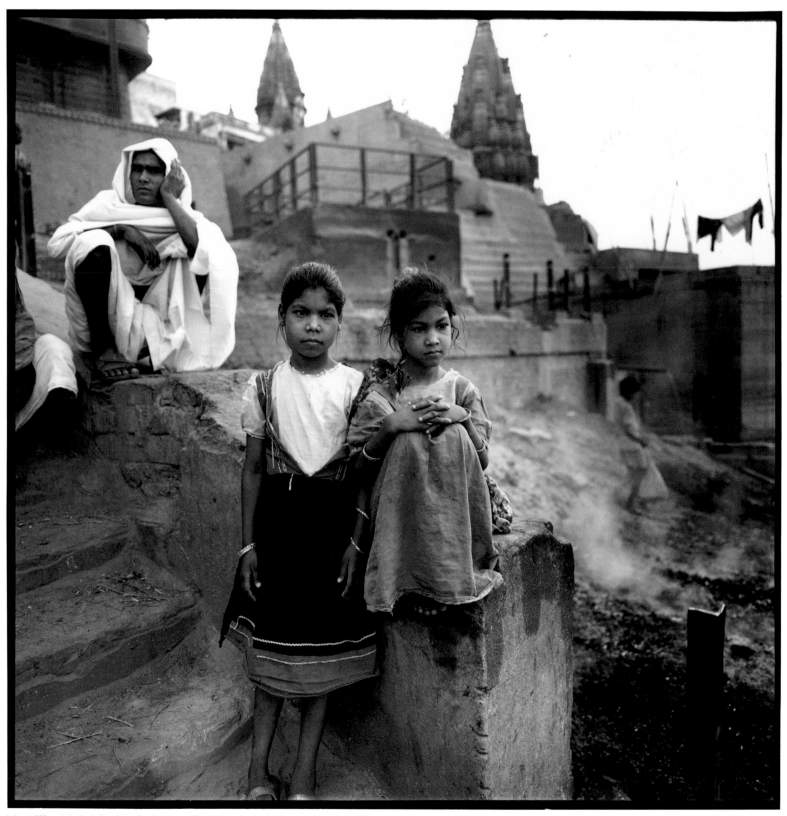

Mary Ellen Mark, *Manikarnika Burning Ghat*, Benares, 1995

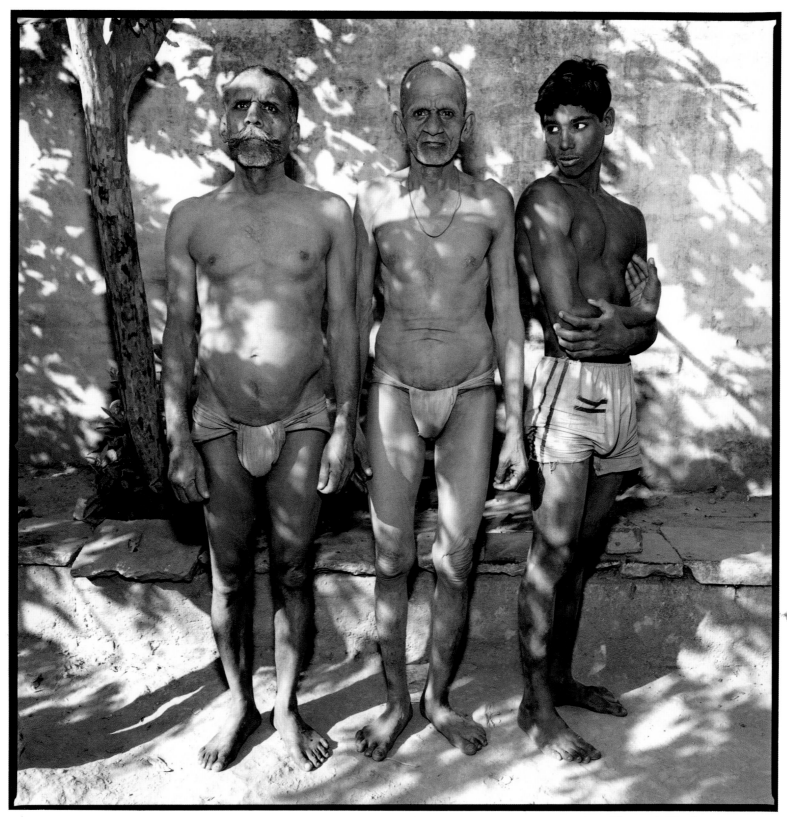

Mary Ellen Mark, *Wrestlers*, Benares, 1989

. . . .We can be proud of the fact that for a long series of centuries beset with vicissitudes of stupendous proportions, crowded with things that are incongruous and facts that are irrelevant, India still keeps alive the inner principle of her own civilzation against the cyclonic fury of contradictions and the gravitational pull of the dust.

—RABINDRANATH TAGORE, *1912*

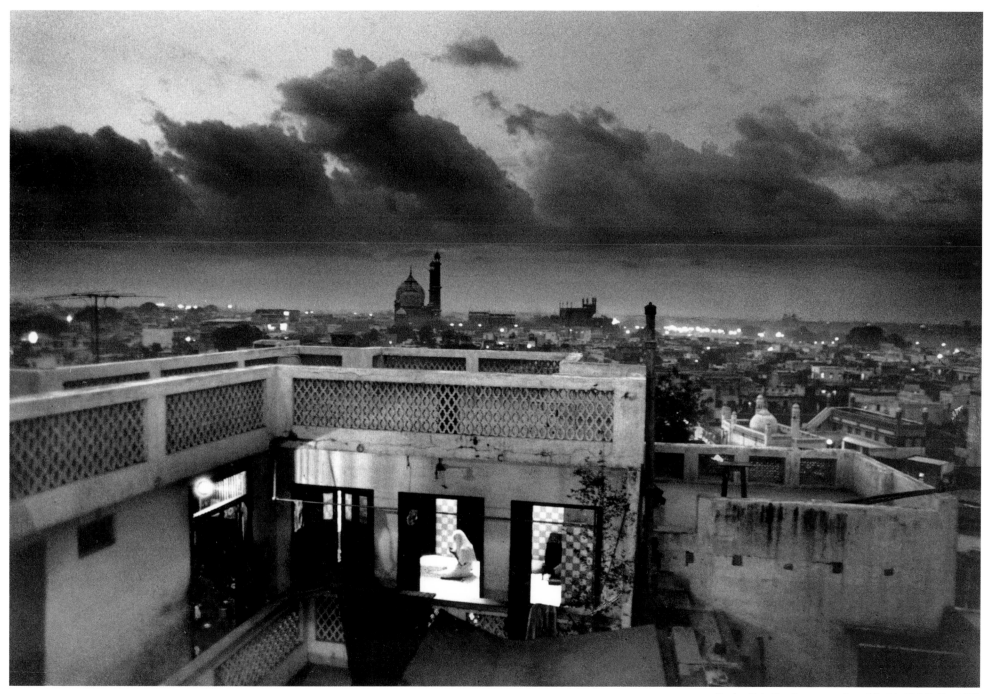

Raghu Rai, *Evening prayer, Jama Masjid*, Old Delhi, 1982

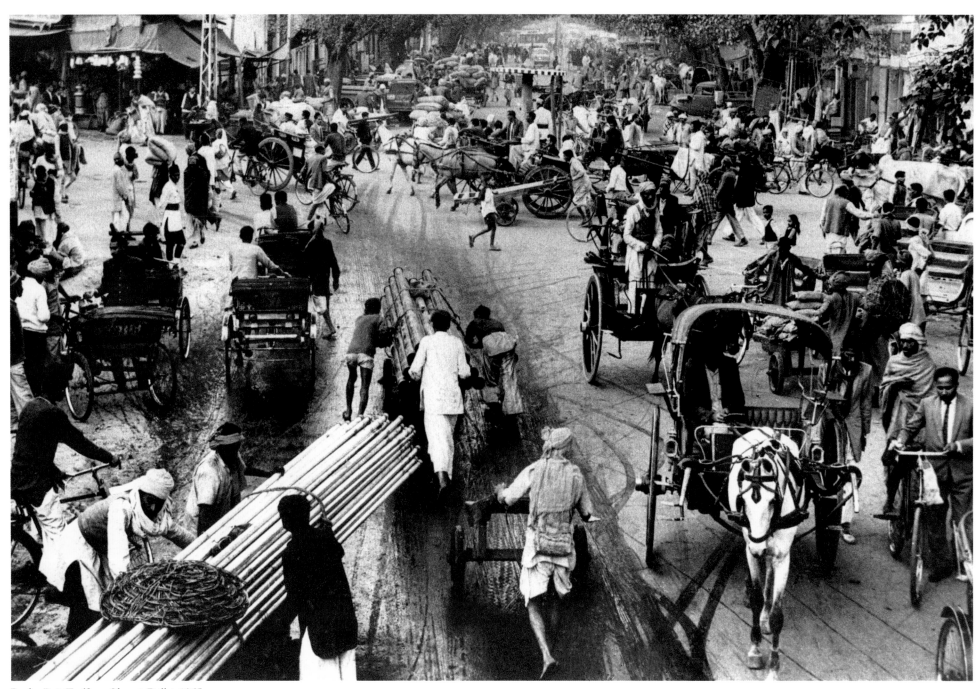

Raghu Rai, *Traffic at Chawri*, Delhi, 1965

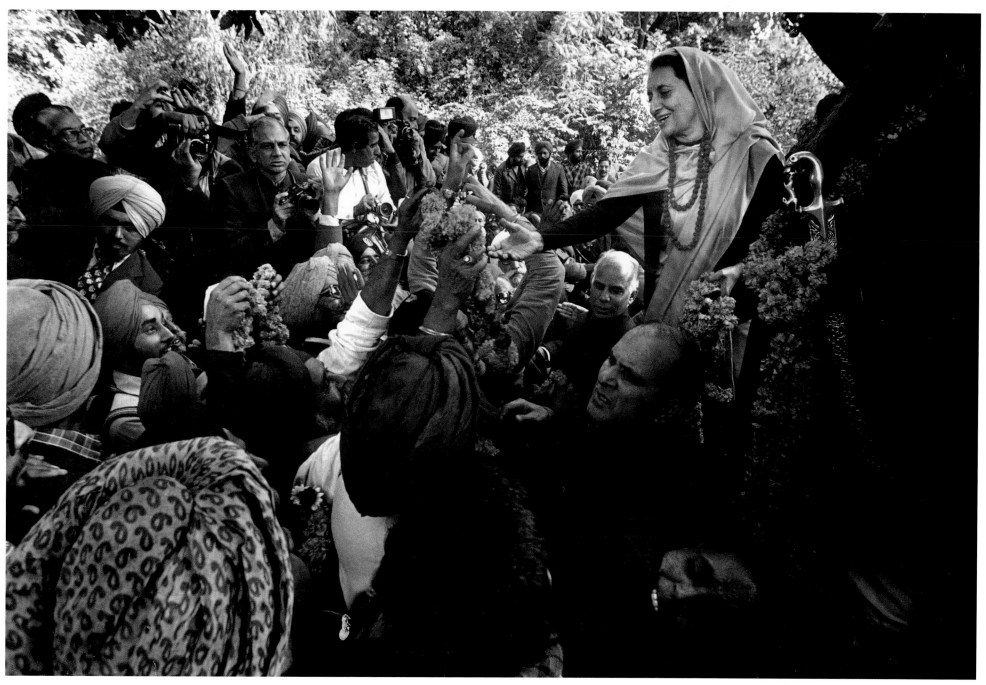

Raghu Rai, *Indira Gandhi with Garlands*, 1980

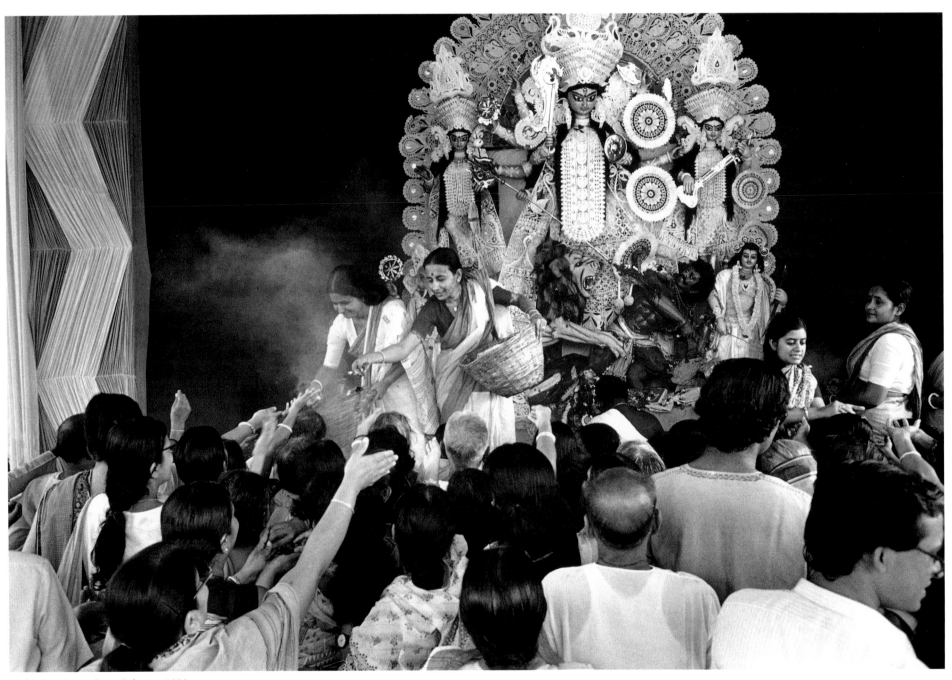

Raghu Rai, *Durga Puja*, Calcutta, 1990

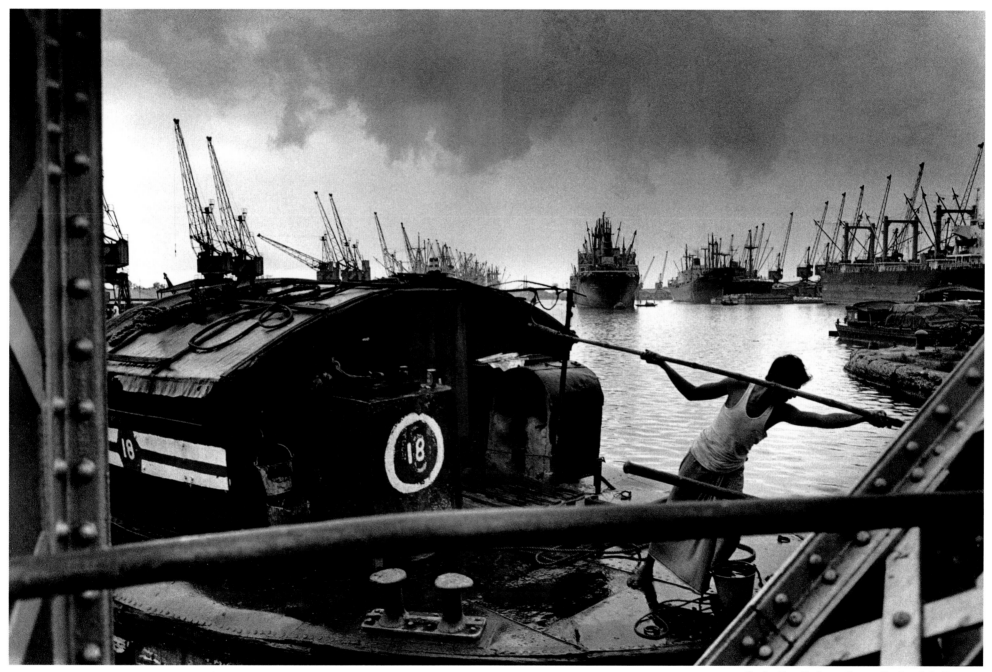

Raghu Rai, *Pushing a Boat in Dockyard*, Delhi, 1989

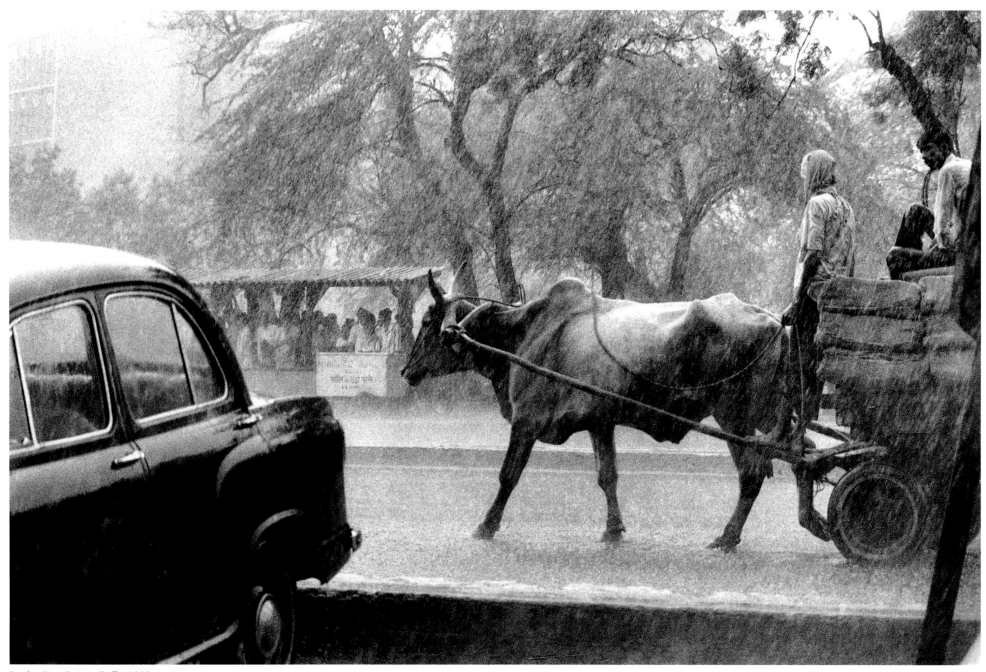

Raghu Rai, *Rain in Delhi*, 1982

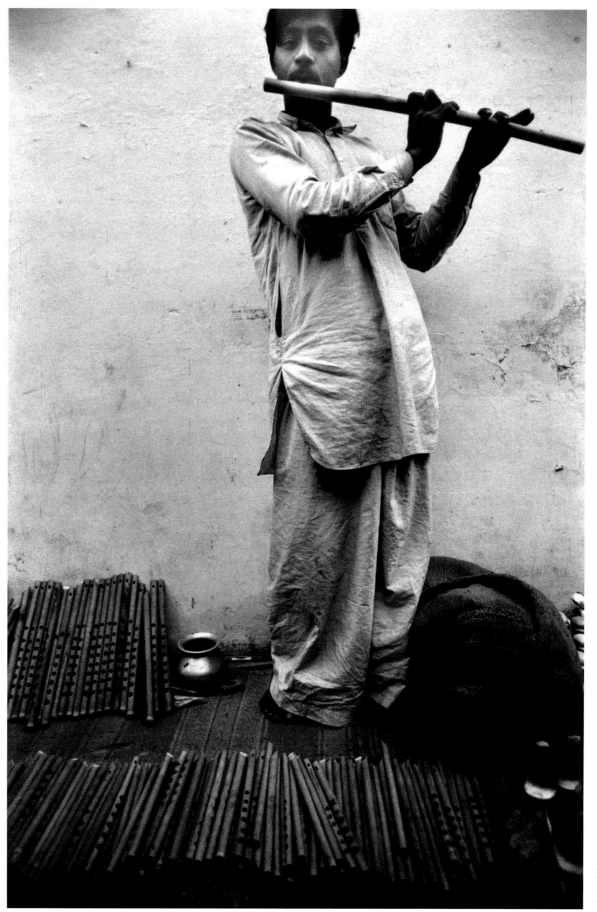

Raghu Rai,
Flute Player,
Delhi, 1975

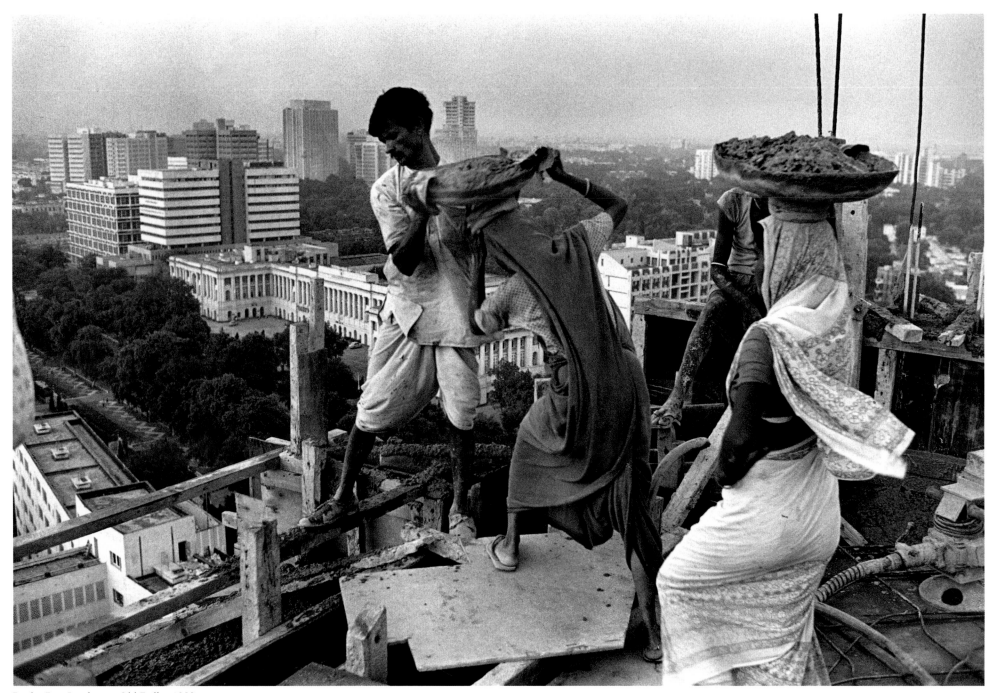

Raghu Rai, *Landscape*, Old Delhi, 1989

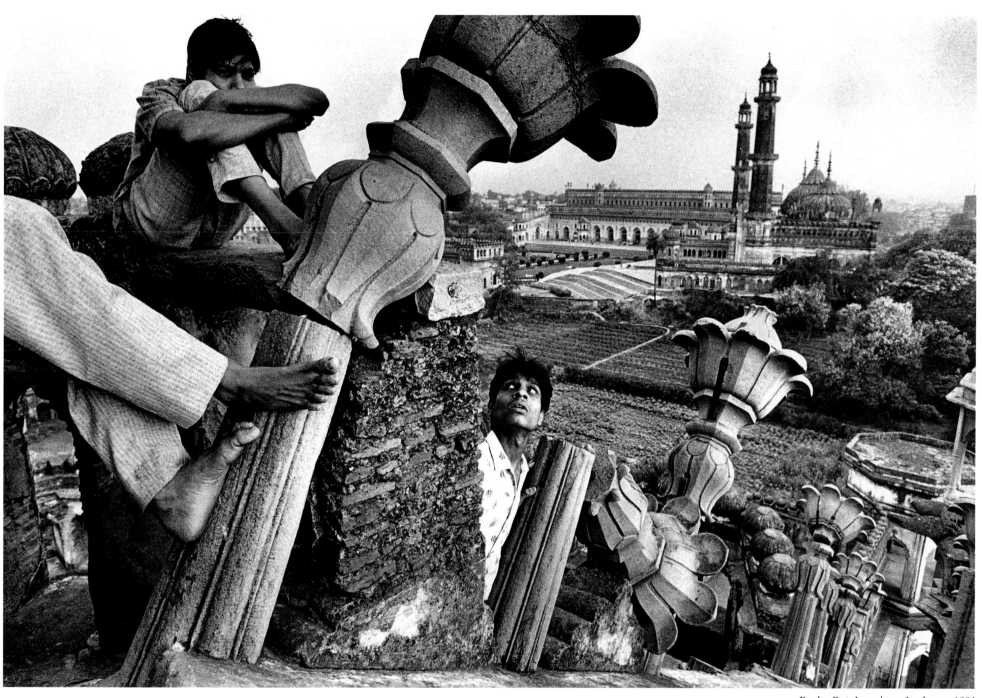

Raghu Rai, *Imambara*, Lucknow, 1991

Pages 114–115: Raghu Rai, *Wrestlers near Howrah*, Calcutta, 1990

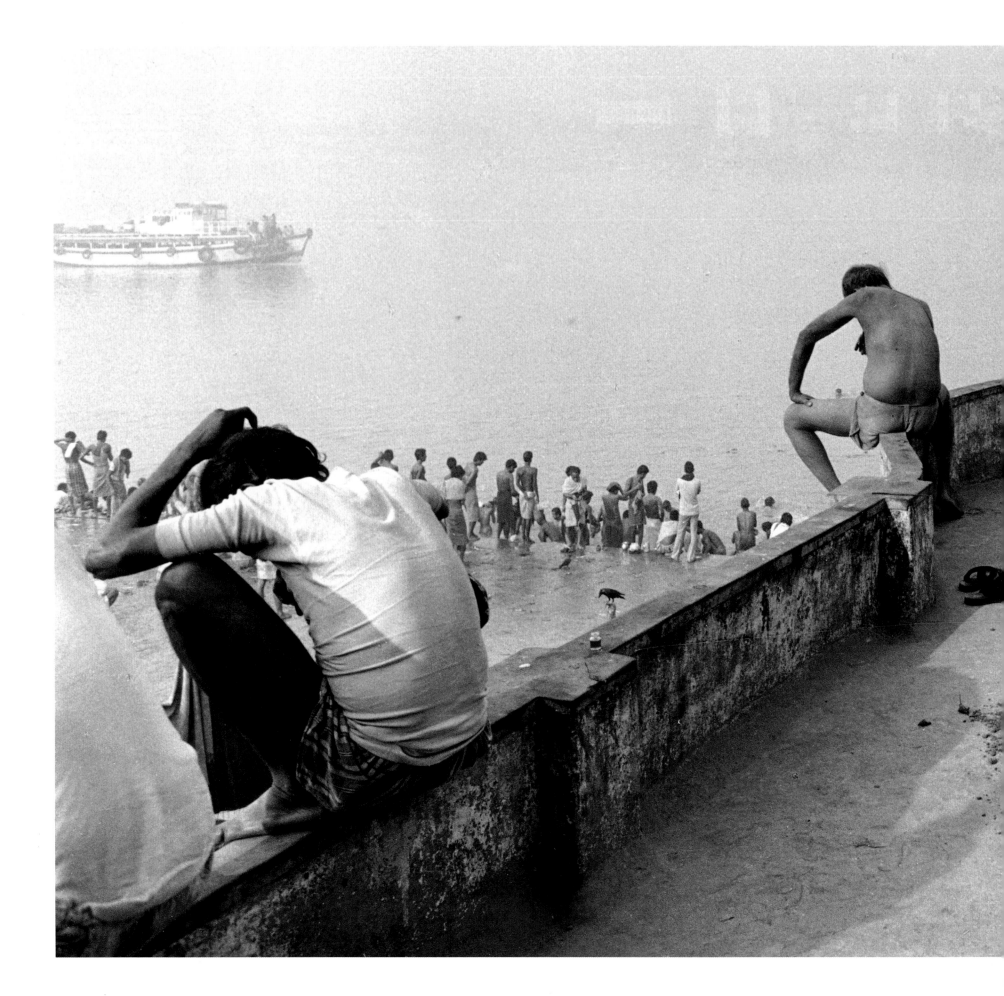

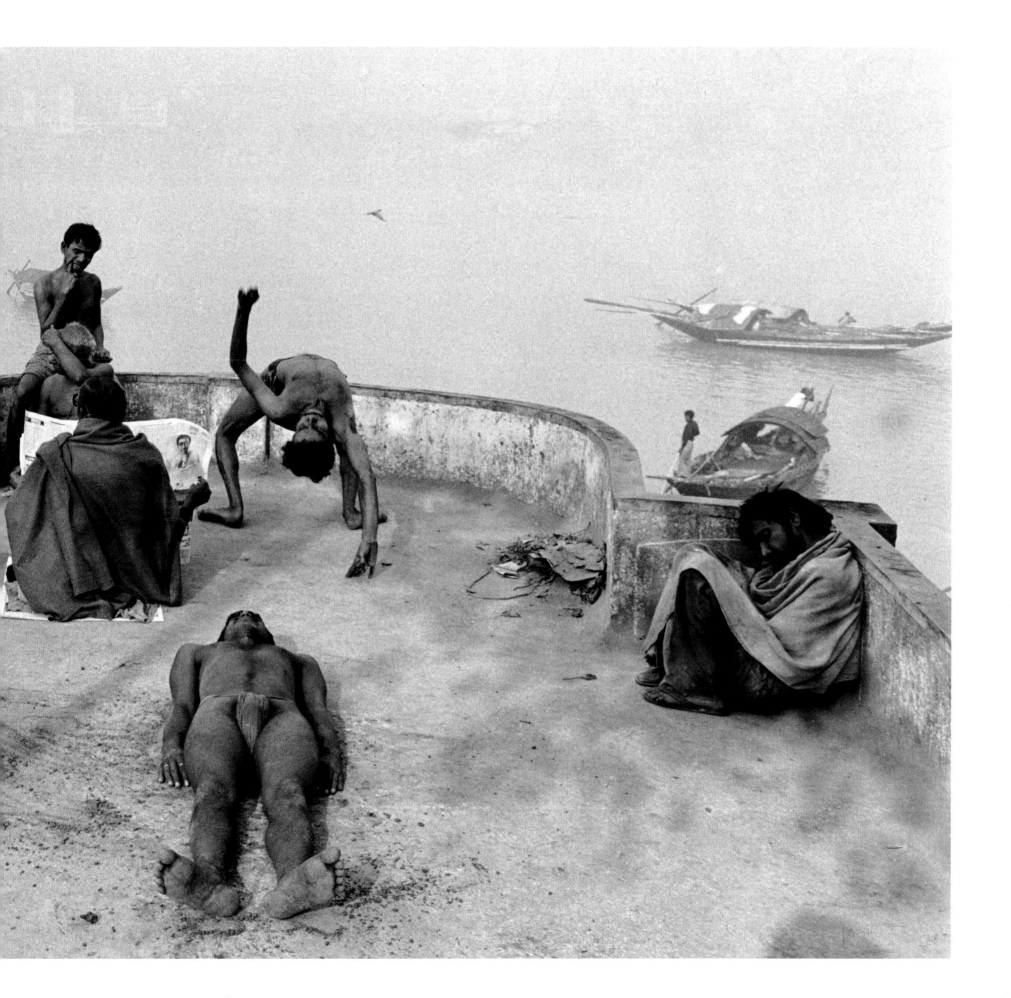

For me, the camera is an instrument of learning. When you look through it, you achieve a kind of concentration, and in those concentrated moments, you can penetrate, discover, feel, and understand. The aim of the artist, in the end, is to liberate yourself and cut yourself free in your own space, free of needs and demands—liberated from all those emotions and excitements and aesthetics that we react to so strongly. You must learn to inhale everything, and understand it to the point that your consciousness, your spirit, is not colored. And that must also reflect in your work.

But each time you take a step, you discover yet another kind of space. It's not that you are reaching Nirvana—you don't reach that. You go closer to it. There are layers and layers of things happening in the human mind, in the human spirit. The possibilities are endless and total.

Even after so many years of photographing, I feel I am just beginning to understand what our country is all about. Over the centuries, so much has melded into India, that it is not really one country; it's not one culture. But it has its own pace, which keeps things together. All that we have in India still lives—several centuries at the same time. The eternity of it all, that is what matters finally.

—Raghu Rai

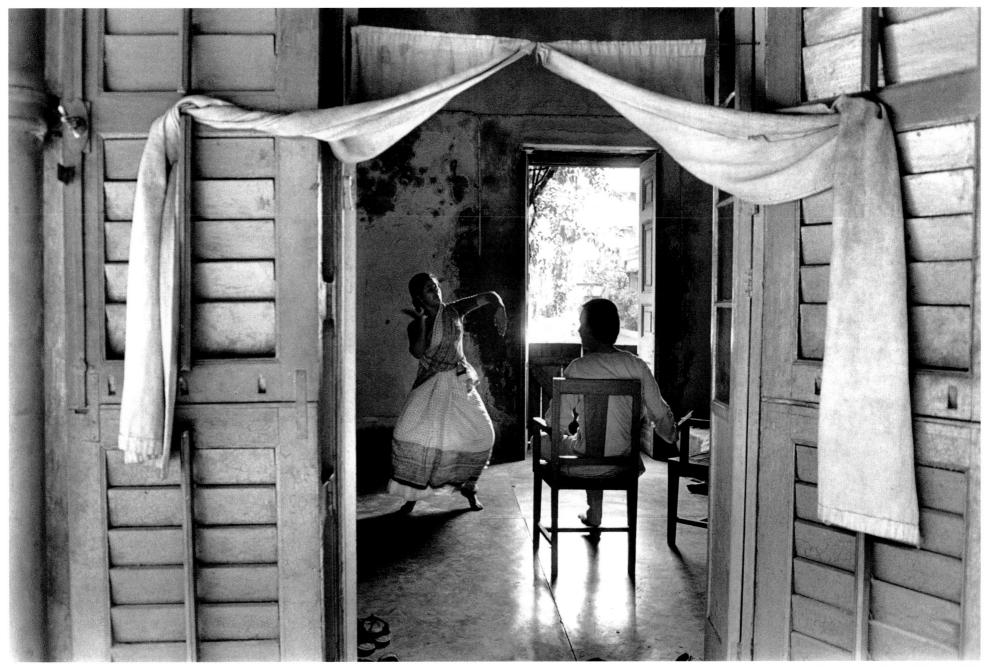

Raghu Rai, *Learning Dance*, Calcutta, 1990

Pages 118–119: Raghu Rai, *Musicians' Portraits at Ghosh's*, Calcutta, 1989

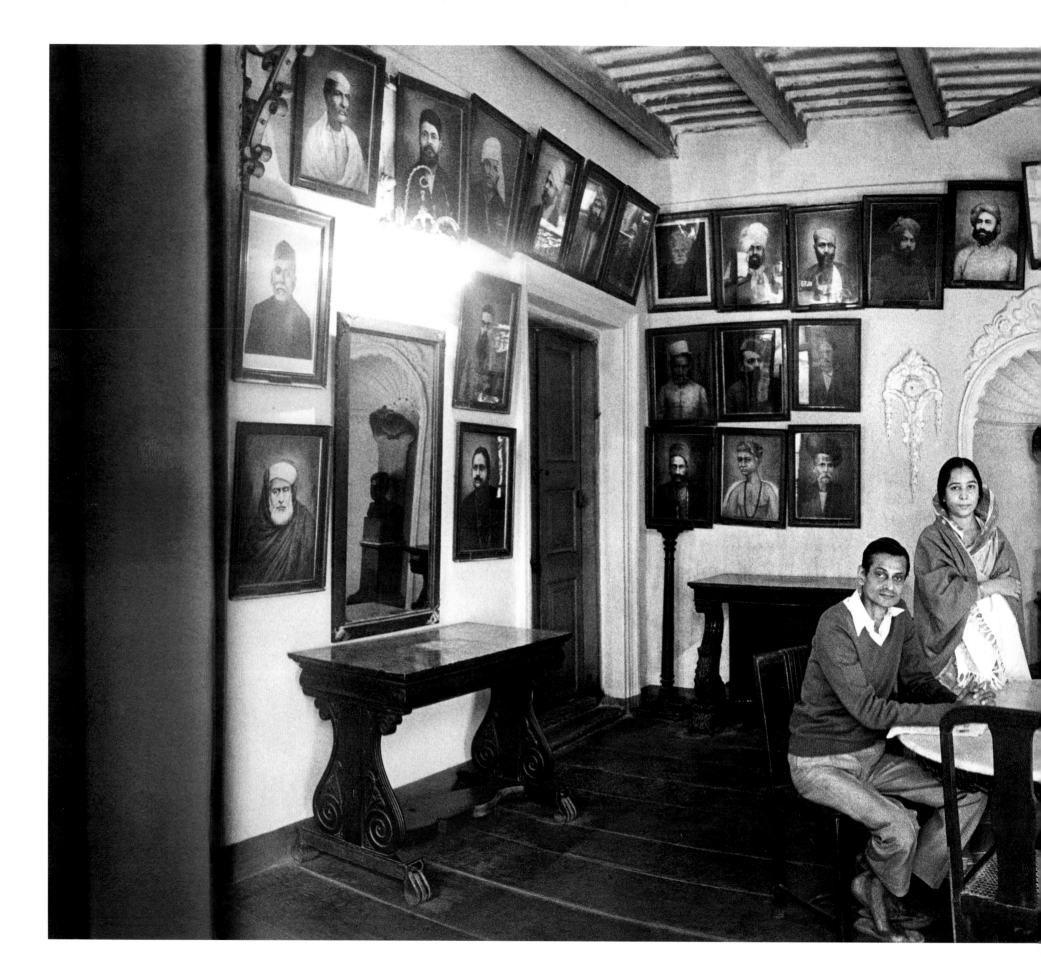

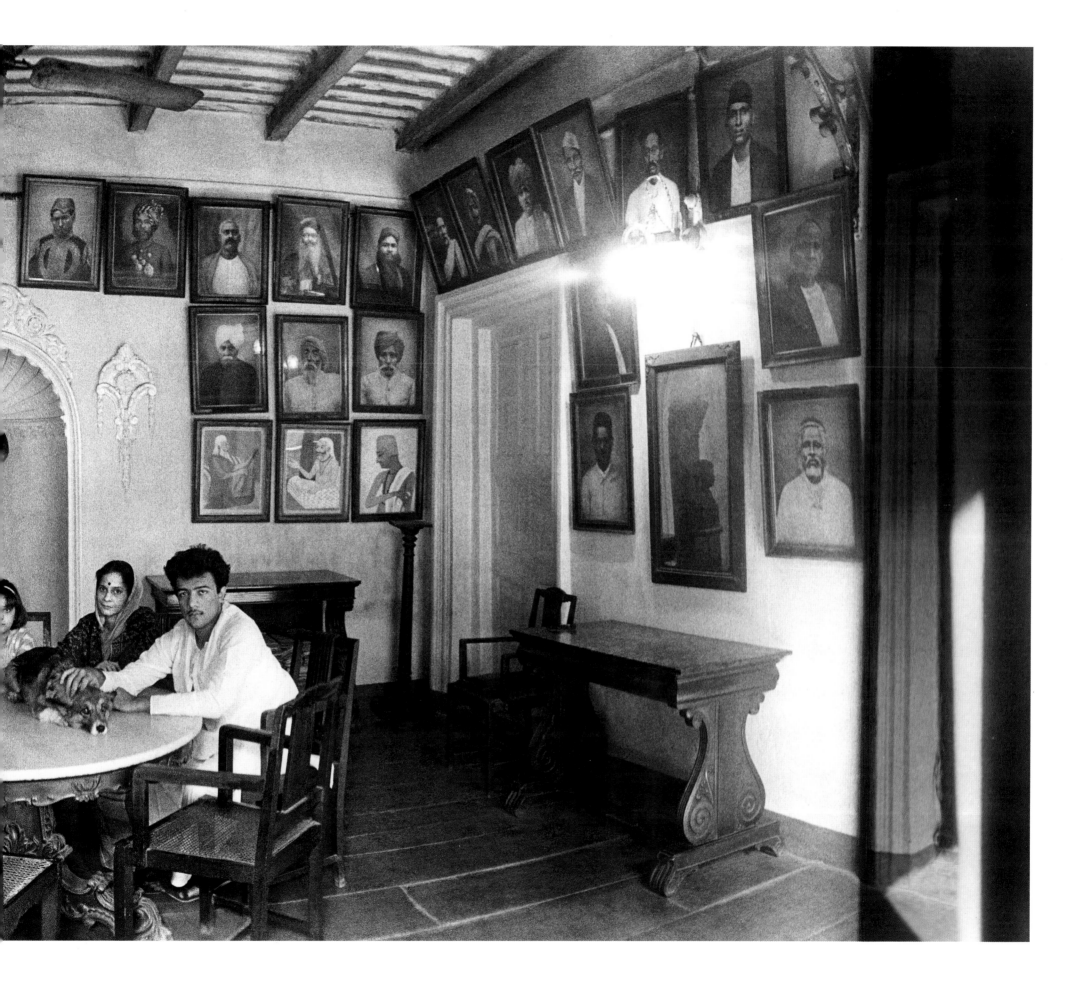

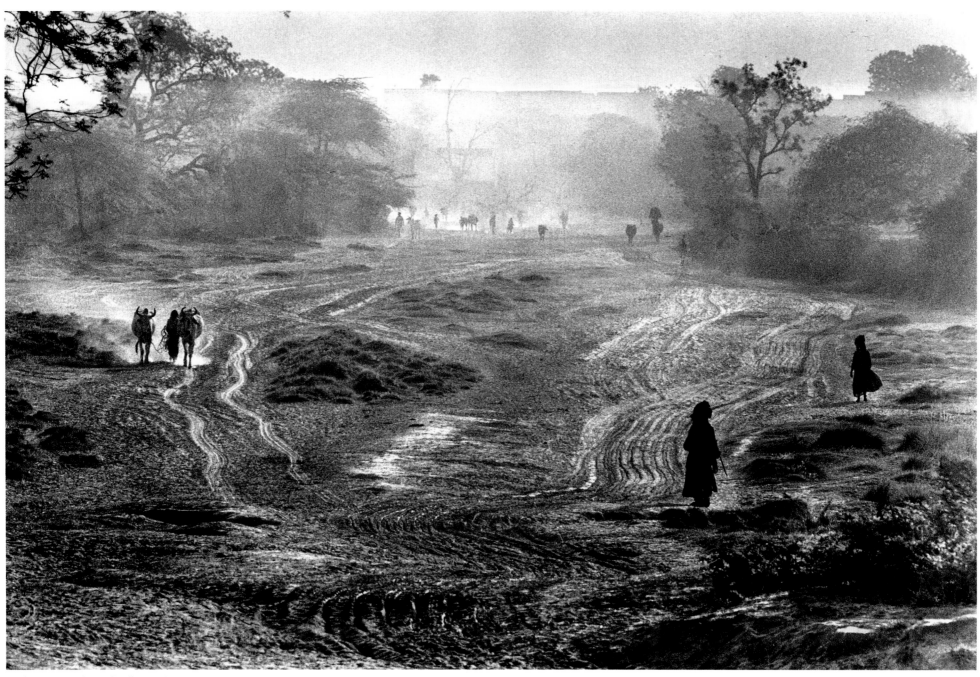

Raghu Rai, *Outskirts of Delhi*, 1965

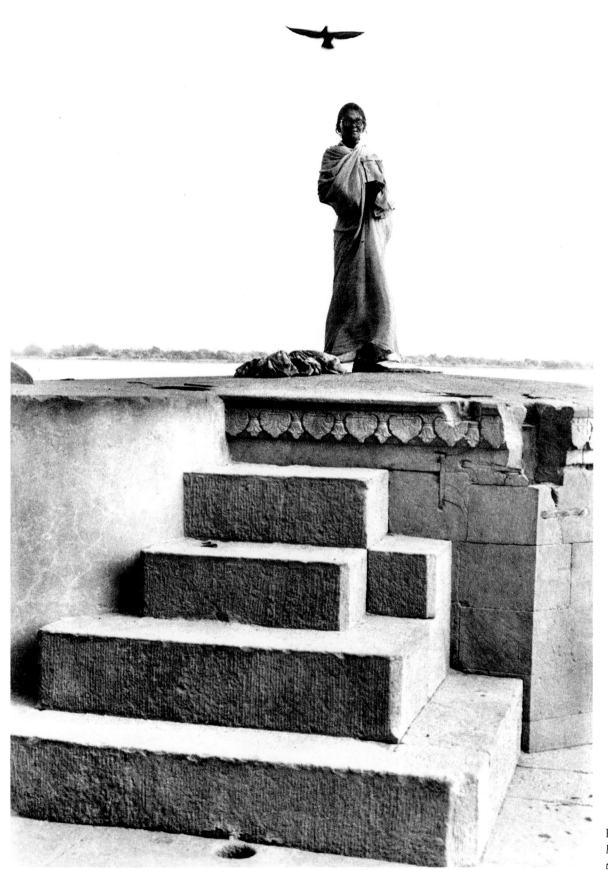

Raghu Rai, *Woman and Bird on the Banks of the Ganga*, Benares, 1972

He said:
"In a single day
I'm forced to listen
to a dozen film songs,
to see
a score of beggars,
to touch
uncounted strangers,
to smell
unsmellable smells,
to taste
my bitter native city."

He said:
"I'm forced by the five senses
to fear the five senses."

I heard him out
in black wordlessness.

 —Nissim Ezekiel, 1976

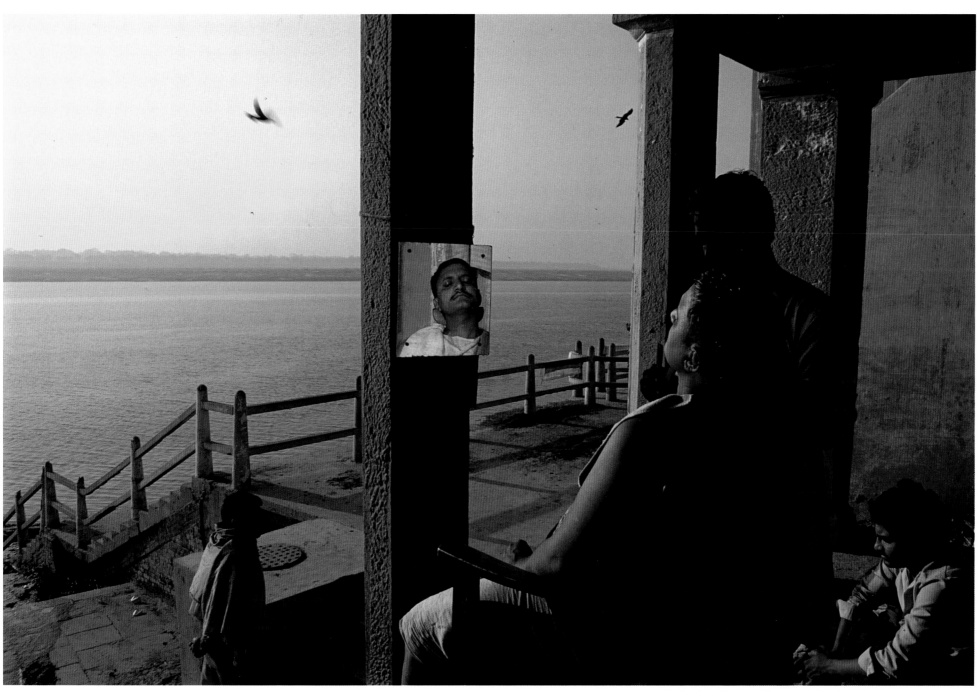

Raghu Rai, *Having a Shave on the Banks of the Ganga*, Benares, 1992

Raghu Rai, *Dancing Girls at Dushera Festival*, Delhi, 1990

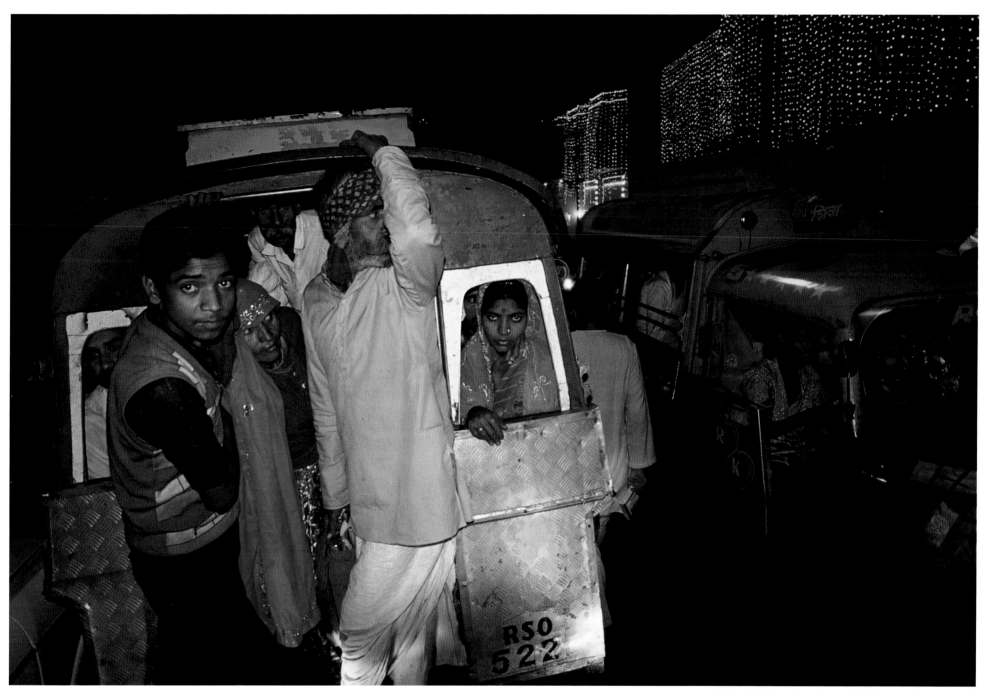

Raghu Rai, *Returning from Pushkar Fair*, Rajasthan, 1993

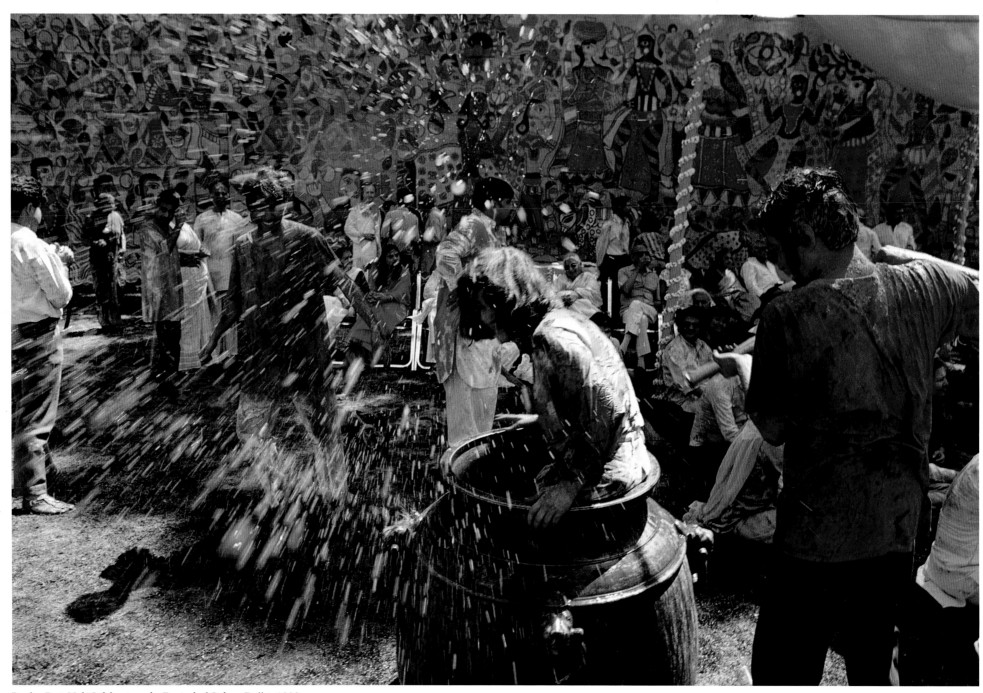

Raghu Rai, *Holi Celebration, the Festival of Colors*, Delhi, 1990

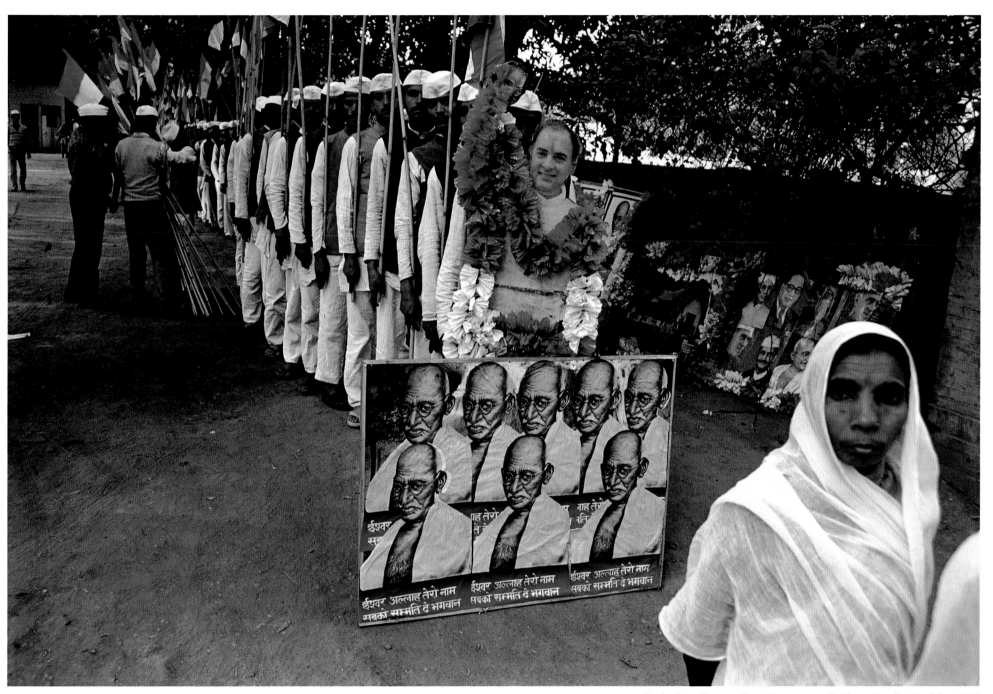

Raghu Rai, *Congress Party Procession to Celebrate Gandhi's Birthday*, 1992

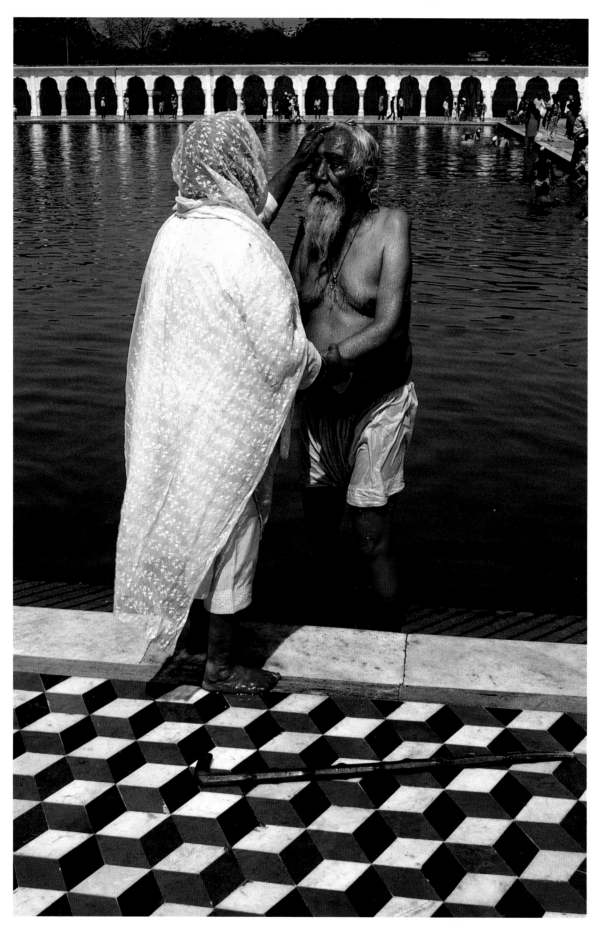

Raghu Rai, *Sikh Couple in Sikh Temple*, Delhi, 1988

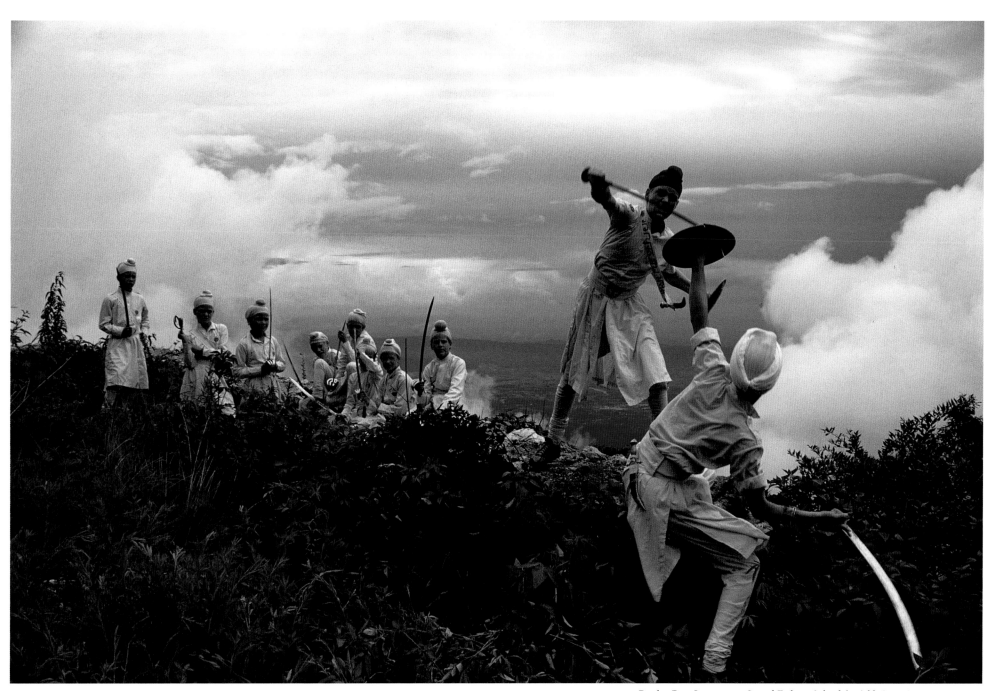

Raghu Rai, *Learning to Sword Fight at School for Sikh Boys*, Mussoorie, 1982

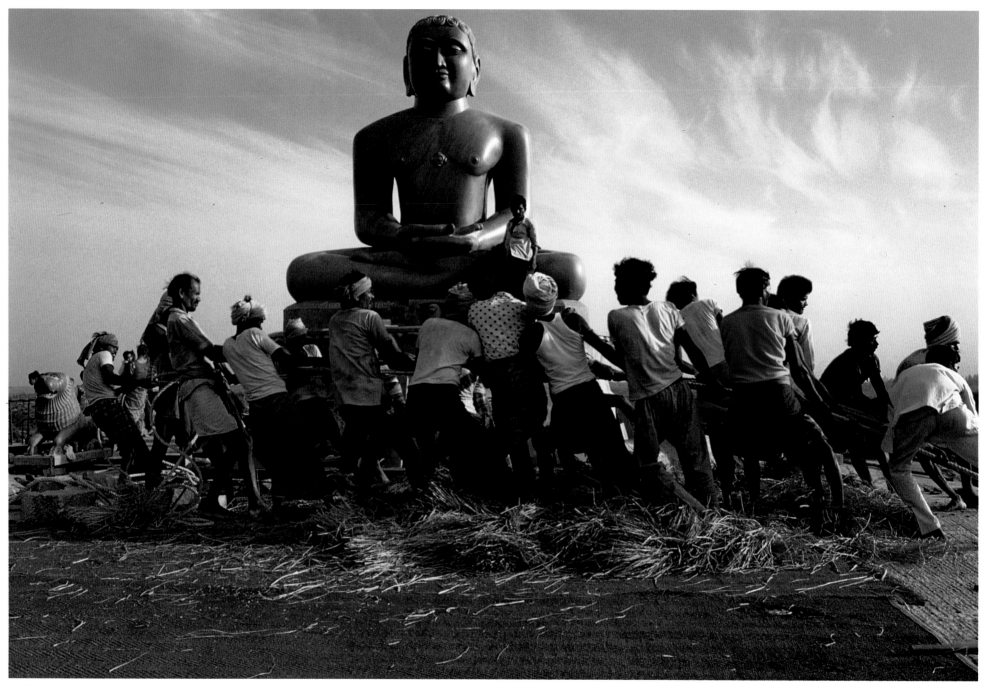

Raghu Rai, *Statue of Jain God Mahavir Being Installed in Qutab Complex*, Delhi, 1990

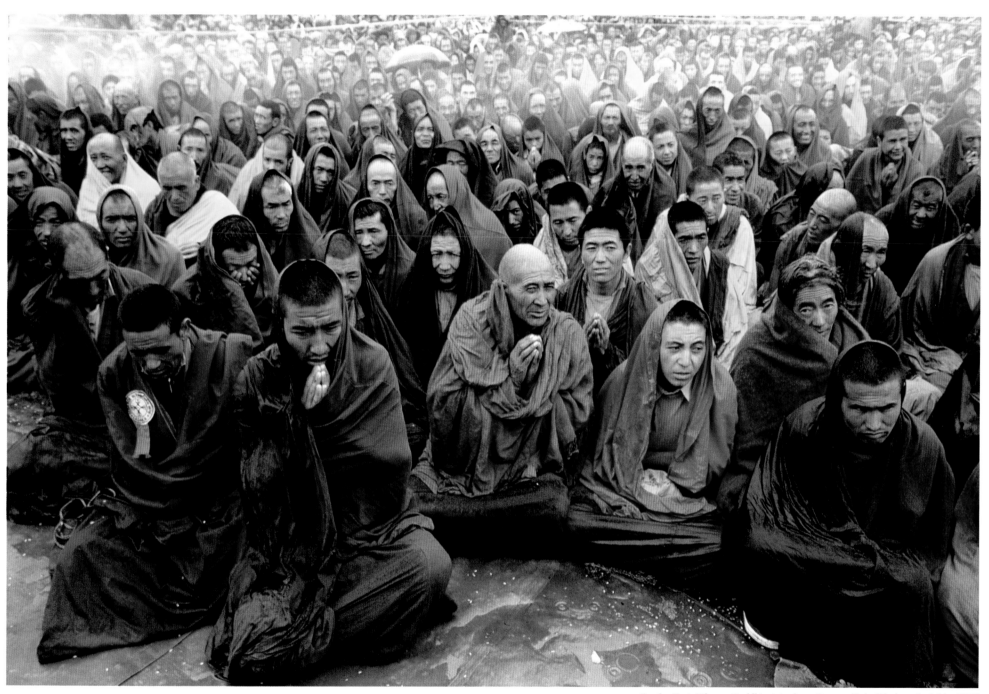

Raghu Rai, *Tibetan Buddhist Monks at Prayer*, Kala Chakra, Ladakh, 1975

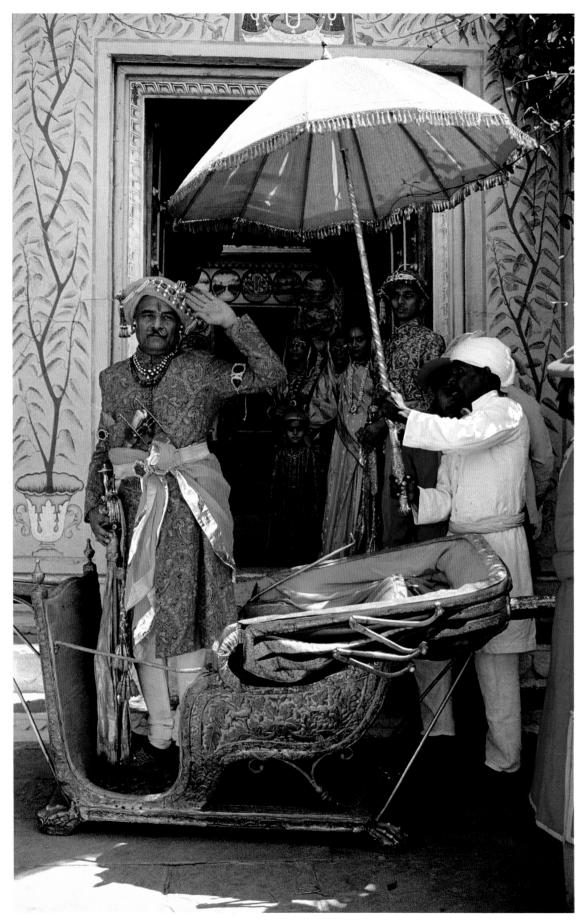

Raghu Rai, *Maharaja of Benares*
Saluting on His Birthday, 1986

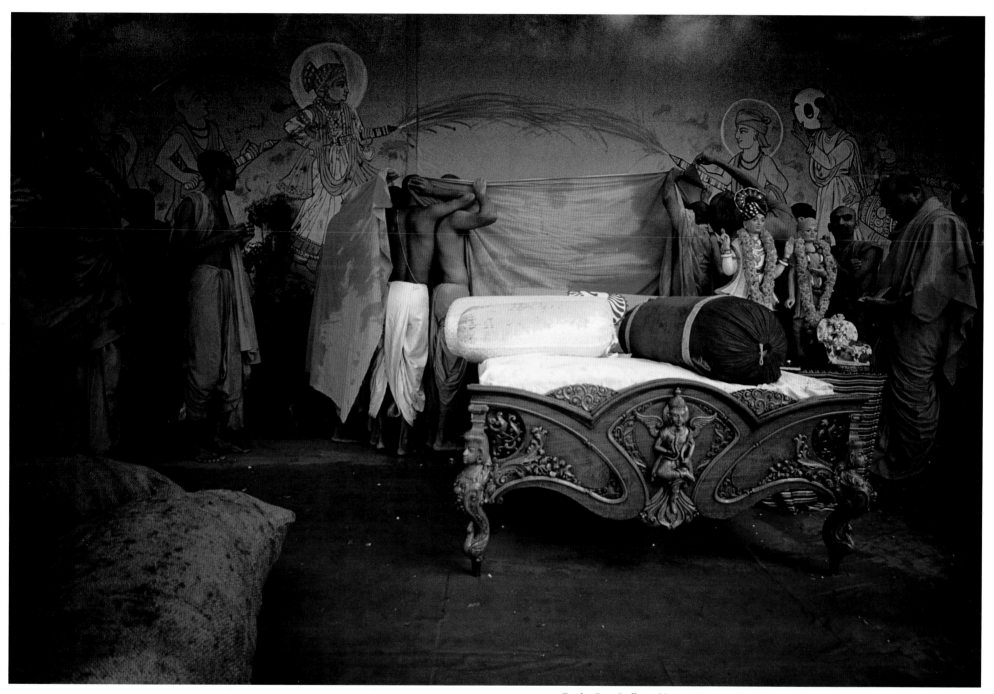

Raghu Rai, *Sadhus of Swami Narayan Sect Giving a Cover to Their Guru*, Ahmedabad, 1993

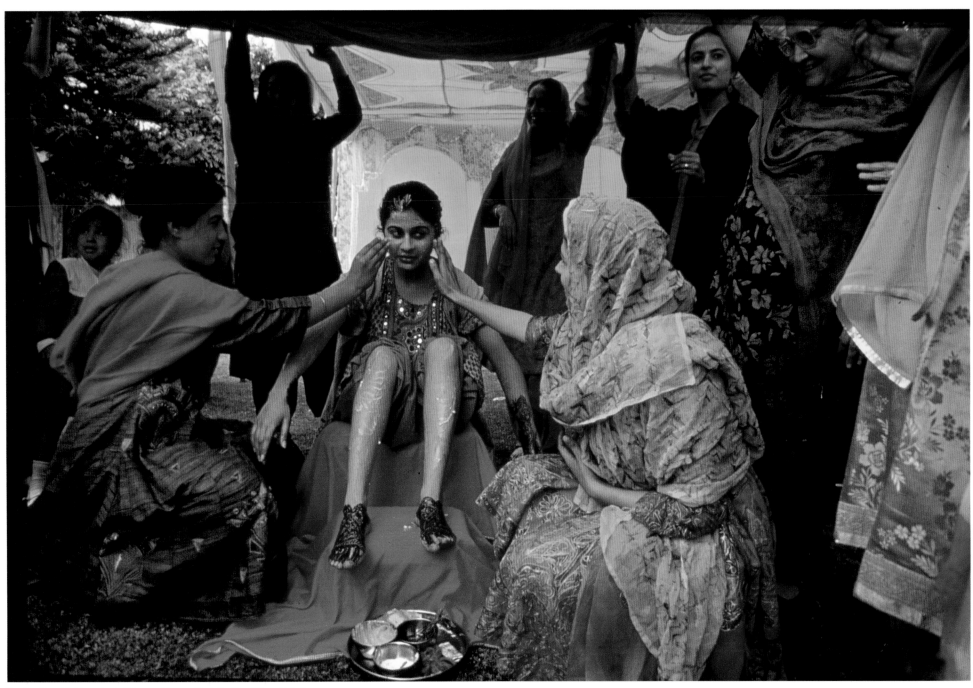

Raghu Rai, *Bride-to-be is Given a Beauty Bath by Her Close Relatives
on the Day Before Her Wedding*, Punjab, 1993

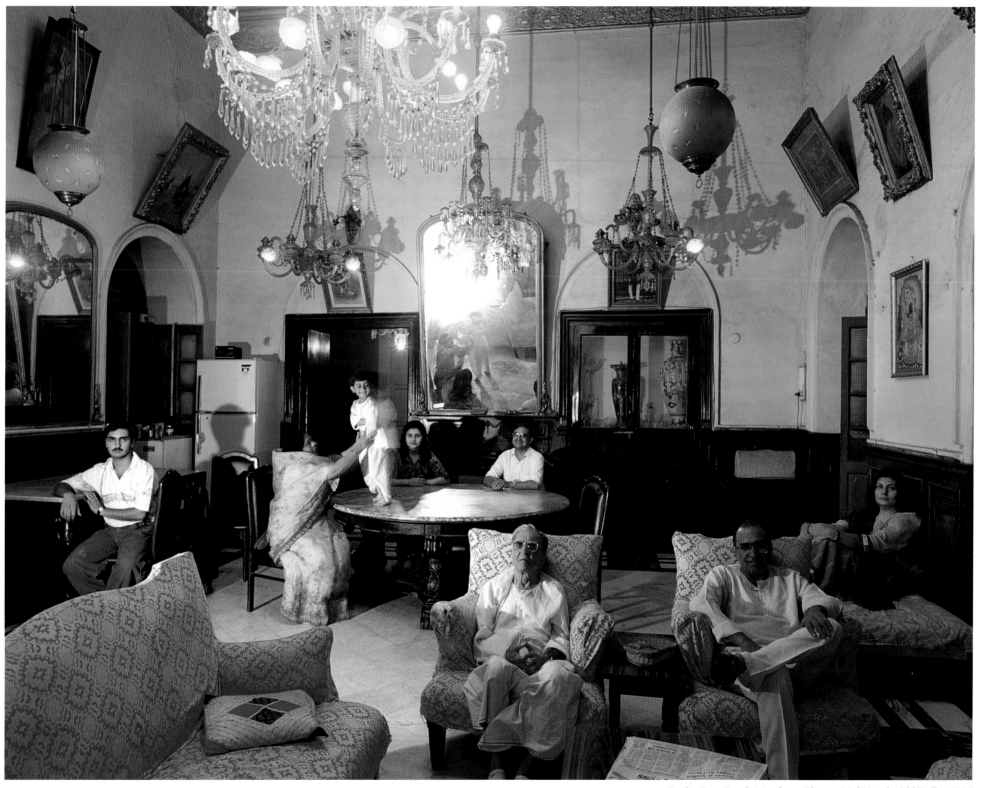

Raghu Rai, *Family Members*, Chunna Mal Haveli, Old Delhi, 1990

Pages 136–137: Raghu Rai, *Secondhand Tire Shop, near
Jama Masjid*, Old Delhi, 1988

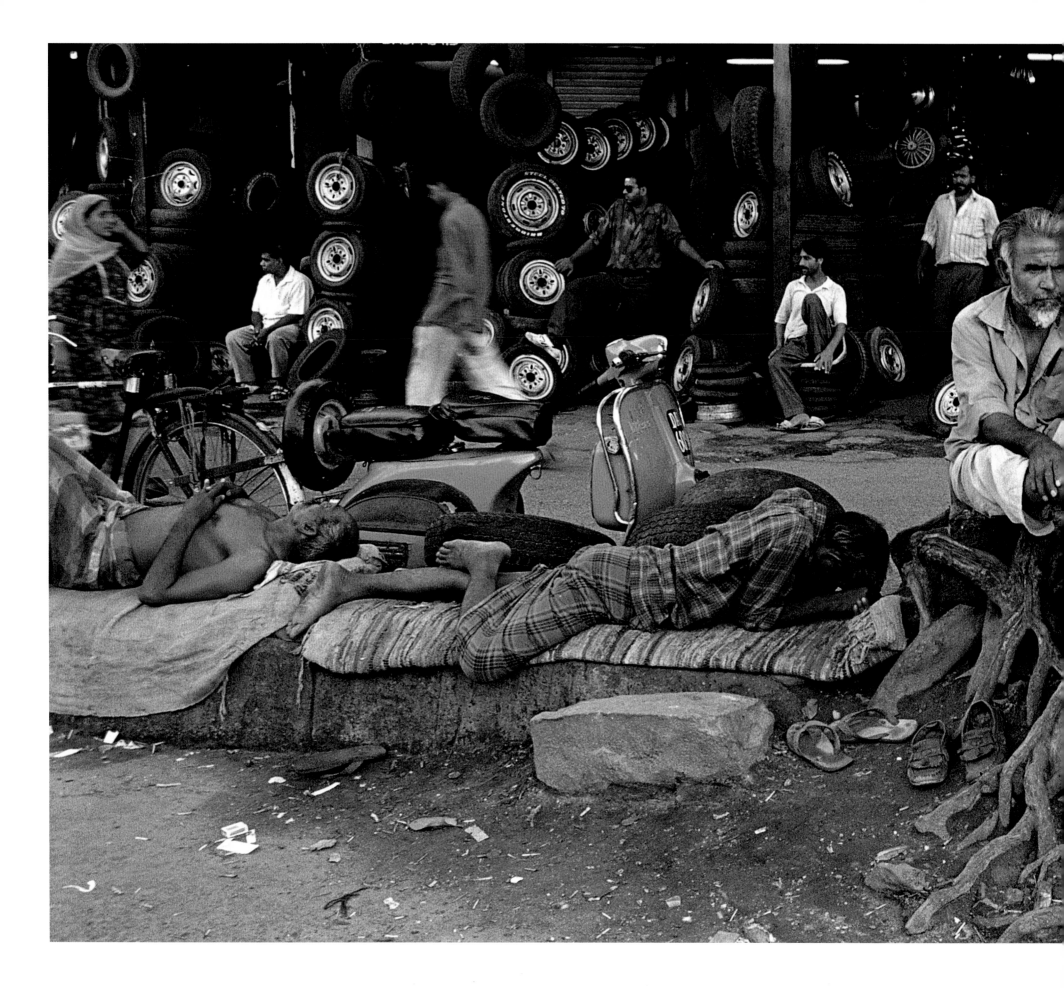

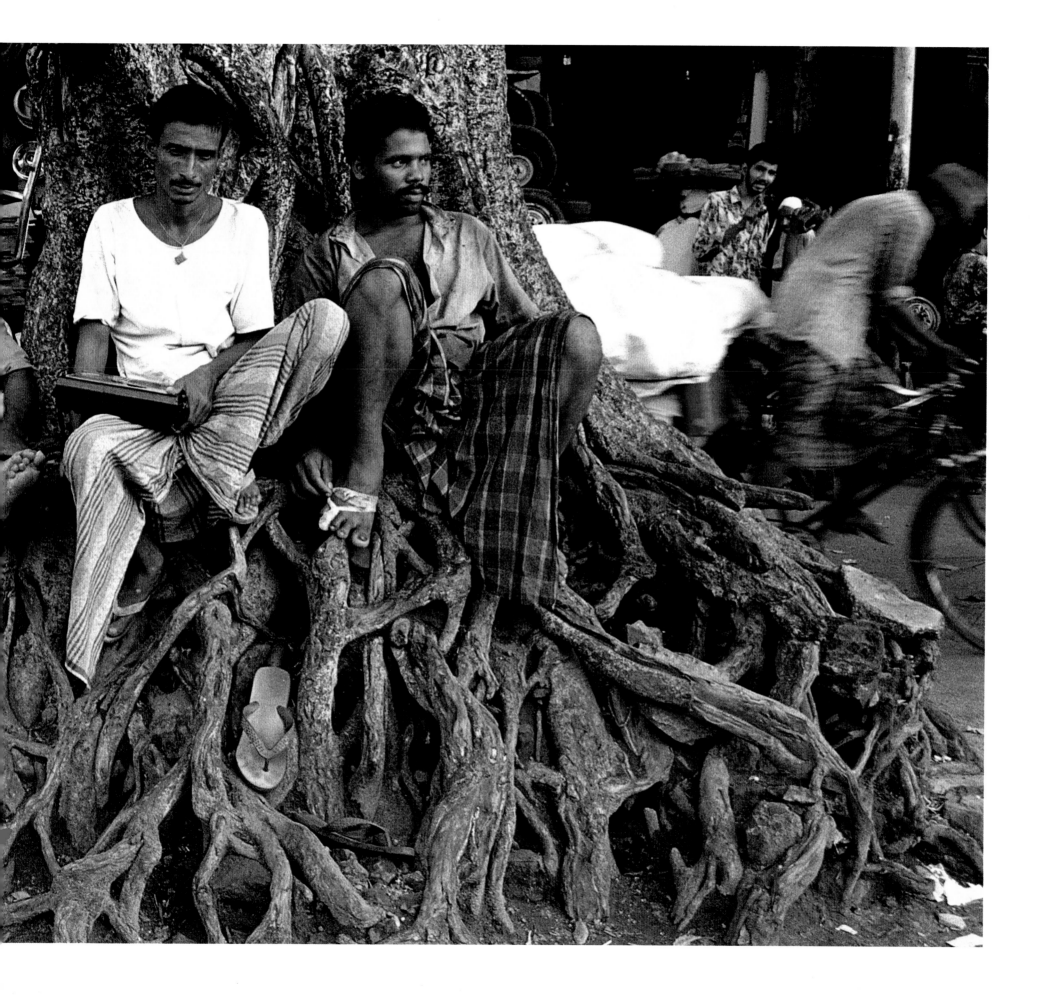

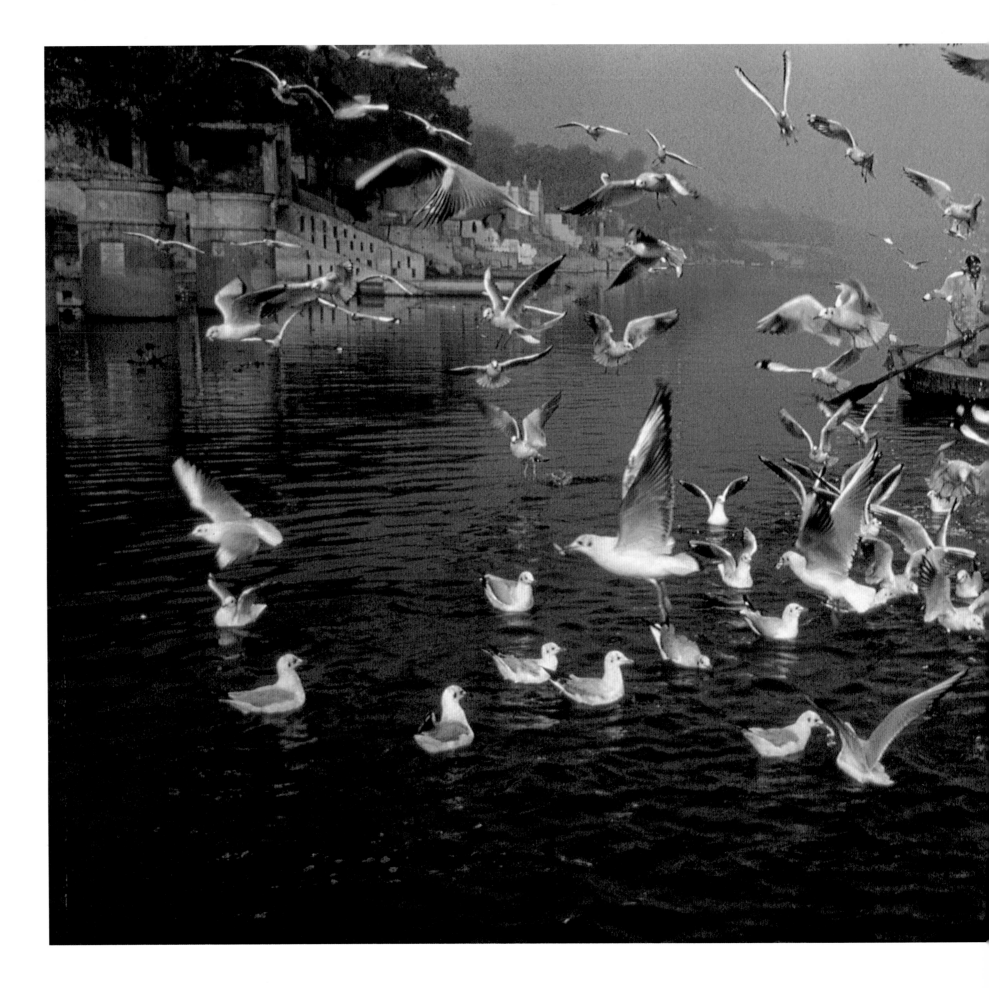

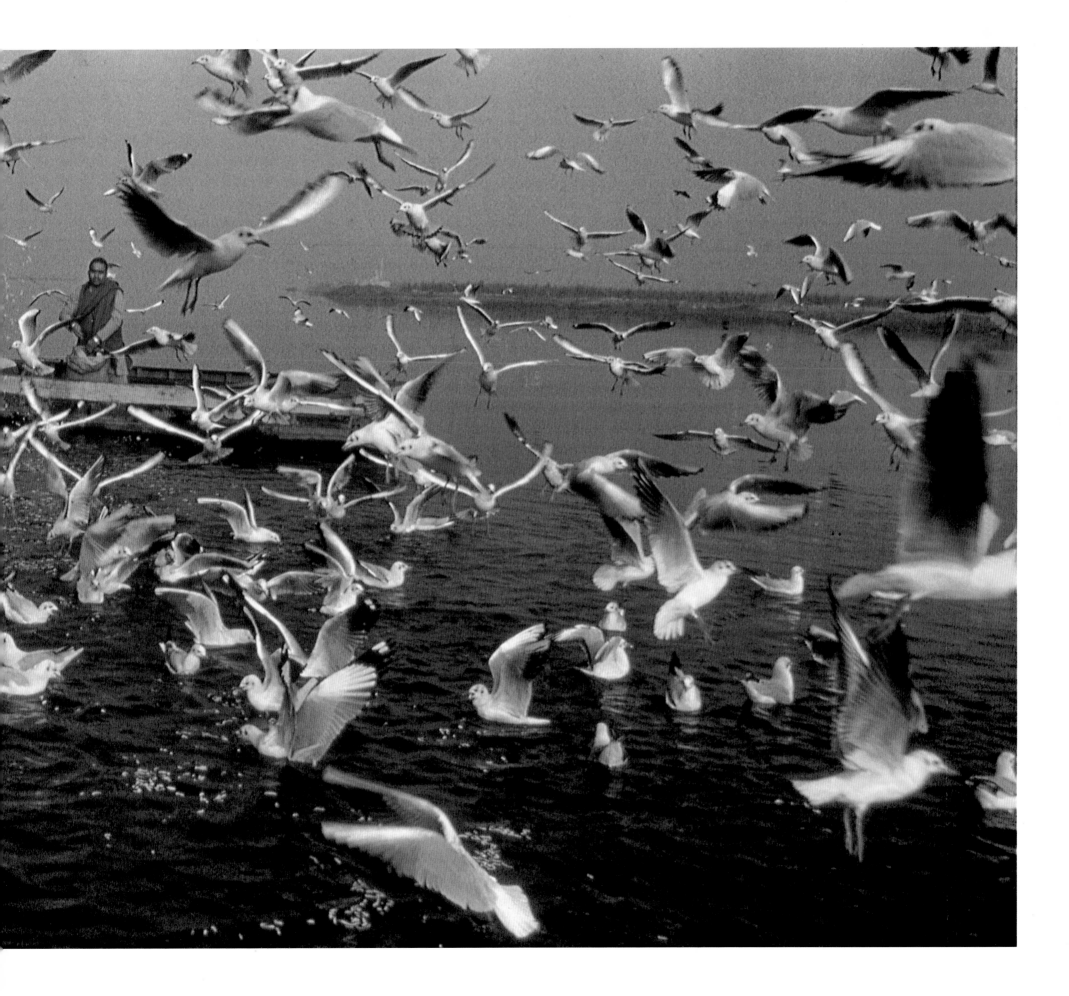

LINES ADDRESSED TO A DEVADASI

Ultimately there comes a time
When all faces look alike
All voices sound similar
And trees and lakes and mountains
Appear to bear a common signature.
It is then that you walk past your friends
And not recognise
And hear their questions but pick
No meaning out of words
It is then that your desires cease
and a homesickness begins
And you sit on the temple steps
A silent Devadasi, lovelorn
And aware of her destiny. . . .

—KAMALA DAS, 1974

Pages 138–139: Raghu Rai,
Businessman of Old Delhi
Feeding Seagulls, Delhi, 1992

Right: Raghu Rai, *Burning*
Ghat on the Banks of
the Ganga, Benares, 1992

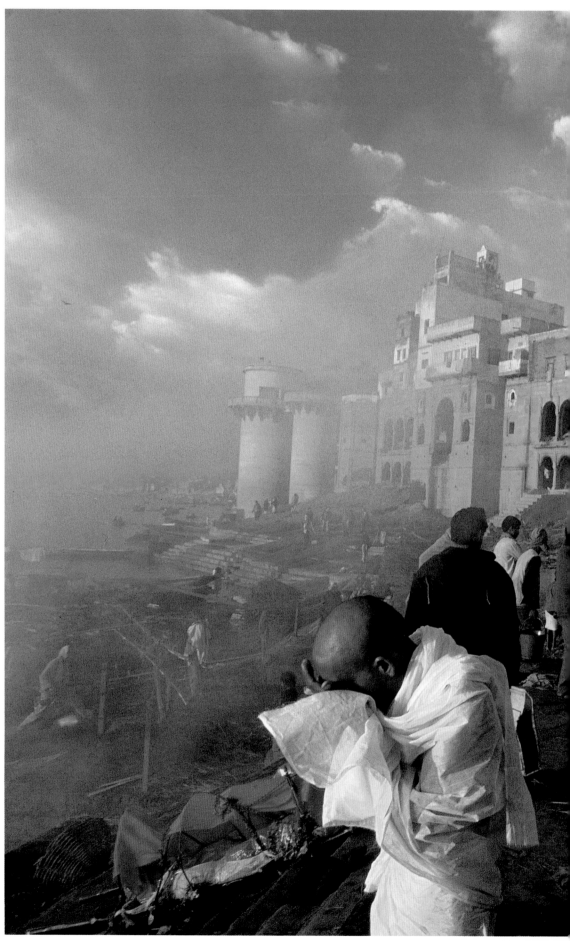

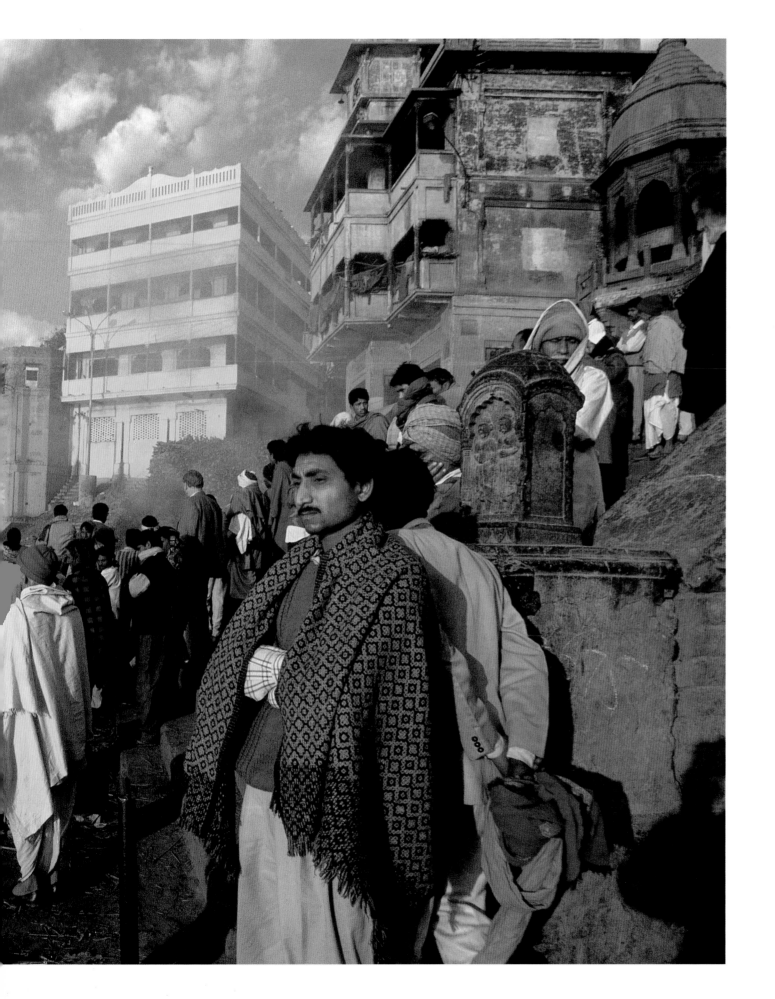

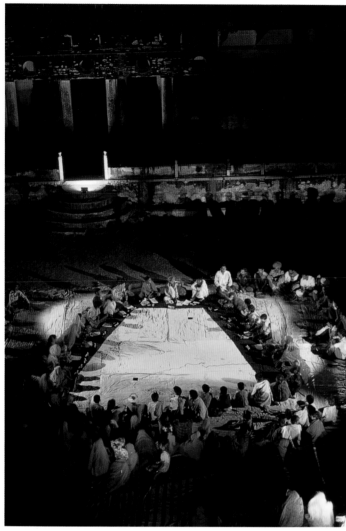

Children's Parliament session at Chota, Naraina Fort, Tilonia, Rajasthan, 1996

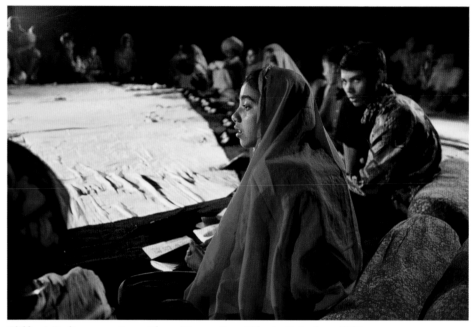

Children's Parliament session at Chota, Narama Fort, Tilonia, Rajasthan, 1996

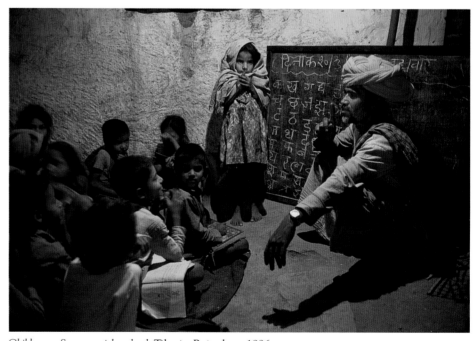

Children at Sargaon night school, Tilonia, Rajasthan, 1996

THE CHILDREN'S PARLIAMENT OF RAJASTHAN

By day, they tend their flocks. By night, the same youngsters go to school, and are transformed into members of parliament and cabinet ministers who help to govern their own society.

The "children's parliament" of Tilonia, in India's Rajasthan desert, is the first of its kind in the world. The prime minister and MP's of this extraordinary system are all shepherds and farm laborers, ages eleven to fourteen, who work in the family fields all day. Their only chance of an education is at night school—in a network of sixty village night schools run by a local volunteer organization called the Social Work and Research Center (SWRC), with support from Britain's Save the Children, which funds seventeen of the schools. Here, attending the so-called "Barefoot College," young shepherds learn to read and write, and other basic skills,

as well as studying subjects—such as animal husbandry—that are highly pertinent to their lives.

It was through these night schools that the children's parliament came about. SWRC had the notion that the best way of teaching the children about democracy and the electoral process was through experience—letting the children do it themselves. They are learning that democracy should be above gender, caste, and creed. An important lesson in Indian society.

The Prime Minister is a thirteen-year-old shepherd girl named Laxmi Devi. She has a cabinet of nine, whose portfolios range from Education and Finance to Water Resources and Women's Development. Education is particularly important, as the MP's help to run their own night schools; they make regular inspections, and are able to fire teachers whose performance is not up to par. There is also an opposition and shadow cabinet. The parliamentary civil servants are all adults, and include SWRC staff—such as Ram Lal, a former night-school pupil and teacher who is now chief advisor to the Prime Minister. The job of the civil servants is to provide the ministers with information, facts, and figures.

The SWRC has been working since 1972 with rural communities in Rajasthan to promote learning by doing, and to mobilize young Indians' power to change their own lives. As the organization's development coordinator, Teja Ram, says: "The children's parliament shows adults what children are capable of doing."

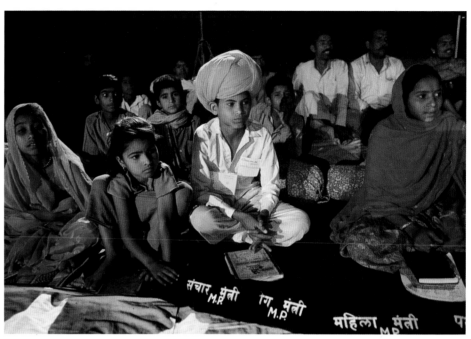

Children's Parliament session at Chota, Naraina Fort, Tilonia, Rajasthan, 1996

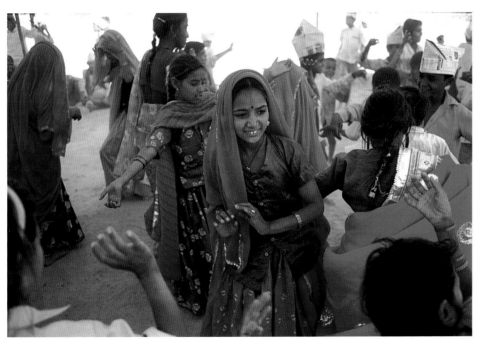

Mordikurg Mela, a three-day children's festival held once a year, Tilonia, Rajasthan, 1996

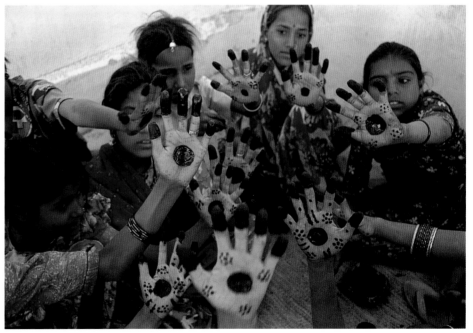

Mordikurg Mela, a three-day children's festival held once a year, Tilonia, Rajasthan, 1996

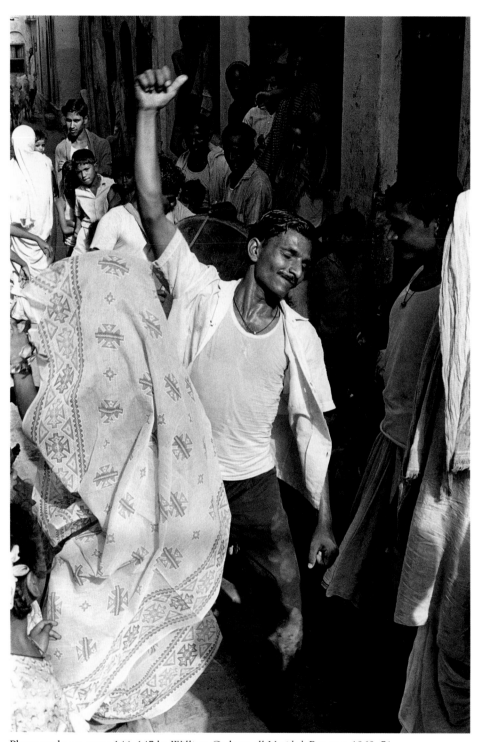

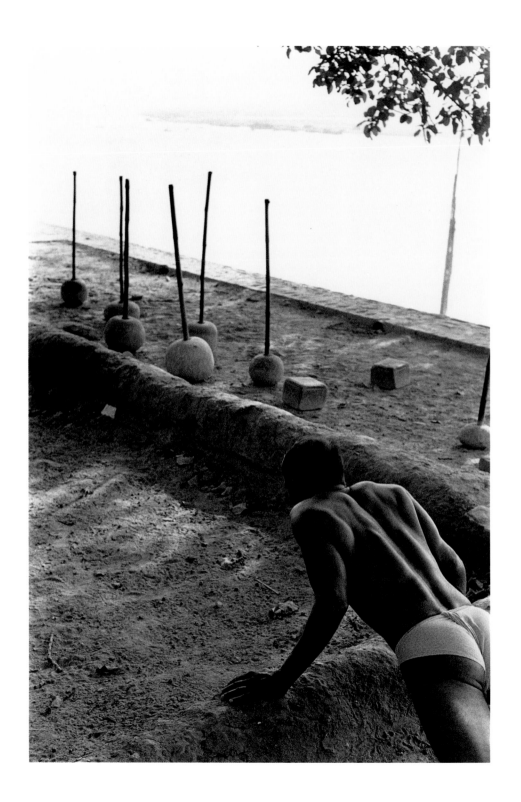

Photographs on pages 144–147 by William Gedney, all *Untitled*, Benares, 1969–71

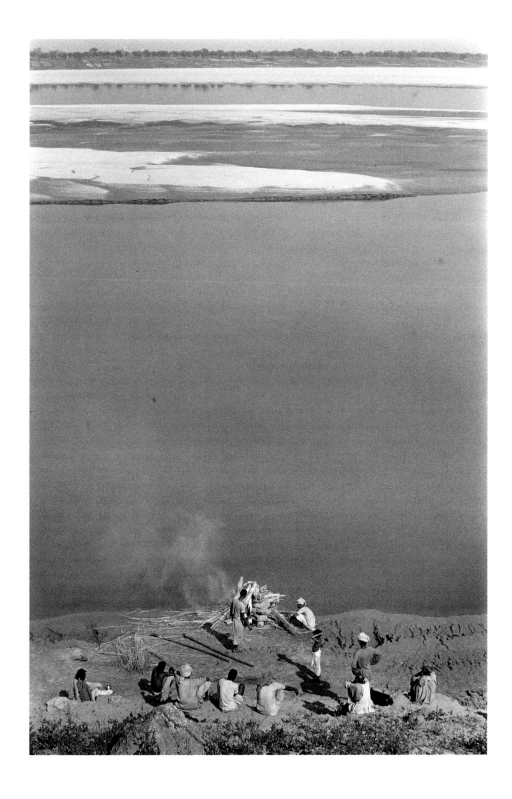

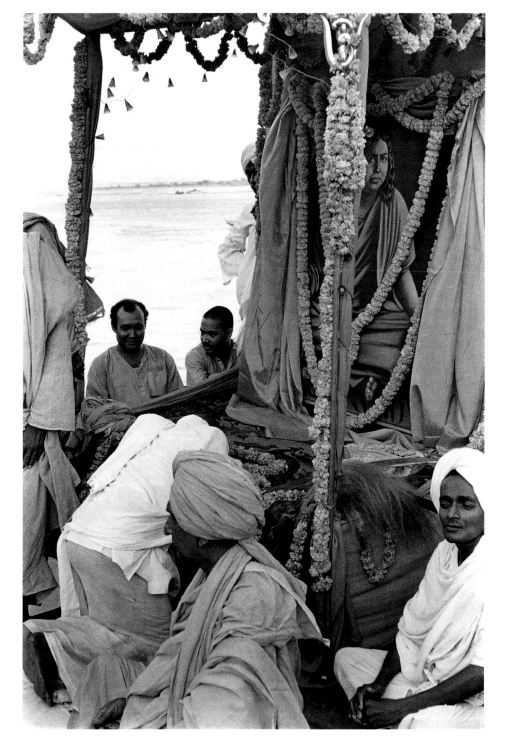

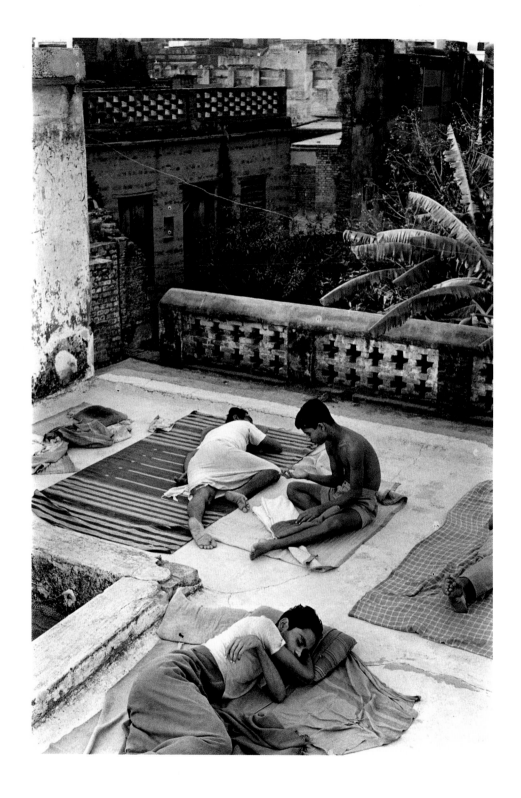
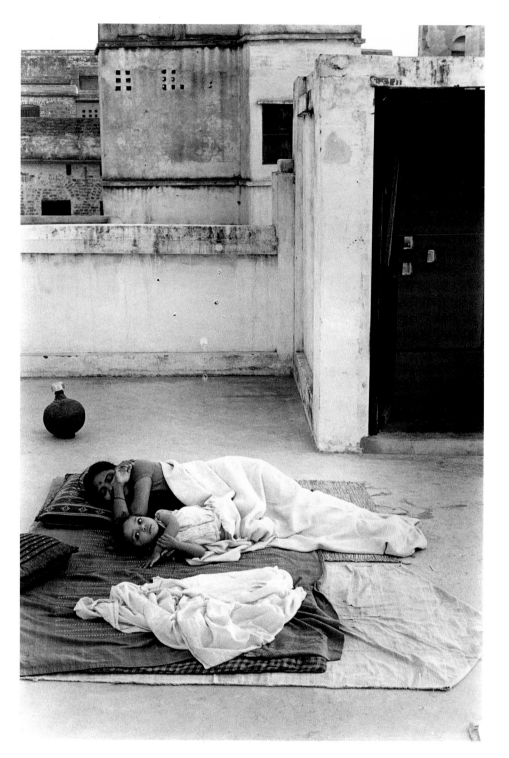

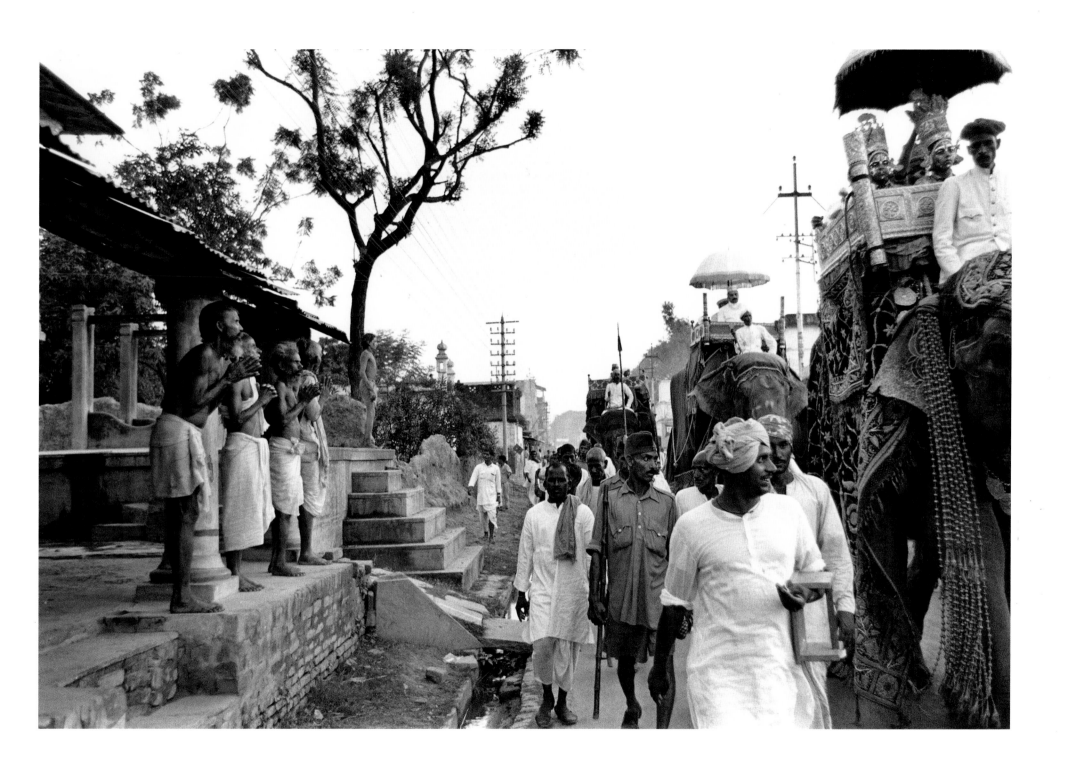

The images in the following pages tell stories of two very different Indian families. Baba Balkar Singh, a former terrorist, has created a "family" and home for relatives of Punjabi antinationalist terrorists who have disappeared or been killed. And Prem Kuwar and Kamal Singh, both seven years old, live in a world where the ancient tradition of child-marriage is still practiced, although today's Indian laws forbid it.

Baba's Story:

For more than a decade, the Sikh separatists in the northern state of Punjab were demanding autonomy for their land by resorting to terrorism. Much blood flowed; thousands of families lost their loved ones, scores of lives were ruined—on both sides of the fight. Many terrorists were tortured or killed by the police. If they were at large, their wives and families were tortured by the police in an effort to extract information on their whereabouts. The children of these terrorists, driven by a desire for revenge, were often lured into the separatist movement.

Sixteen-year-old Amarjit Singh, whose father was killed by the police, says: "Sometimes I feel like killing these police who did this to my father and us." Traumatic experiences such as Amarjit's led many such children to take up arms and join the antinationalist movement.

"Baba" Balkar Singh seeks out and gives shelter to children like Amarjit Singh, hoping to help them create a new meaning and direction in their lives. Baba's story is an unusual one: he began as a terrorist himself, with the Babbar Khalso terrorist group. Now a reformed man, he has started a home for the widows and orphaned children of terrorists, in the small town of Anandpur Sahib. Baba provides the children with food, education, and care-taking. He also provides shelter to families, and to women who have been brutally tortured for information about their militant husbands and relatives.

As these people live here and share their personal losses, they discover a new strength and hope in their torn lives. This is a world where their wounds can heal—although slowly. "Thanks to Baba," says Labhkaur, the mother of an at-large terrorist, "we now eat and drink and lead a peaceful life, instead of being on the run all the time."

Prem and Kamal's Story:

Today, the Gujjars of Madhya Pradesh, as well as a few other communities in rural India, carry on the tradition of arranging marriages for young children, despite a government ban on these unions. Kamal Singh and Prem Kuwar, both seven years old, are one couple whose lives were so arranged.

The marriage rituals in Madhya Pradesh are generally spread out over a period of nine days. It is, of course, impossible to know what went on inside the young minds of Kamal, the groom, and his bride Prem as they were prepared for their wedding day. But the face of the little girl was a landscape of questions she would never have the chance to ask, and Kamal revealed an ordinary boyish curiosity and boredom. Through the nine days of rituals, alternating between their roles as children and as adults, these two children did not seem to suspect that a central element of their fates was soon to be sealed.

—SWAPAN PAREKH

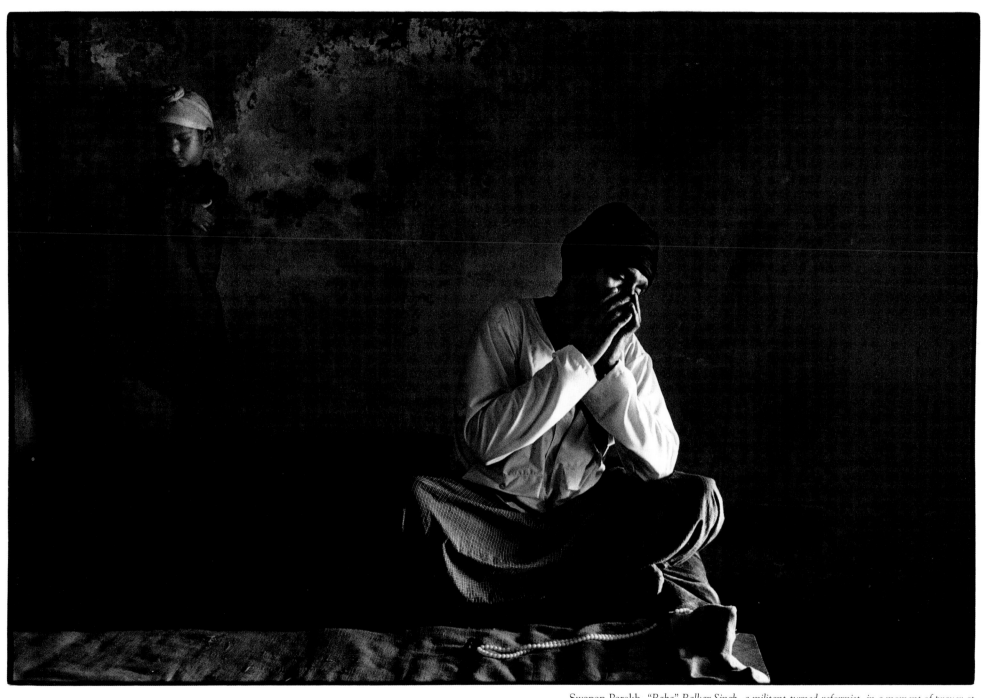

Swapan Parekh, *"Baba" Balkar Singh, a militant-turned-reformist, in a moment of prayer at his home for the families of terrorists,* Anandpur Sahib, Punjab, 1995

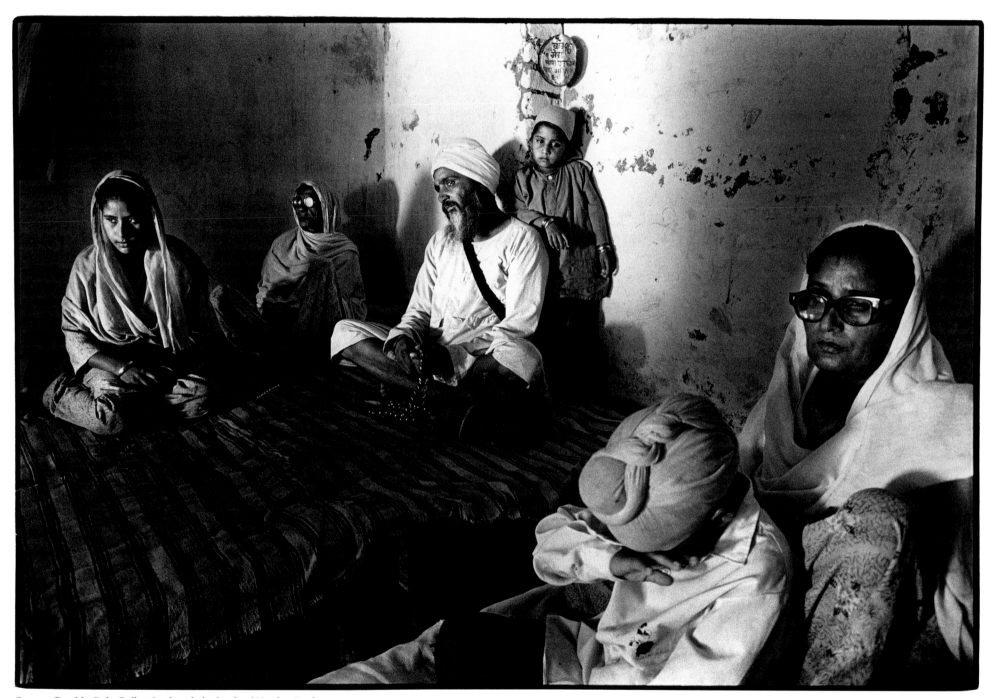

Swapan Parekh, *Baba Balkar Singh with the family of Kundan Singh, a terrorist
who was killed in the army's 1984 "Operation Bluestar," when it stormed the holiest
of Sikh shrines in Amritsar to flush out hiding terrorists, 1995*

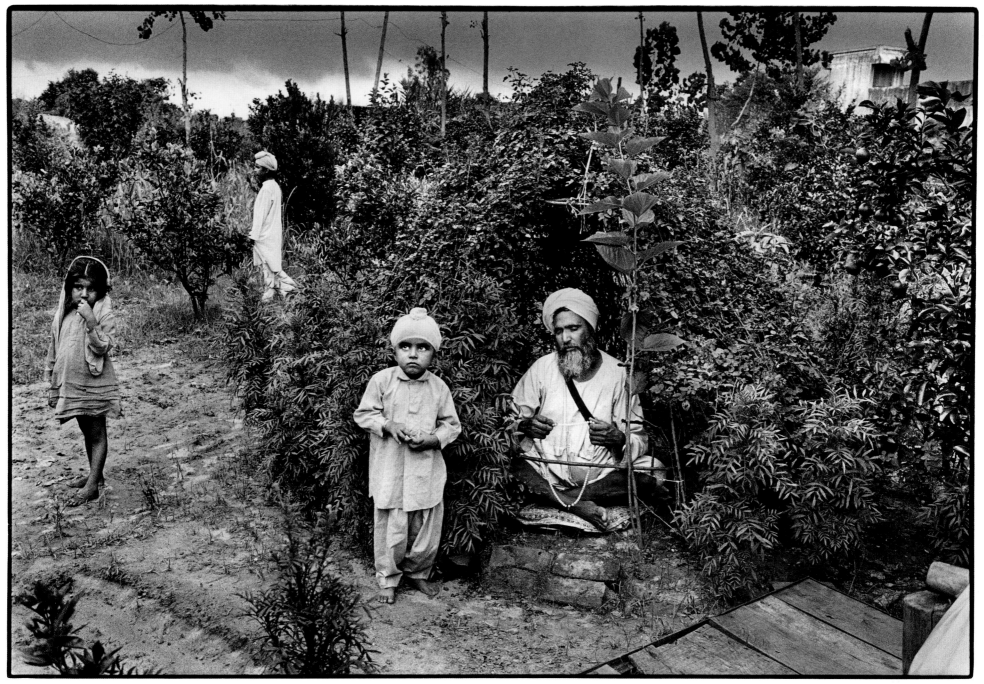

Swapan Parekh, *Baba sitting in a meditation-hut created in the bushes of his garden*, 1995

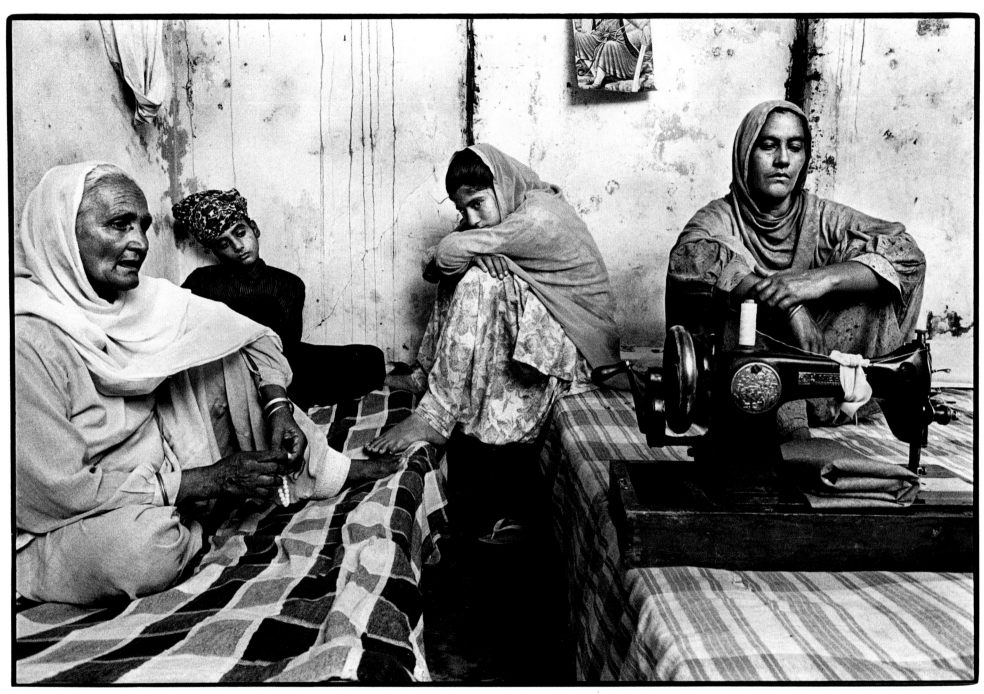

Swapan Parekh, *The family of Zarnail Singh Satrana, one of the most notorious terrorists in Punjab, who is still at large after more than four years and carries a reward of $75,000 on his head. His family was severely tortured, and the children were incarcerated for six months. Baba Balkar Singh was instrumental in their release, 1995*

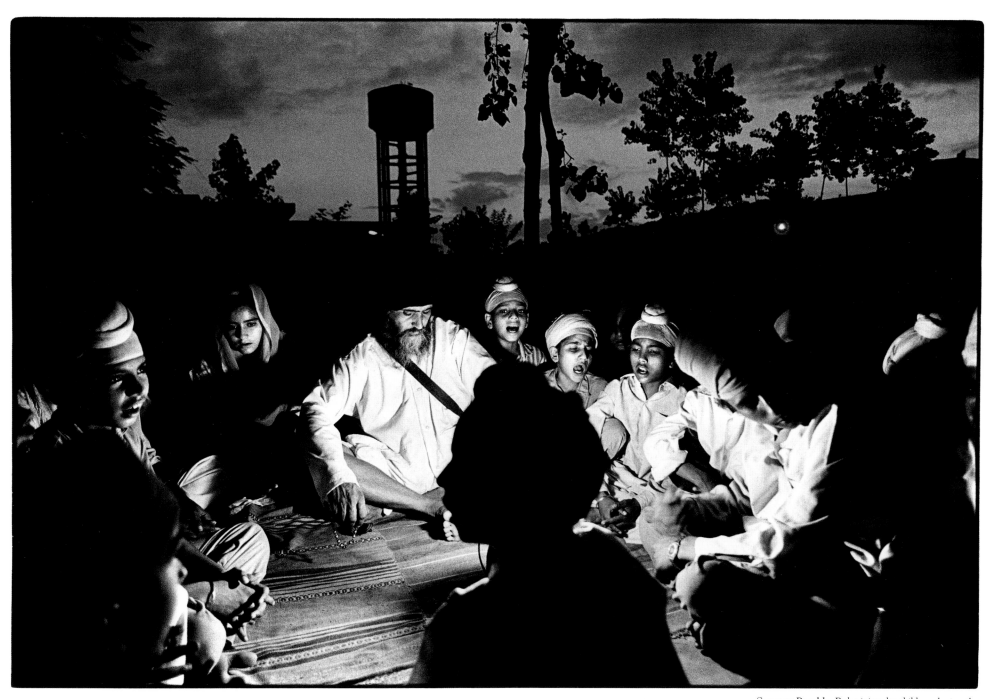

Swapan Parekh, *Baba joins the children during the evening* kirtans, *or recitation of hymns,* 1995

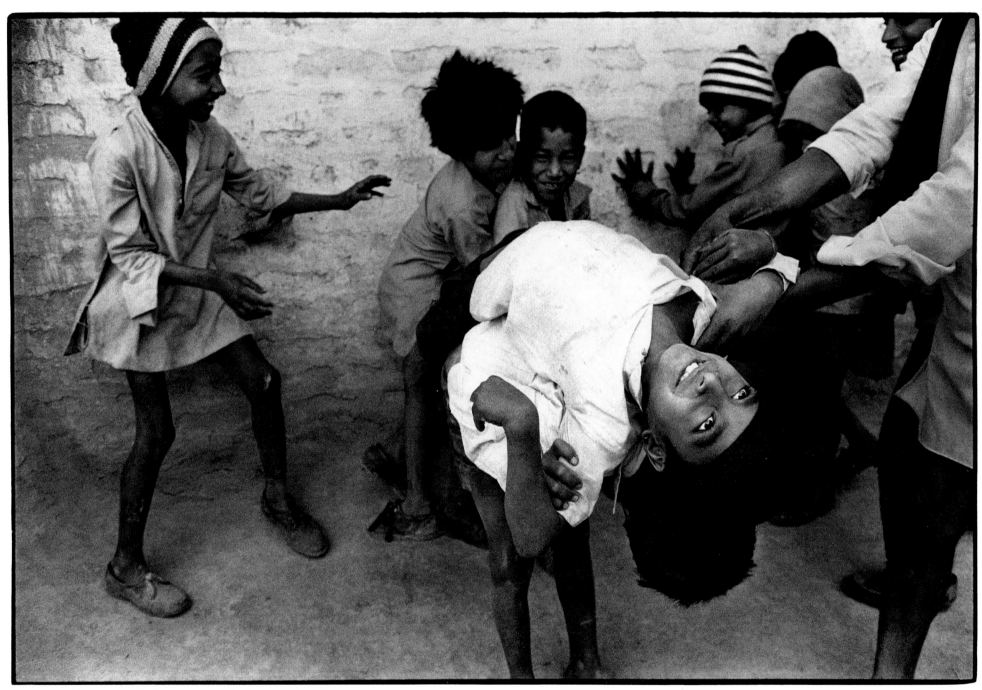

Swapan Parekh, *Kamal Singh, the seven-year-old bridegroom-to-be, takes a moment off from his wedding rituals to play with his friends*, 1990

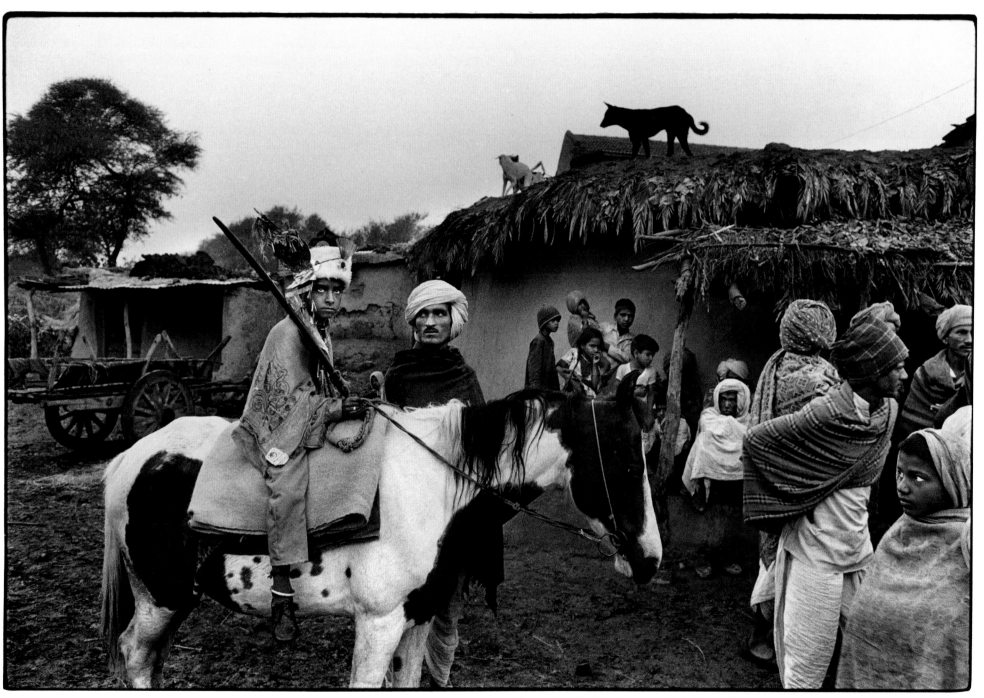

Swapan Parekh, *Kamal arrives with the baraat (the procession from the bridegroom's village to the bride's village). The wedding ceremony takes place in village of the seven-year-old bride, Prem Kuwar. The couple will walk around a small pyre seven times accompanied by the chanting of religious hymns. This is the first time that the children will see one another. After this they are man and wife.* 1990

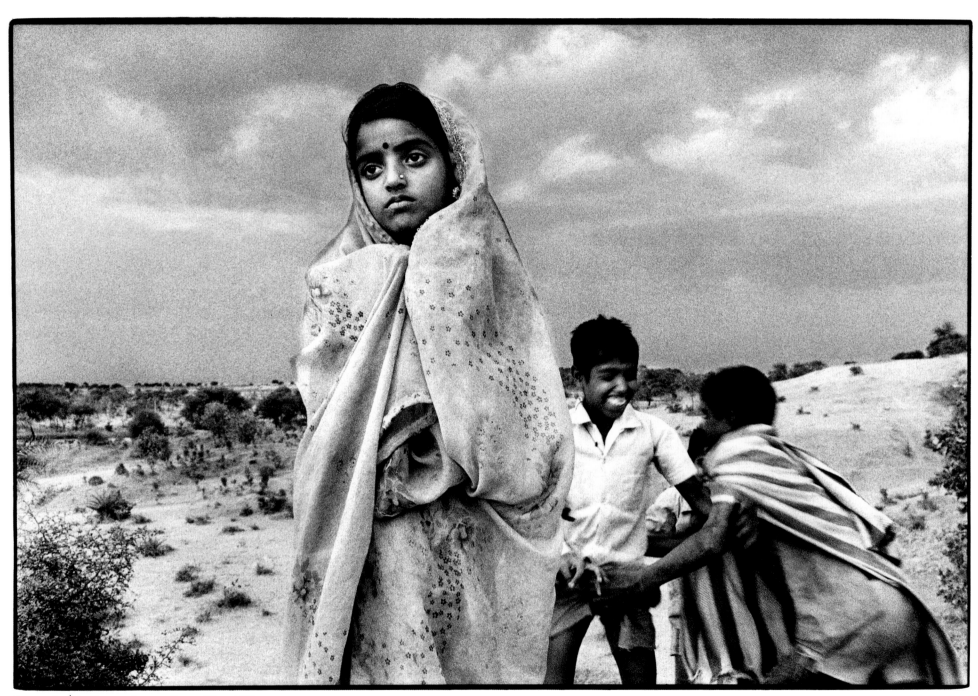

Swapan Parekh, *Prem on the eve of her wedding*, 1990

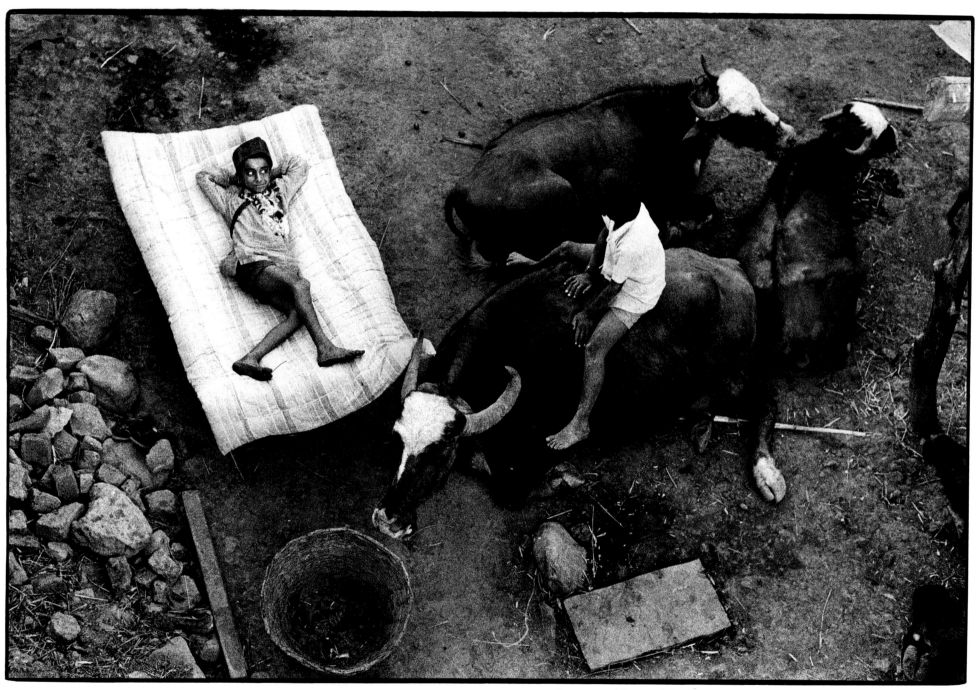

Swapan Parekh, *Kamal, dressed in his wedding outfit, relaxes in the portico of his house*, 1990

Although I have traveled and photographed in many parts of India (among them Orissa, Kulu, Darjeeling, Varanasi, Madurai, and Rajasthan), I have spent the most time in Calcutta, where I stayed for many months at the Bengal Chambers, a fourth-floor pension in a big old apartment building off Park Street. In Calcutta, they told me that every Bengali child dreams of becoming a poet. So I decided to seek out and photograph some of the creators—poets, musicians, actors, sculptors, painters, and filmmakers—to draw from their energy and to understand another aspect of a city known for its agonies. That is how I came to ring up Satyajit Ray— legendary, internationally recognized renaissance man, celebrated filmmaker, author, and composer. He answered the call himself, and told me that if I would come early the next morning, I could photograph him, but after that he would be unavailable for weeks as he was editing his new film. On my second day in Calcutta, I walked through his doorway, feeling unprepared to make a portrait of this extraordinary artist. But there I was, camera in hand, facing my hero. Soon after, I visited Santiniketan, where the philosopher and poet Rabindranath Tagore lived, wrote, and founded a school.

For three years, I arrived in Calcutta just before the festival season, which begins with the Hindu observance of Durga Puja. Every day I visited two sculptors' communities at opposite ends of the city. There I observed family life and photographed people as they crafted statues made of bamboo, mud, and straw. I learned about Hinduism and the *shakti* of goddesses Durga and Kali, as I documented the festivals. The religious imagery assumed a prime place in my visual vocabulary and the pictures I took related to those I had taken in other cultures, for I saw the various manifestations of the goddess, her attendants, and her husband Siva, as haunting and universal symbols: metaphors for female power, gender conflict, and the perpetual tension between the forces of good and evil.

—ROSALIND SOLOMON

Rosalind Solomon, *Tagore's Garden*, Santiniketan, West Bengal, 1982

159

Rosalind Solomon, *Hijra Street Dancer near the Ghats Celebrating at a Festival*, Calcutta, 1982

Rosalind Solomon, *Family near the Hoogley River during Festival*, Calcutta, 1982

Rosalind Solomon, *Woman of the Sculptors' Community of Patua Para*, Calcutta, 1982

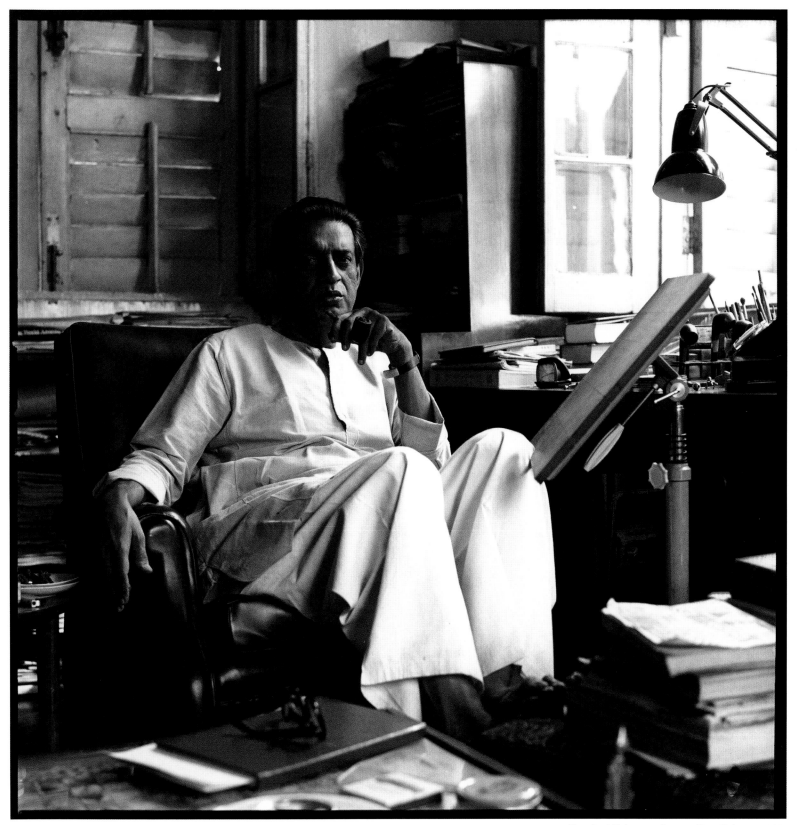

Rosalind Solomon, *Satyajit Ray*, Calcutta, 1981

These images are from a work in progress that examines the environmental dichotomy between Hindu religious respect for life and nature, and the reality of modern India. Factories, power plants, and other industrial structures appear like gigantic temples and allude to the danger inherent in industrialization. In particular the Parsi Lime Works at Katni offer a frightening irony: operated by a people who worship fire, the high sulphur coal burned to reduce the lime creates a nightmare of pollutants. Other images in the series refer to the trophy-hunting slaughter in the period of the Raj, and the inevitable demise of both species and India's once-great forests.

—CHARLES LINDSAY

Charles Lindsay, *Bridge Over the Ganges*, Varanasi, 1992

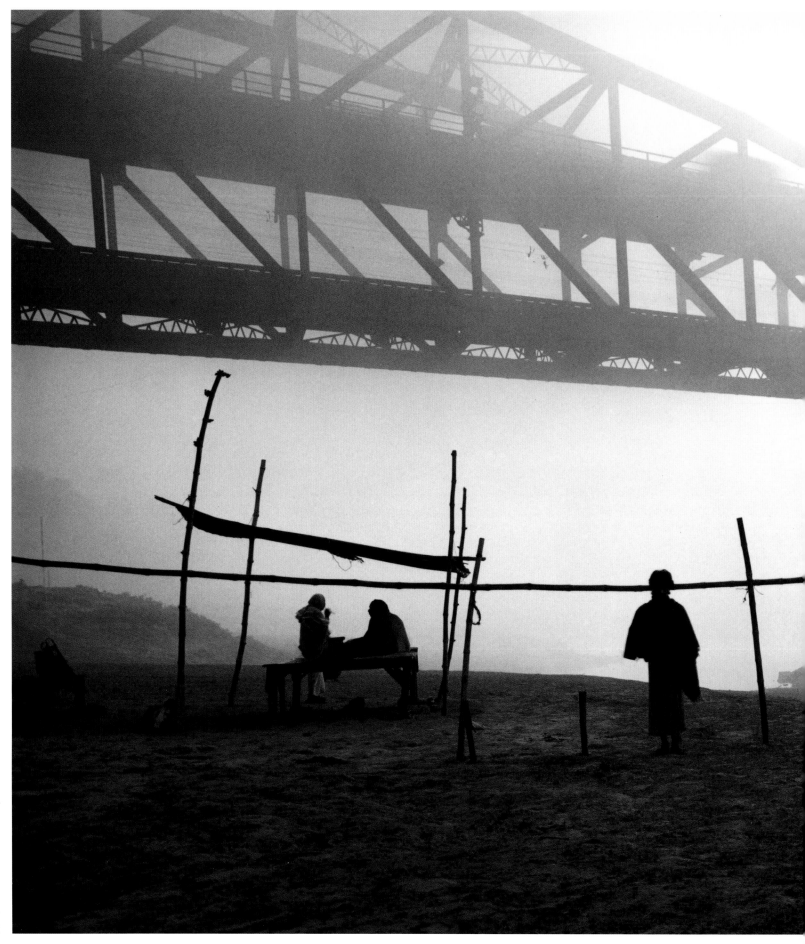

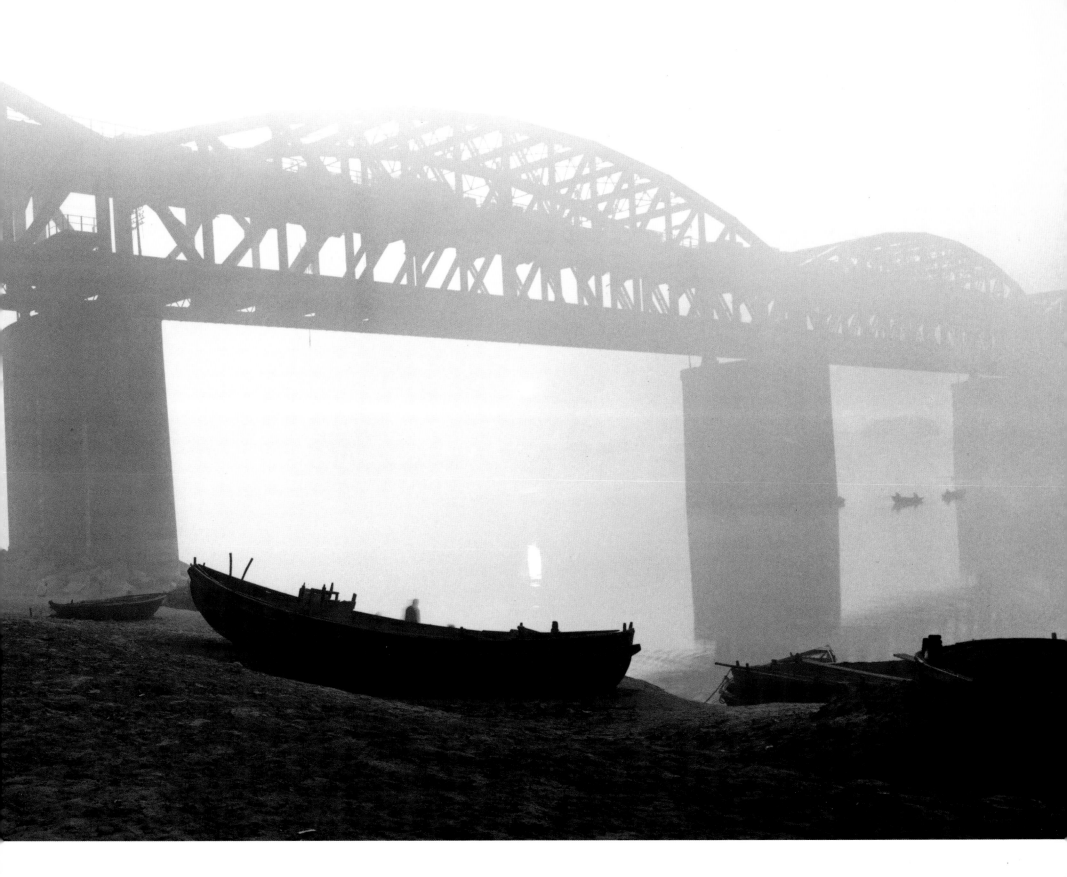

Charles Lindsay, *Parsi Lime Works*, Katni, 1992

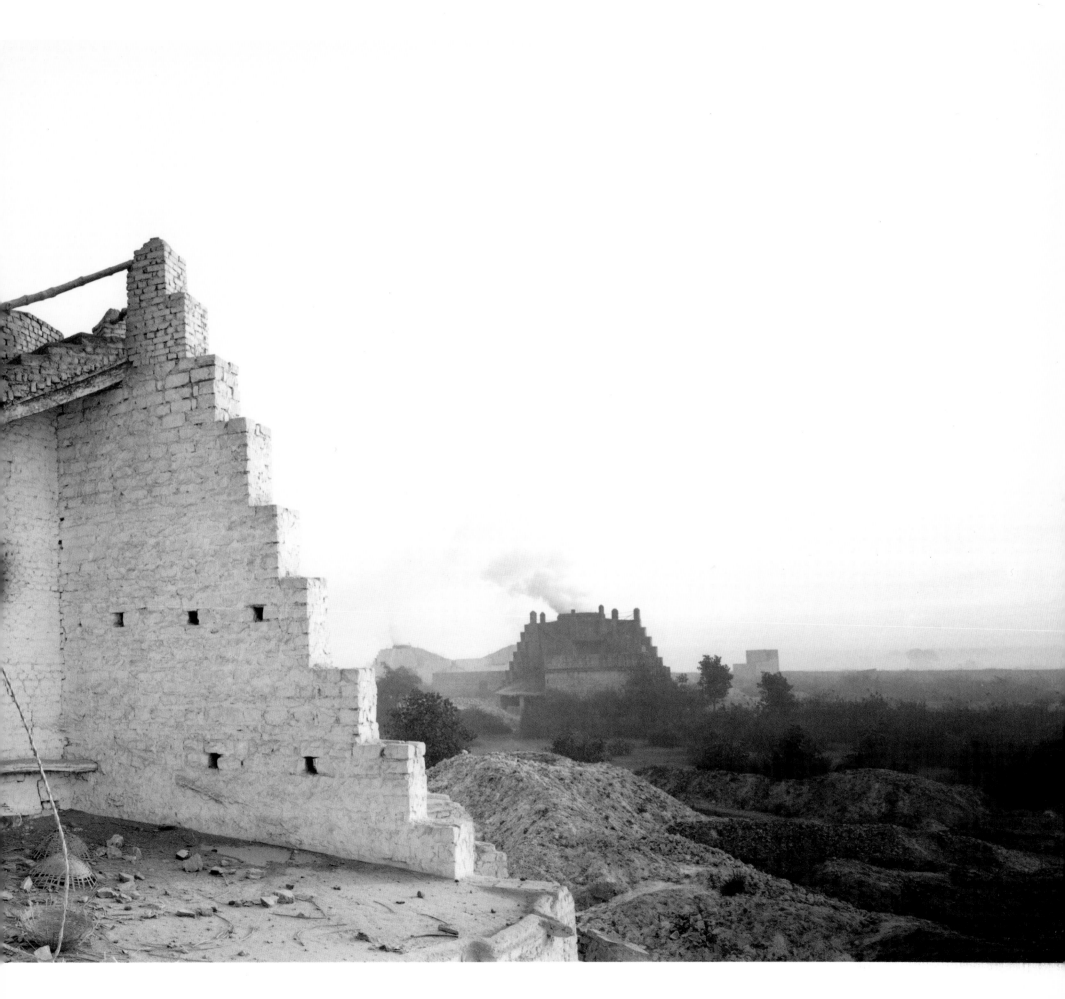

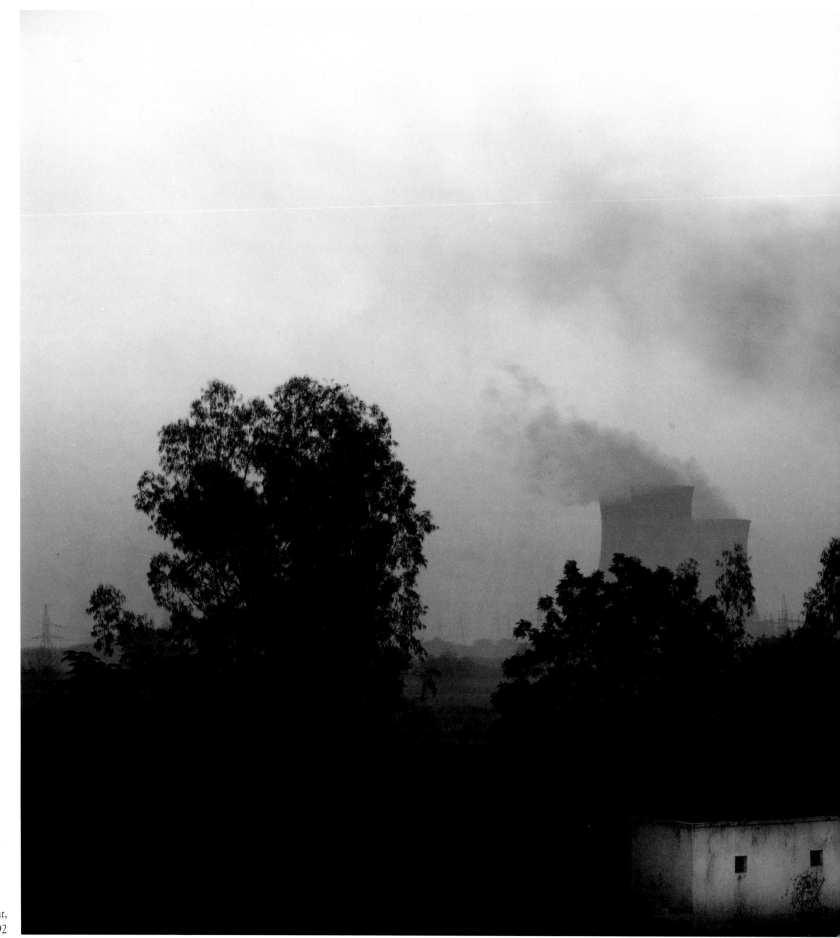

Charles Lindsay, *Power Plant*,
Andhra Pradesh, 1992

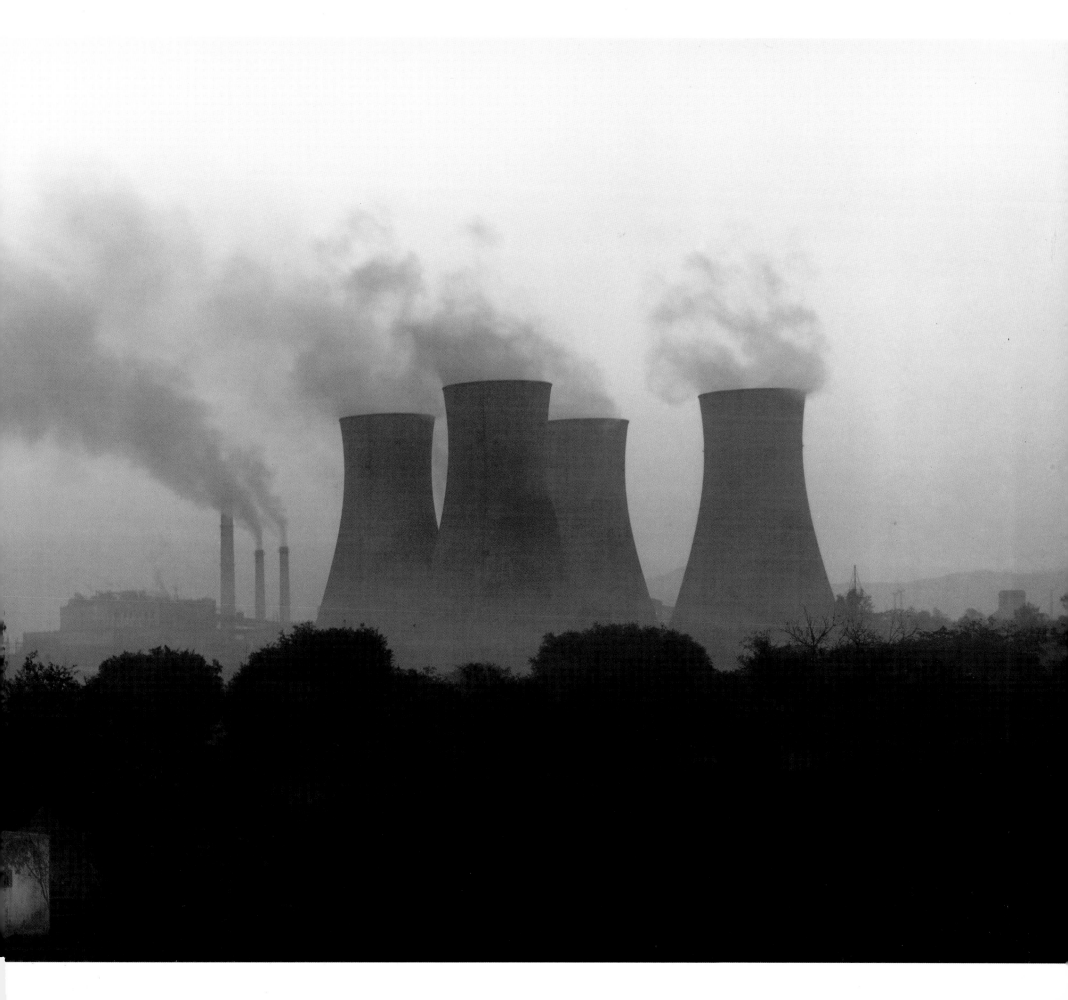

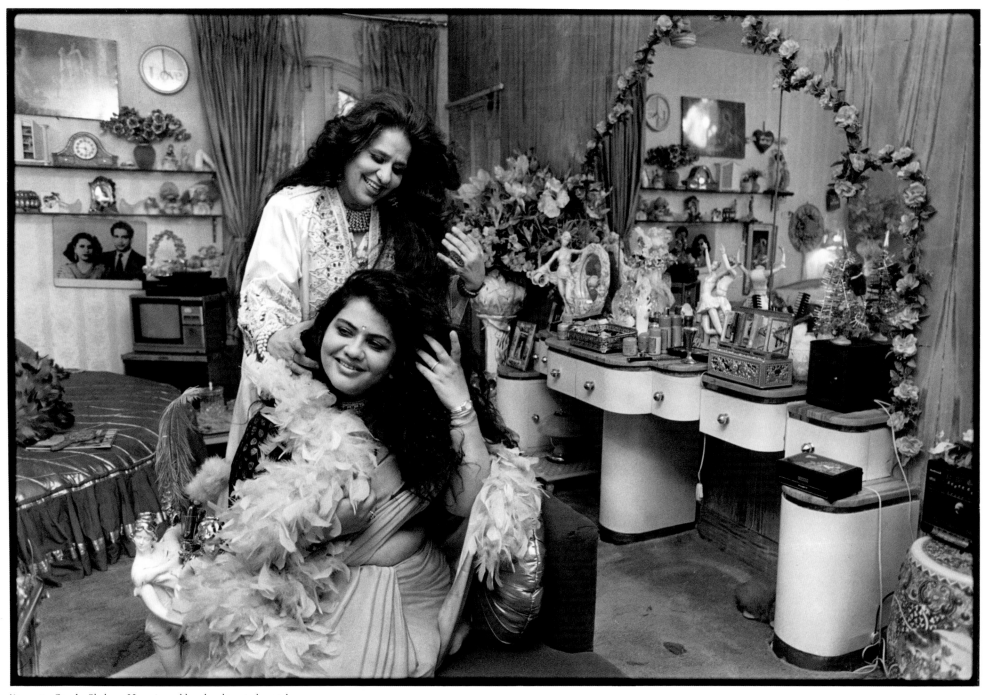

Dayanita Singh, *Shahnaz Hussain and her daughter, in her pink
siesta room inspired by Barbara Cartland*, New Delhi, 1992

I work as a documentary photographer in people's homes and in the worlds they inhabit,

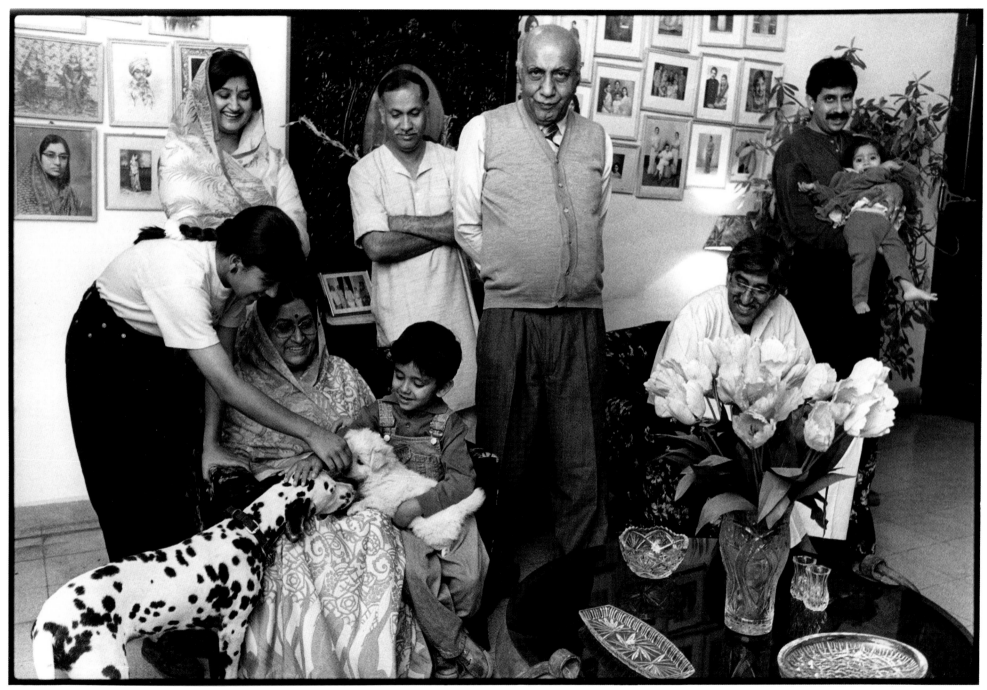

Dayanita Singh, *The Sarguja royal family at their home in Bhopal*, 1996

moving between the "reality" of photojournalism and the "fantasy" of family portraits. The photojournalism often caters to

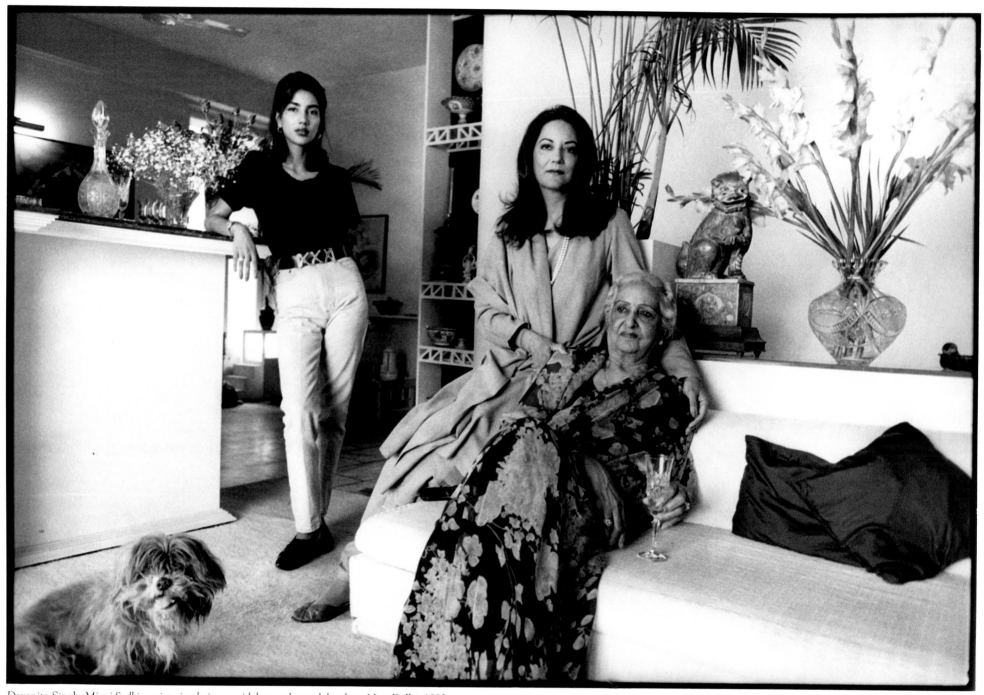

Dayanita Singh, *Minni Sodhi, an interior designer, with her mother and daughter,* New Delhi, 1992

a Western media image of exotic/disaster India. This is not the India I inhabit. My India, the "other" India,

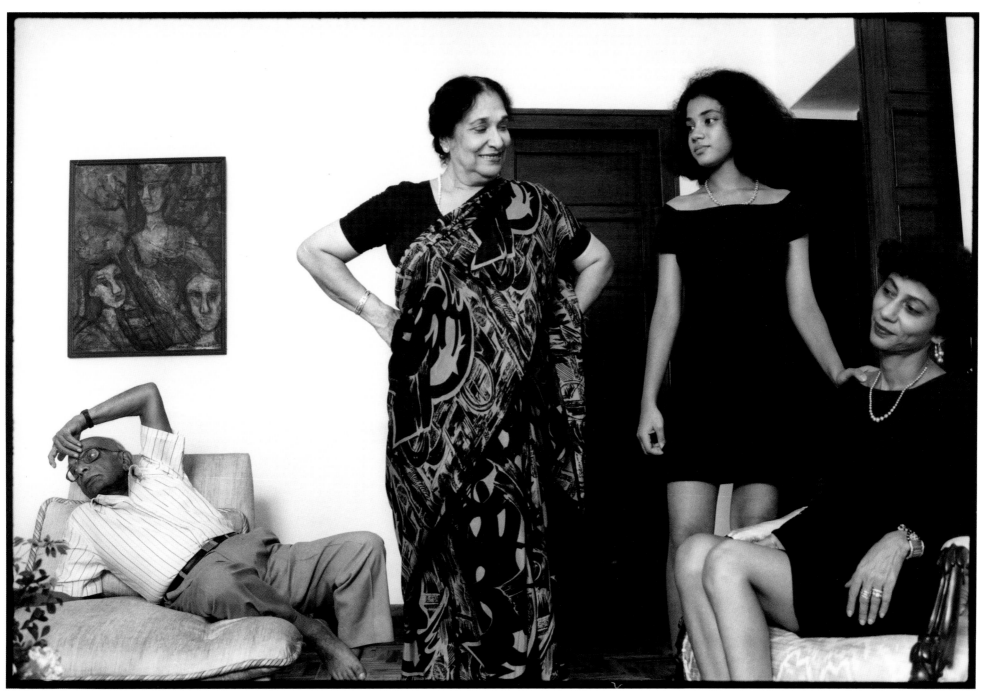

Dayanita Singh, *Doctor Chopra's parents, his wife, and his daughter at their New Delhi apartment*, 1995

seldom finds space in the international media. So I photograph my friends and my families.

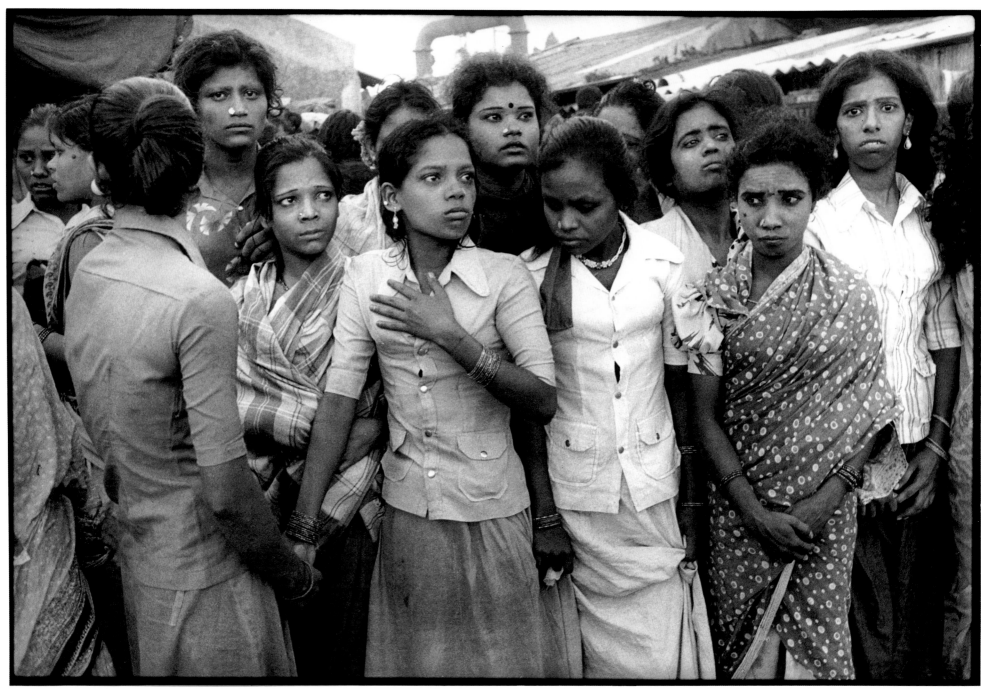

Dayanita Singh, *One thousand minor sex workers/prostitutes rescued by a social organization and the police in Bhandup*, Bombay, 1989

In my photojournalism too, I finally gravitate to the family, be it a family of eunuchs in Delhi or of riot victims. —DAYANITA SINGH

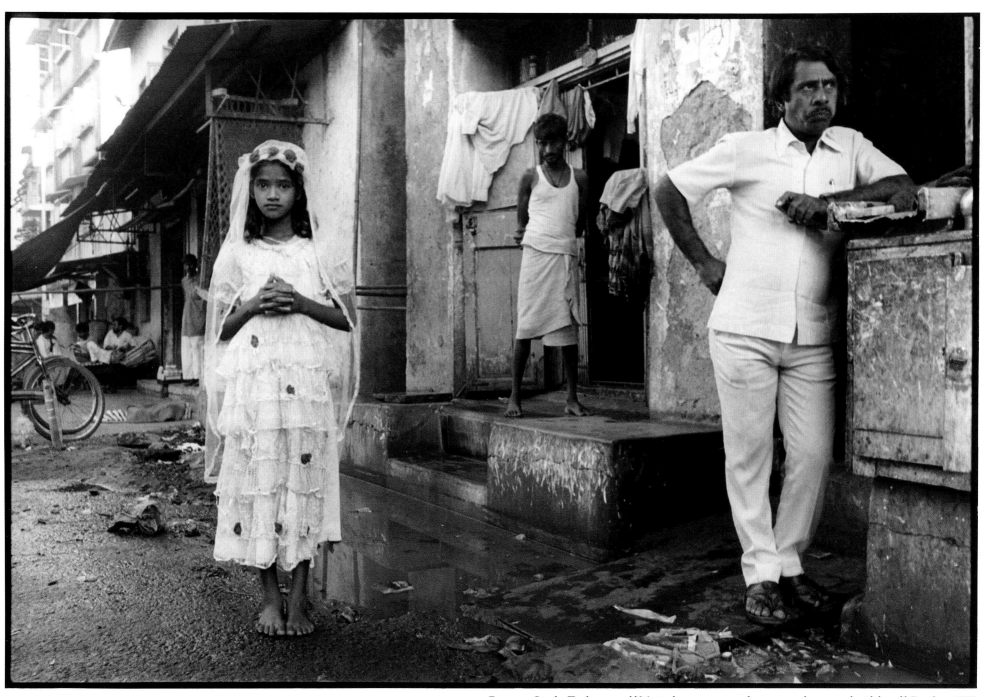

Dayanita Singh, *Twelve-year-old Marie, born to a sex worker, waits to be put on the job herself*, Bombay, 1990

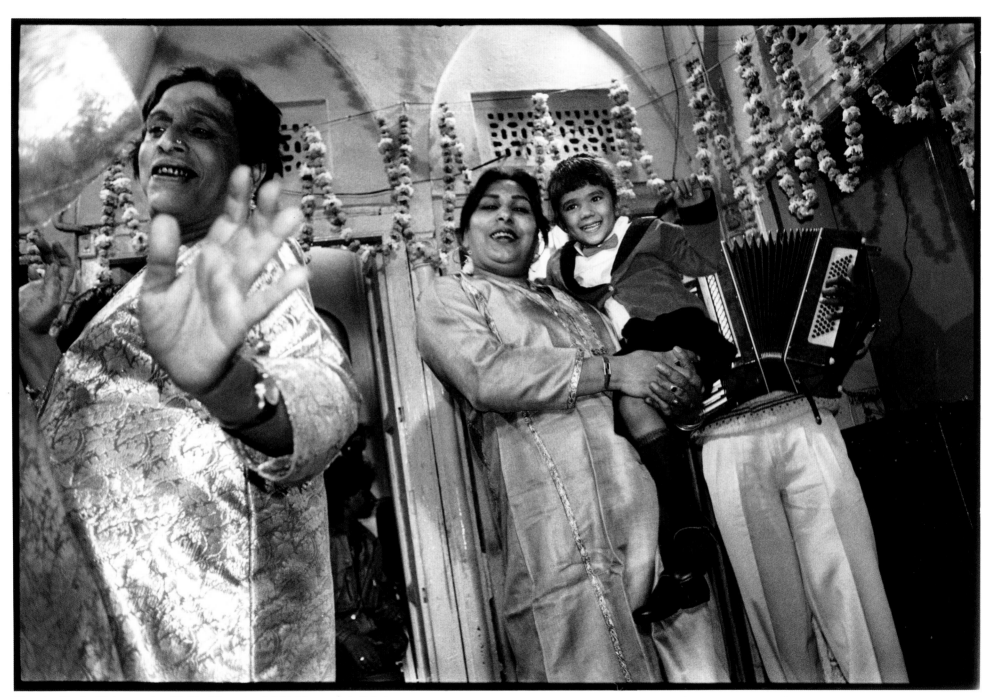

Dayanita Singh, *All the eunuchs of Delhi celebrate Ayesha's birthday over a period of three days. Ayesha was adopted at birth by the eunuch Mona Ahmed, 1993*

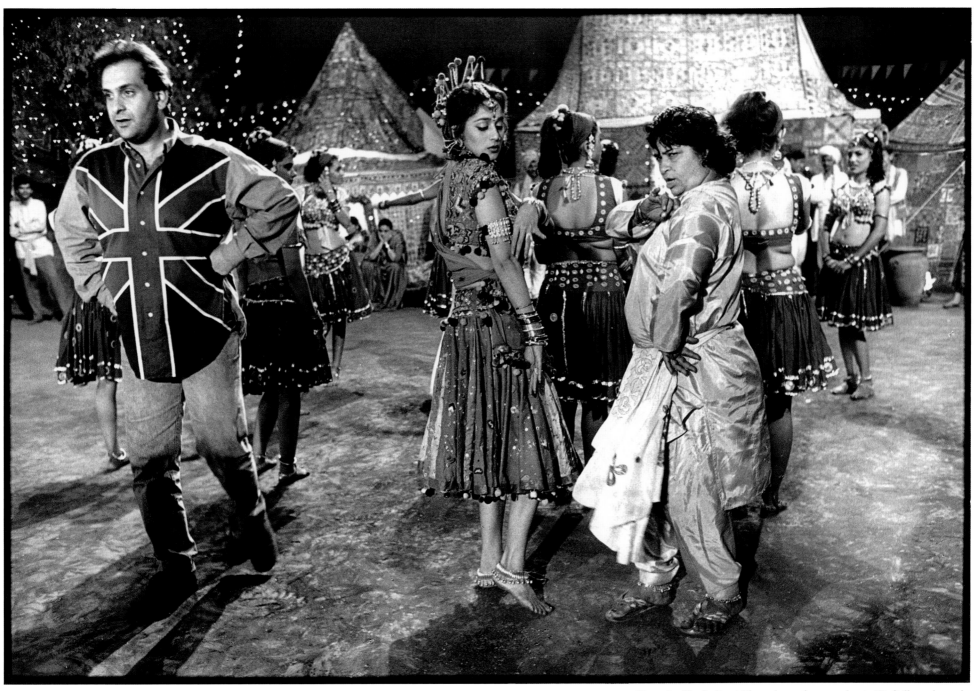

Dayanita Singh, *Saroj Khan, dance choreographer in Hindi films, shows the steps to Madhuri Dixit, heart-throb of India*, Bombay, 1993

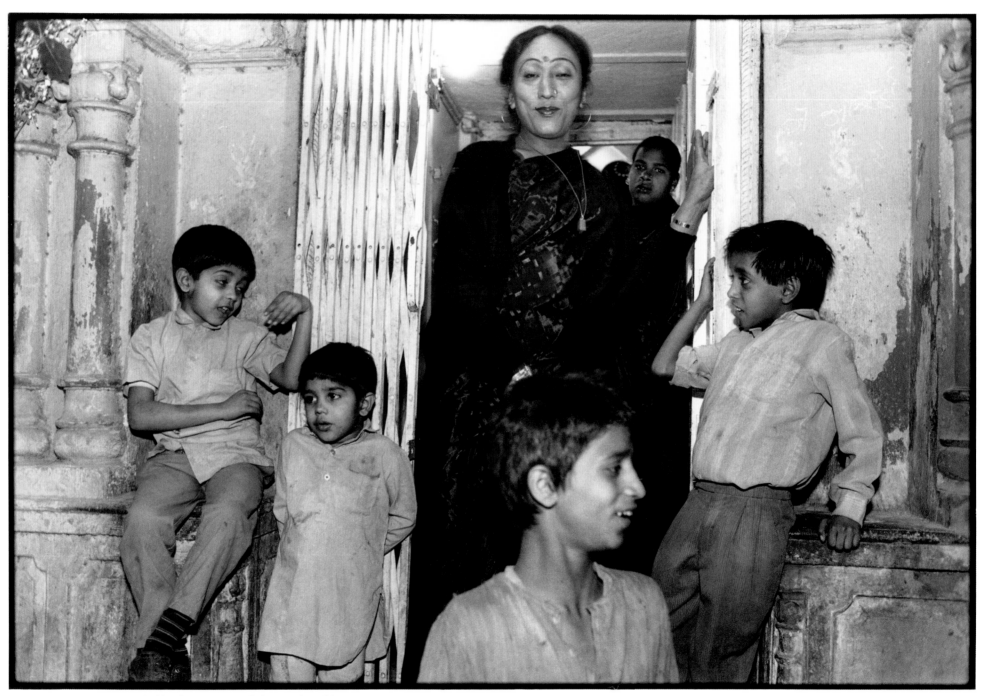

Dayanita Singh, *Street boys of Old Delhi come to watch the eunuchs' celebrations*, 1992

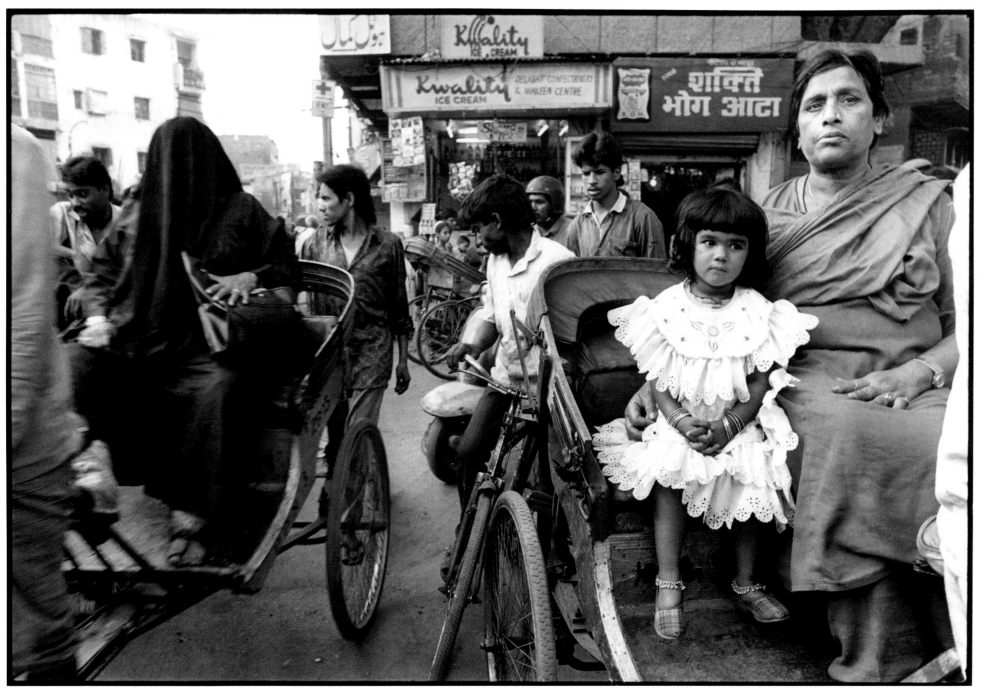

Dayanita Singh, *Mona Ahmed, a eunuch by choice, and her adopted baby girl Ayesha, in Turkman Gate*, Old Delhi, 1994

To the youth of this country I would make a special appeal for they are the leaders of tomorrow and on them will be cast the burden of upholding India's honor and freedom.

My generation is a passing one and soon we shall hand over the bright torch of India, which embodies her great and eternal spirit, to younger hands and stronger arms. May they hold it aloft, undimmed and untarnished, so that its light reaches every home and brings faith and courage and well-being to our masses.

—Jawaharlal Nehru, 1948

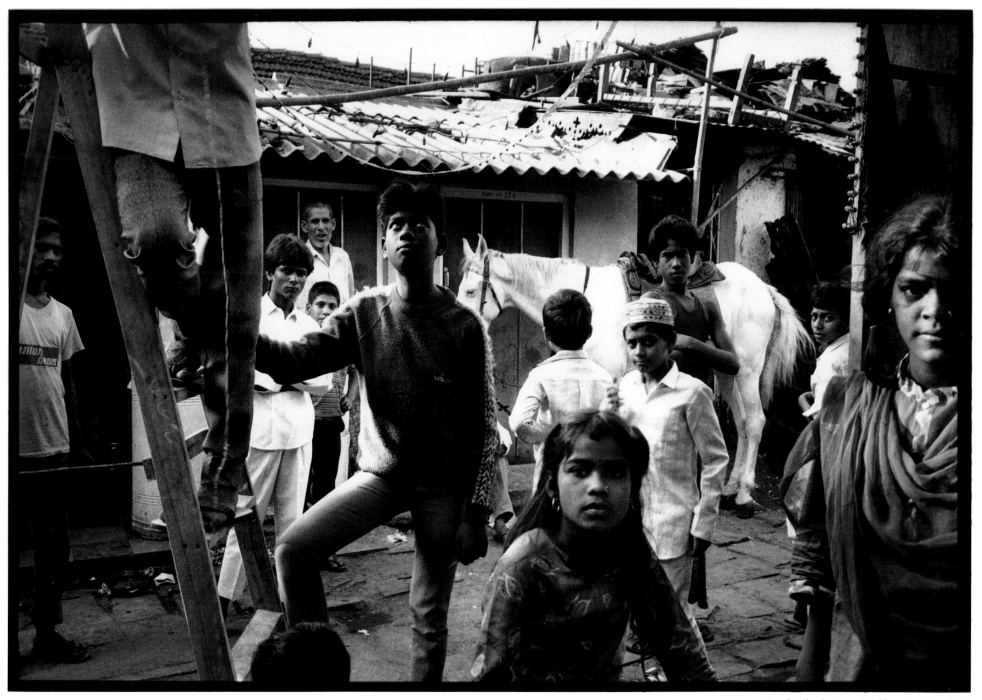

Ketaki Sheth, *Street Wedding*, Bombay, 1990

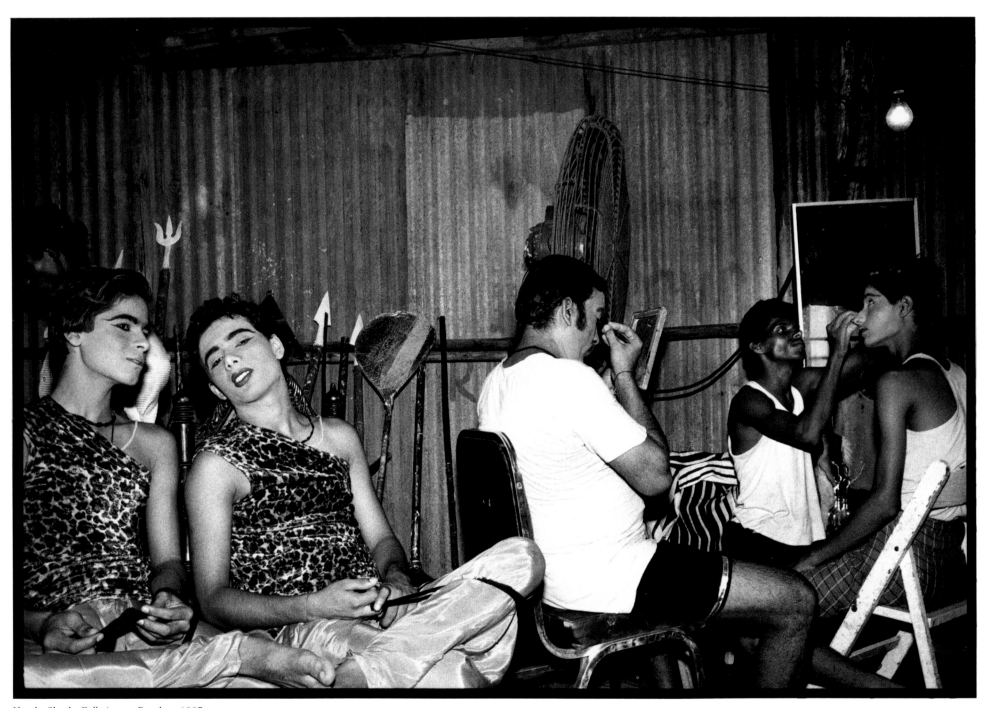

Ketaki Sheth, *Folk Actors*, Bombay, 1987

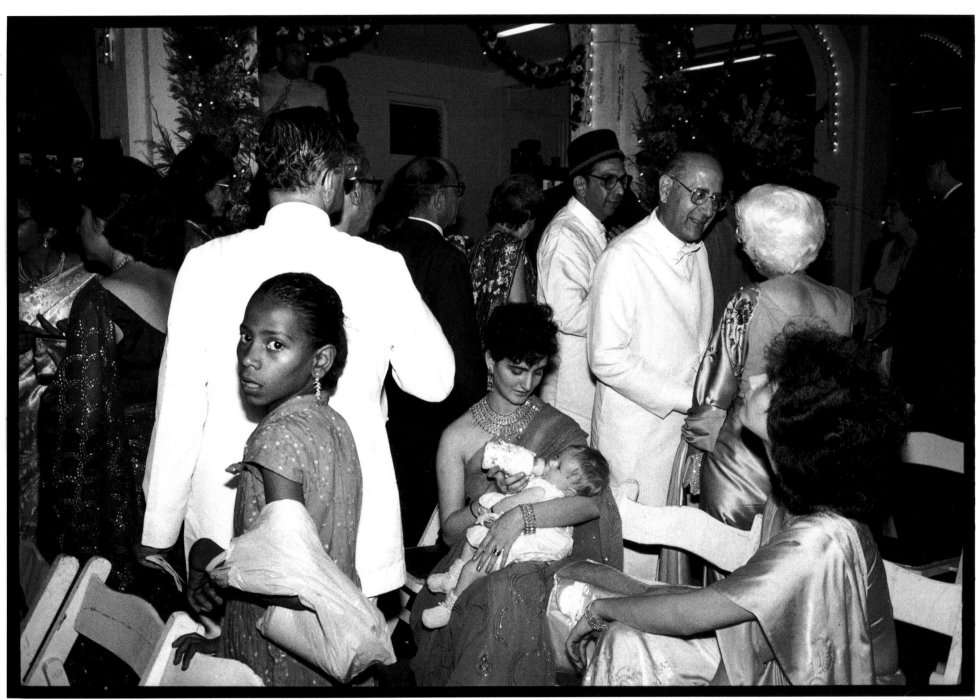

Ketaki Sheth, *Mother and Child, Wedding Reception*, Bombay, 1988

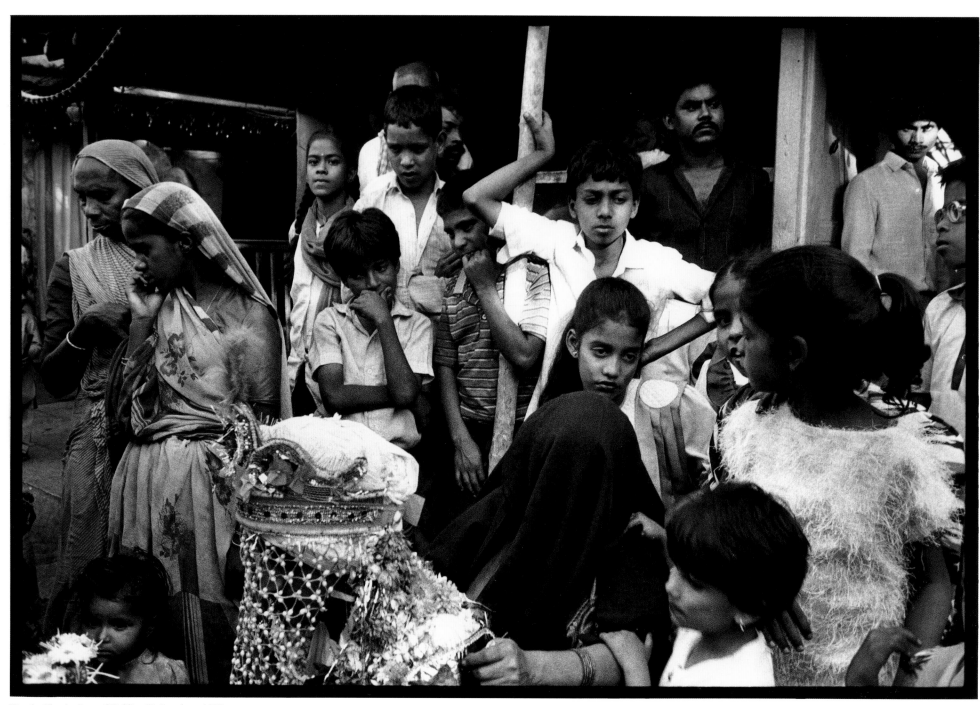

Ketaki Sheth, *Street Wedding II*, Bombay, 1990

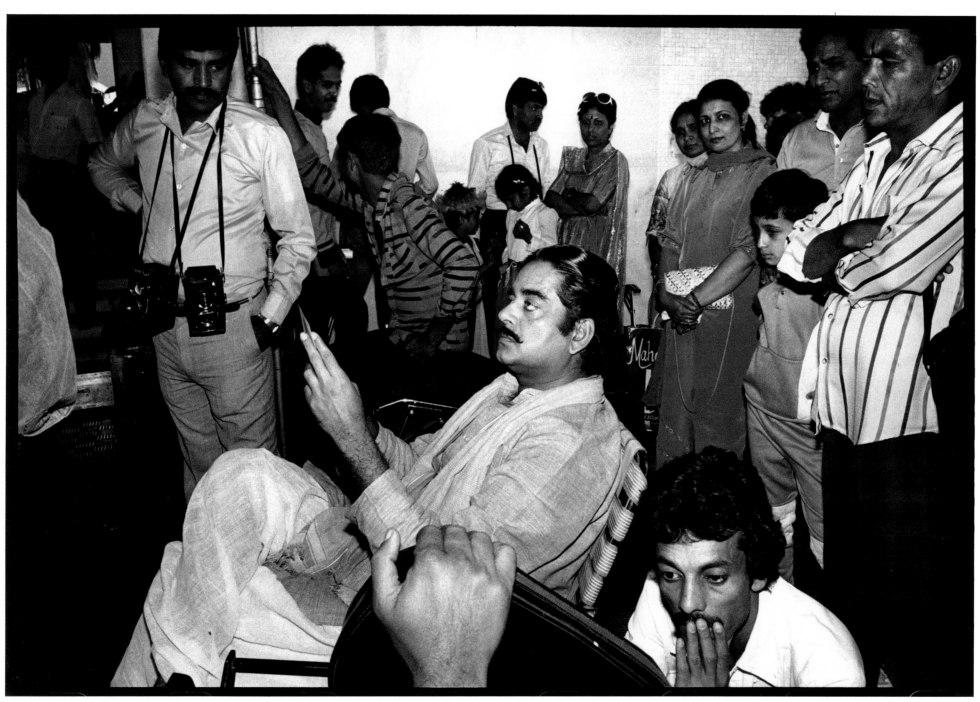

Ketaki Sheth, *Movie Star Rehearses His Lines*, Bombay, 1987

JAISALMER, 1

In a desert land, this pearl-studded city.
Peacocks perch on the brackets
and elephants roam on the walls.
Every balcony lace-embroidered in stone,
every window festooned
with the gashes of blunt swords.
In the twilight, walls flare like orange odhnis.
Eight generations of hands
have smoothed the door's iron ring.
Black goats loiter in the courtyard;
beyond the yard door, the dutiful camel neighs.
Red garments dry on the middle wall.
A limp flame flickers
in the room's mouldy darkness.
In the hearth's red flush,
in the chundadi's glow,
a golden girl kneads a loafshaped city.

—GHULAM MOHAMMED SHEIKH, 1974

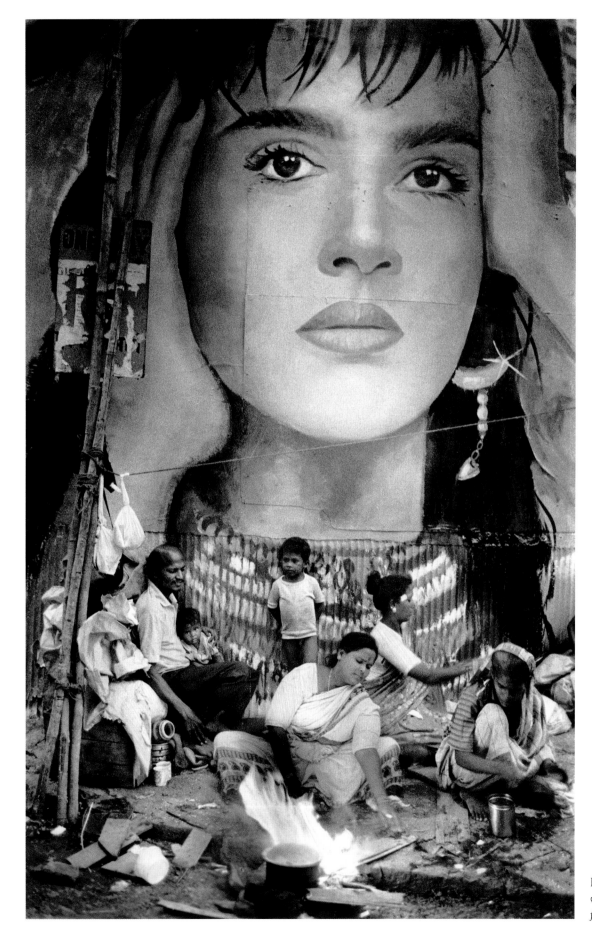

Pamela Singh, *Migrant workers living under poster of film star*, Bombay, 1995

PAMELA SINGH

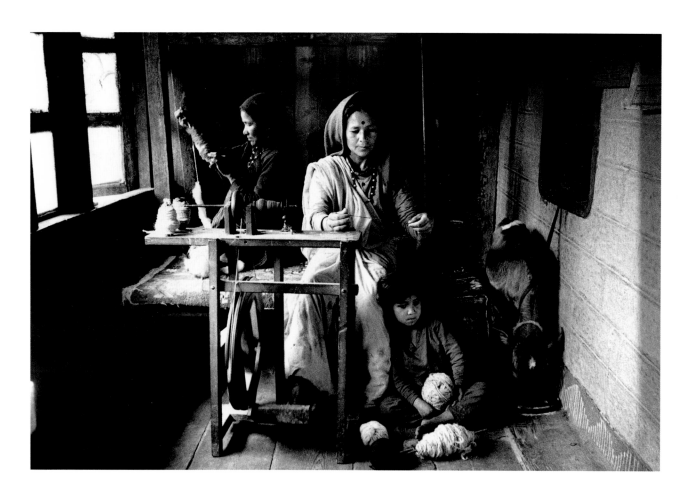

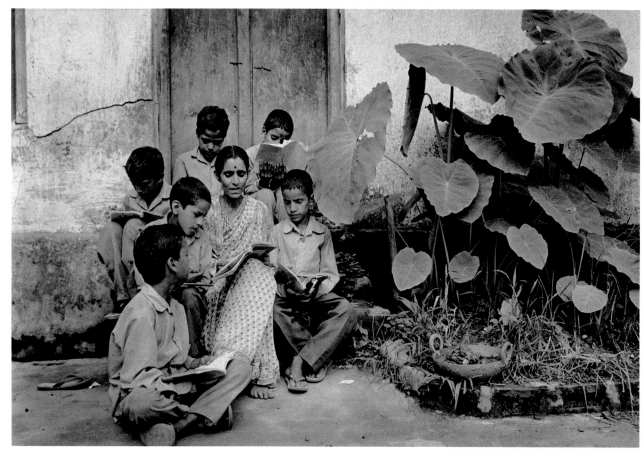

Top: Pamela Singh, *Women of the Chipko movement spinning wool carpets, Uttar Pradesh, 1994*

Bottom: Pamela Singh, *Vimla Bhaguna in her school teaching Gandhian principles, 1993*

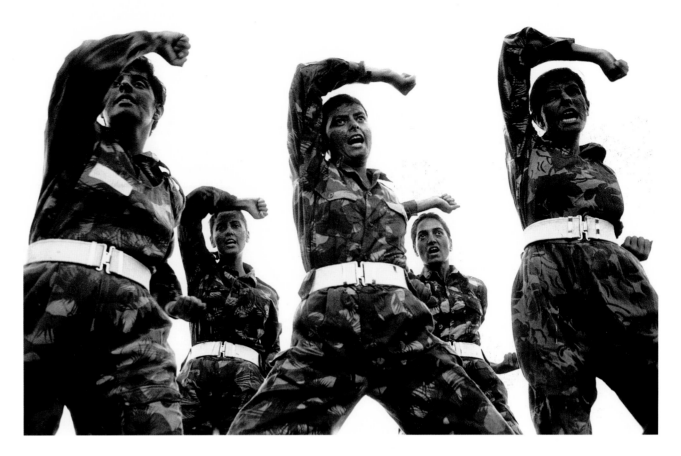

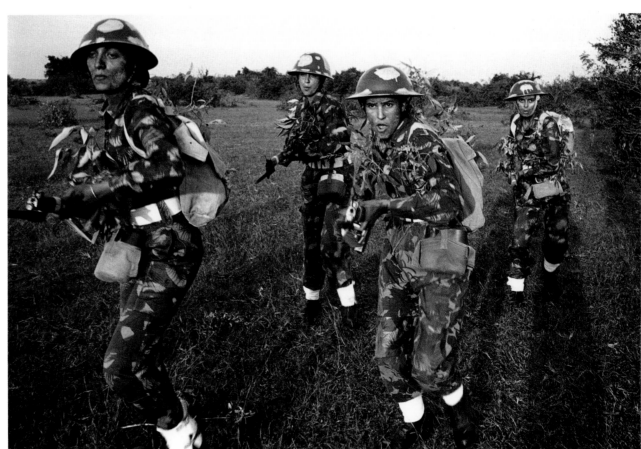

Top: Pamela Singh,
*First group of female
air-force helicopter
pilots in training camp,
Hyderabad, 1995*

Bottom: Pamela Singh,
*Route march—air-force-
pilot training camp,
Hyderabad, 1995*

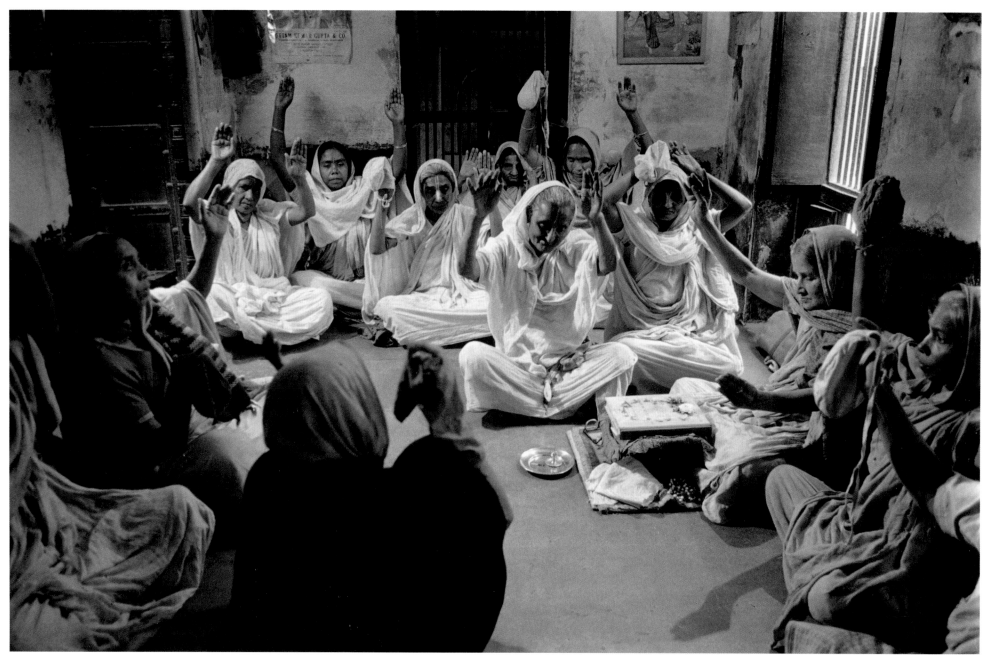

Pamela Singh, *Widows (previously child widows) chant in Brindavan Ashram,* 1995

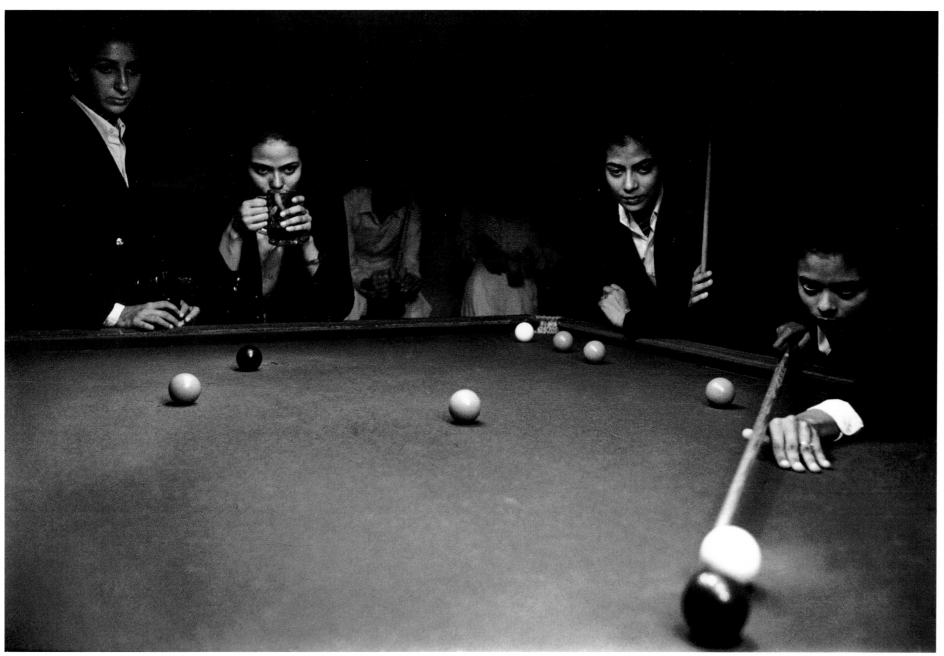

Pamela Singh, *Air-force pilot officers playing billiards at helicopter-training school*, Hyderabad, 1995

Pamela Singh,
Model in Bombay, 1996

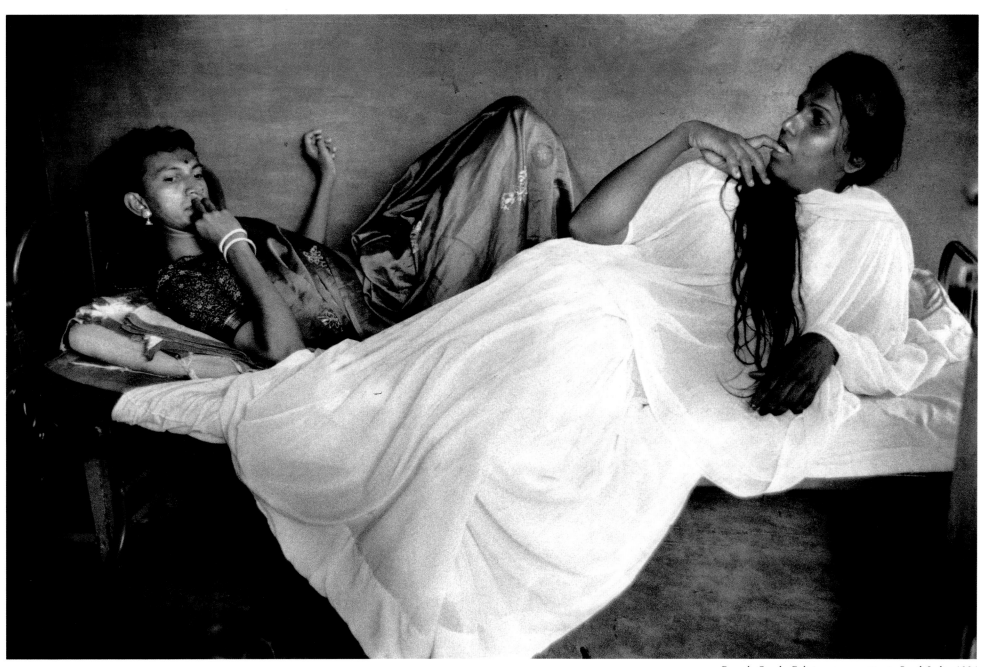

Pamela Singh, *Religious transvestites in South India*, 1994

The river is a voice
in this desert of human lives.

A sail is hoisted,
the color of musk-melon,
the color of daggered flesh.
Beggars hoist their deformities
as boatmen hoist their sails.

The Ganga flows through the land,
not to lighten the misery
but to show it.

　　—KEKI N. DARUWALLA, 1976

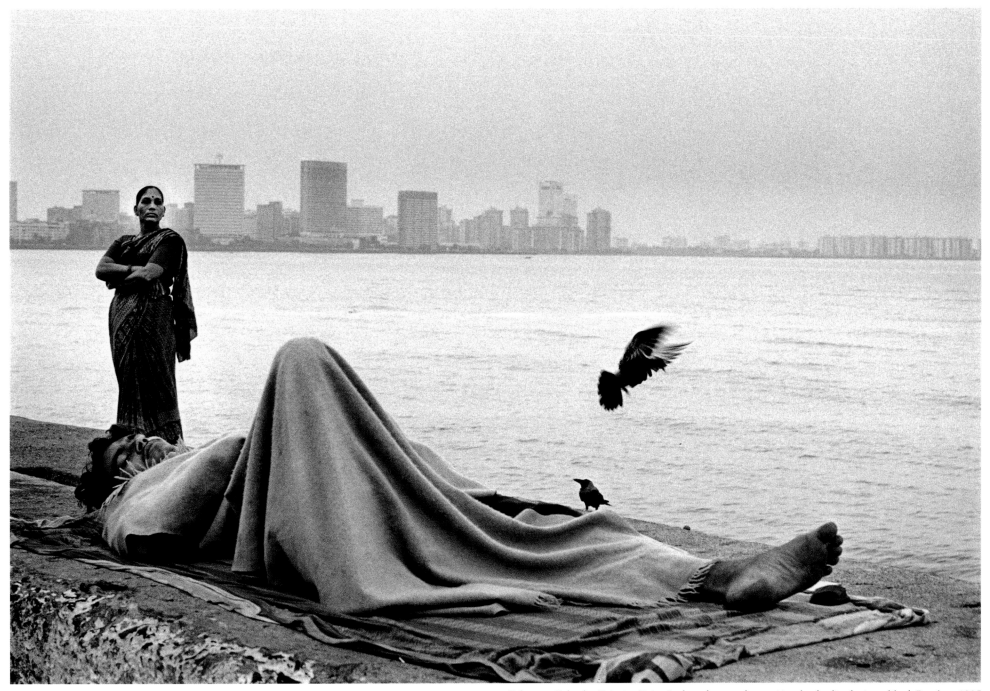

Sebastião Salgado, *"Marina Drive," where the poor sleep waiting for the distribution of food*, Bombay, 1995

SEBASTIÃO SALGADO

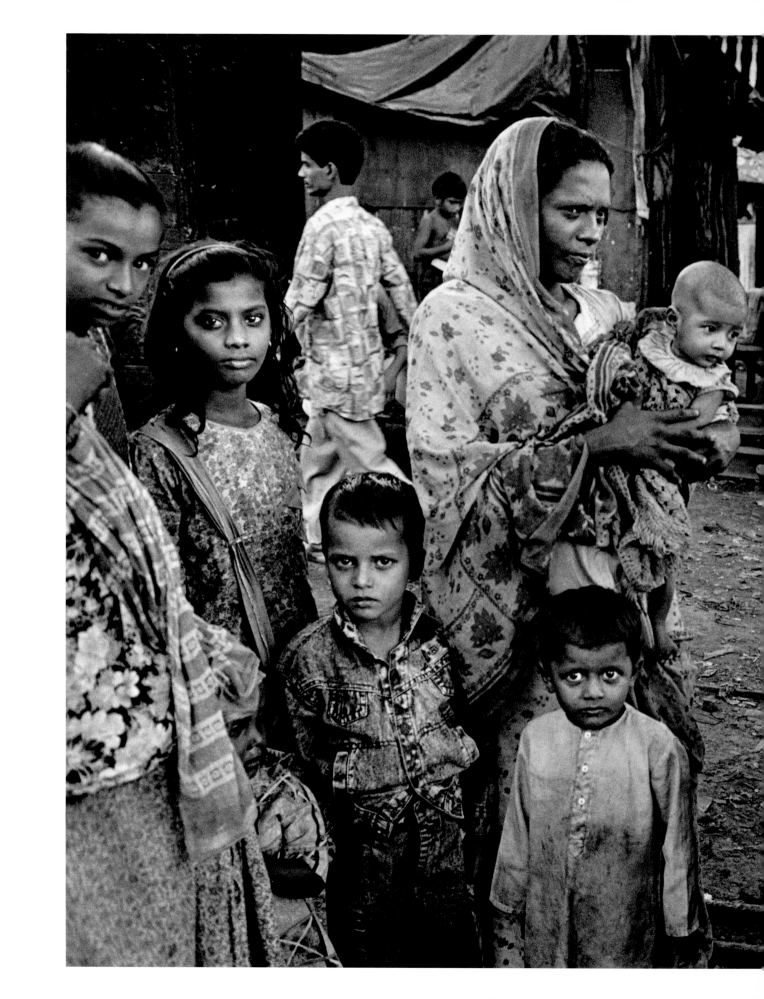

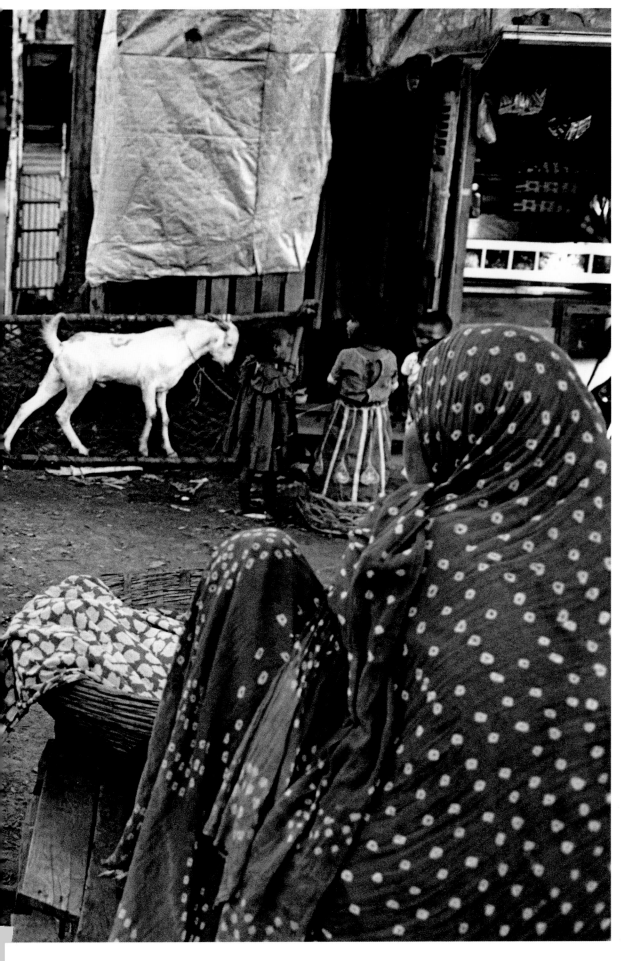

You have a camera that's part of your hands, part of your eyes. And then you go inside, without judging anything. You don't come with your American (or your Brazilian or whatever) culture and presume, "That's good, that's bad, that's black, that's white"—you come because you must come, it's your way of life. You're there to see, hear, listen, understand, integrate. . . .

I believe that if a photograph doesn't make a man as big as he really is, it's better not to photograph. The people I shoot reveal from within their dignity and their struggle to be alive.

—SEBASTIÃO SALGADO

Sebastião Salgado, *The shantytown of Worli, near a sophisticated area of Bombay*, 1995

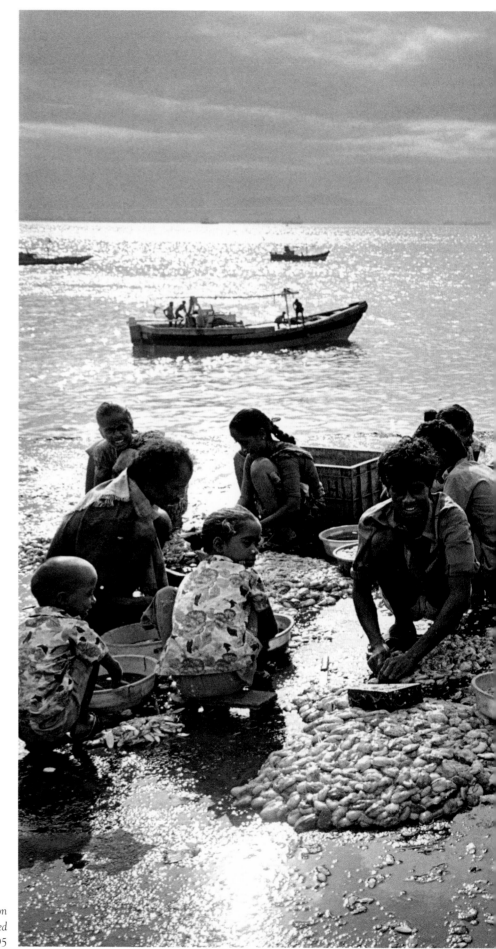

Sebastião Salgado, *The Sassoon
docks, where the small fish are sorted
out by the workers*, Bombay, 1995

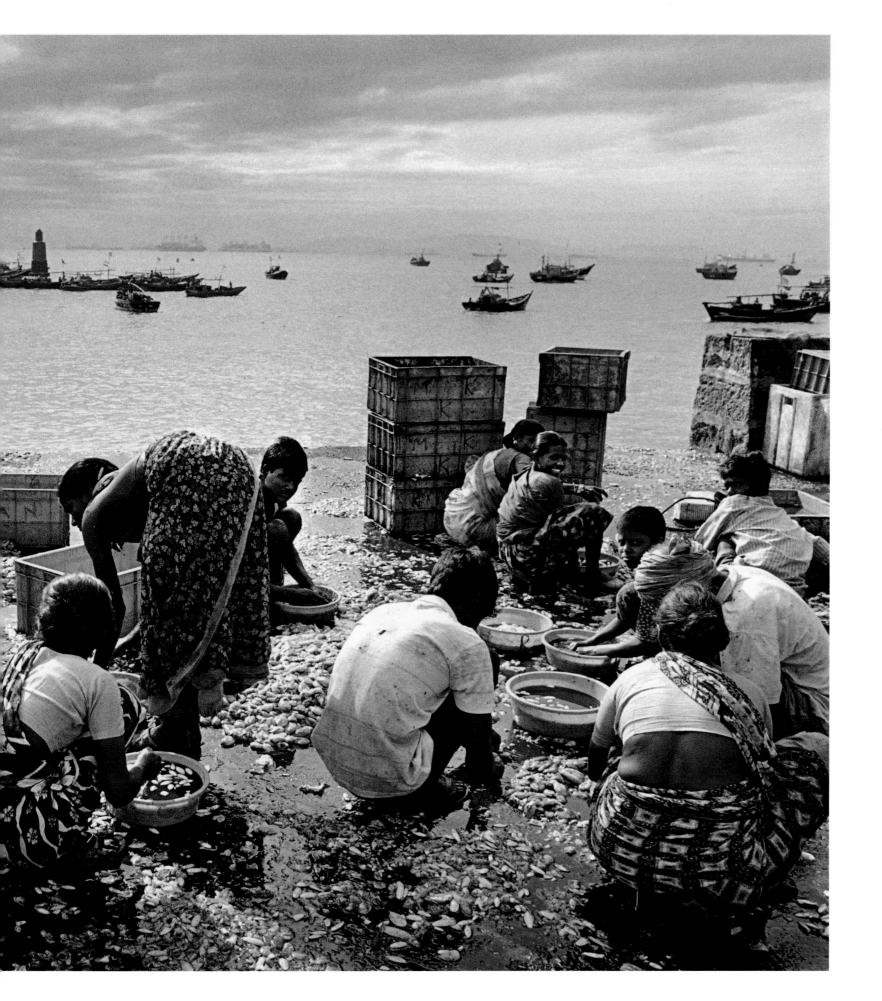

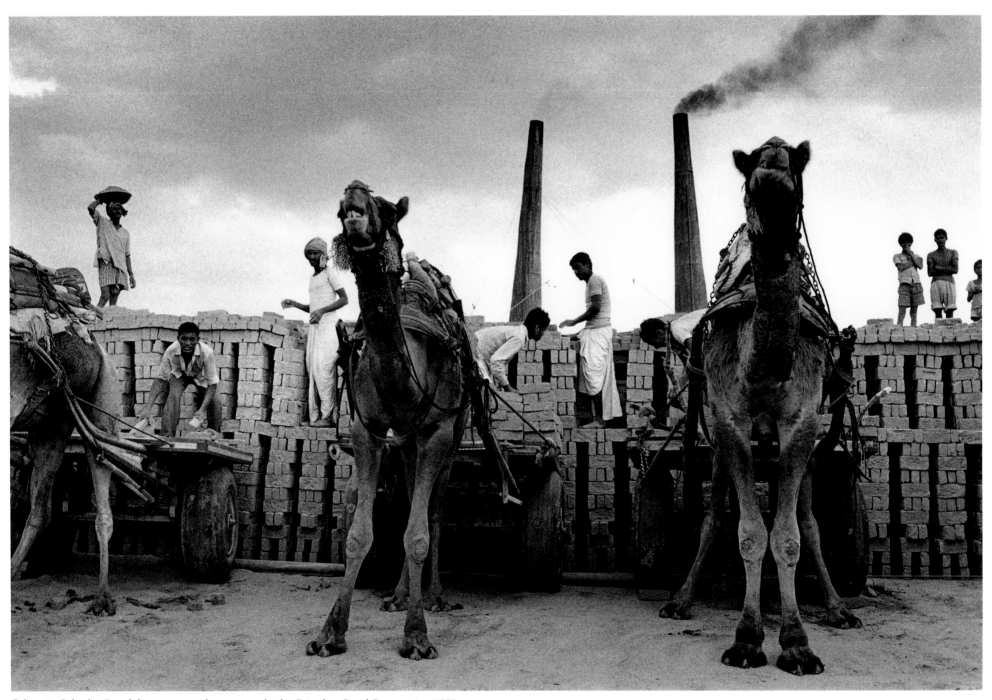

Sebastião Salgado, *Camel-drawn carts used to transport bricks, Rajasthan Canal Construction*, 1989

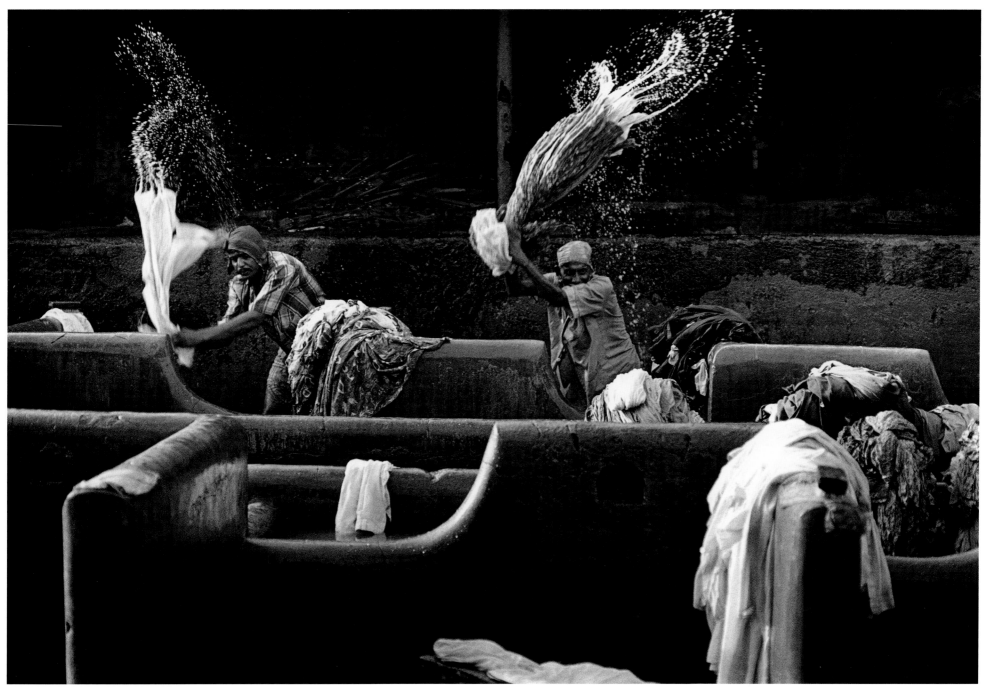

Sebastião Salgado, *The Mahalaxmi Dhobighat cloth-washing center, Bombay,* 1995

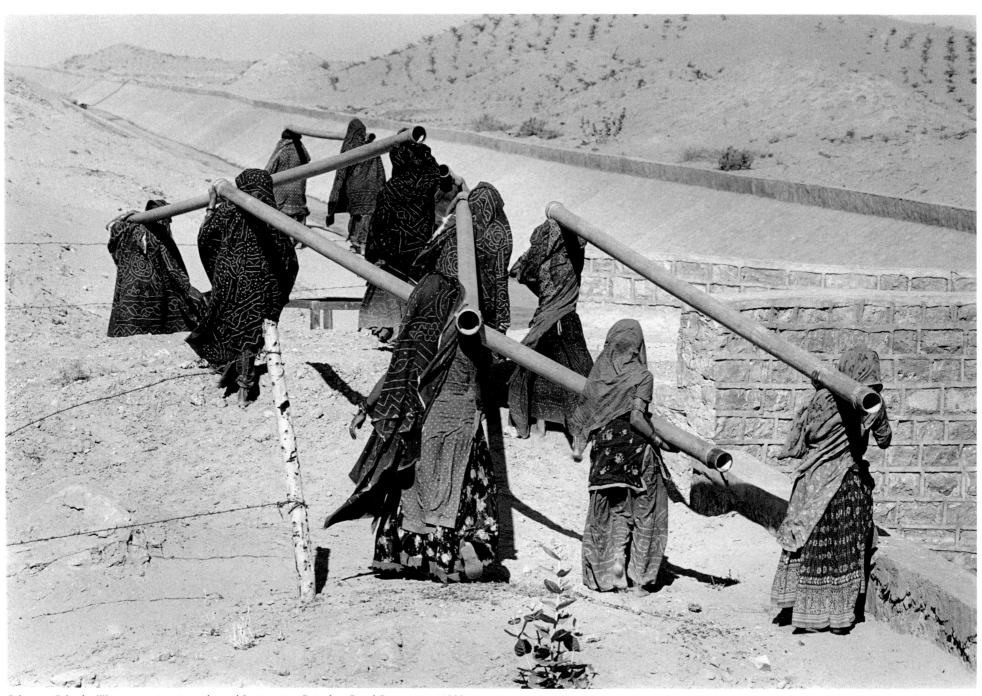

Sebastião Salgado, *Women carrying pipes to be used for irrigation, Rajasthan Canal Construction, 1990*

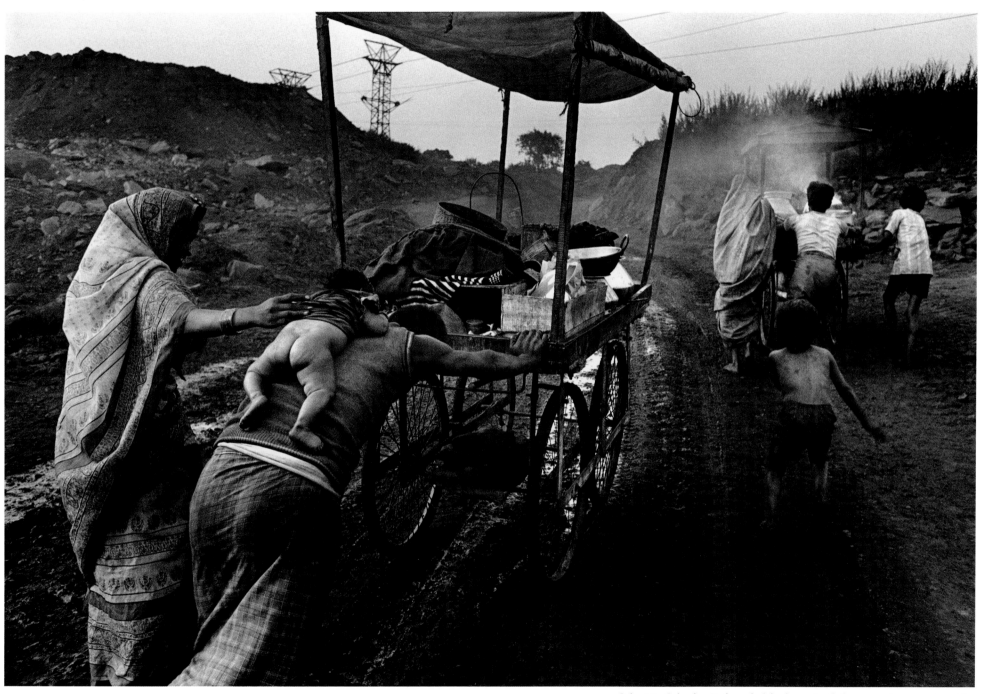

Sebastião Salgado, *At the end of the day, a family leaves an open-cut mine with a cart used to bring food to workers, Dhanbad Coal Mines*, Bihar State, 1989

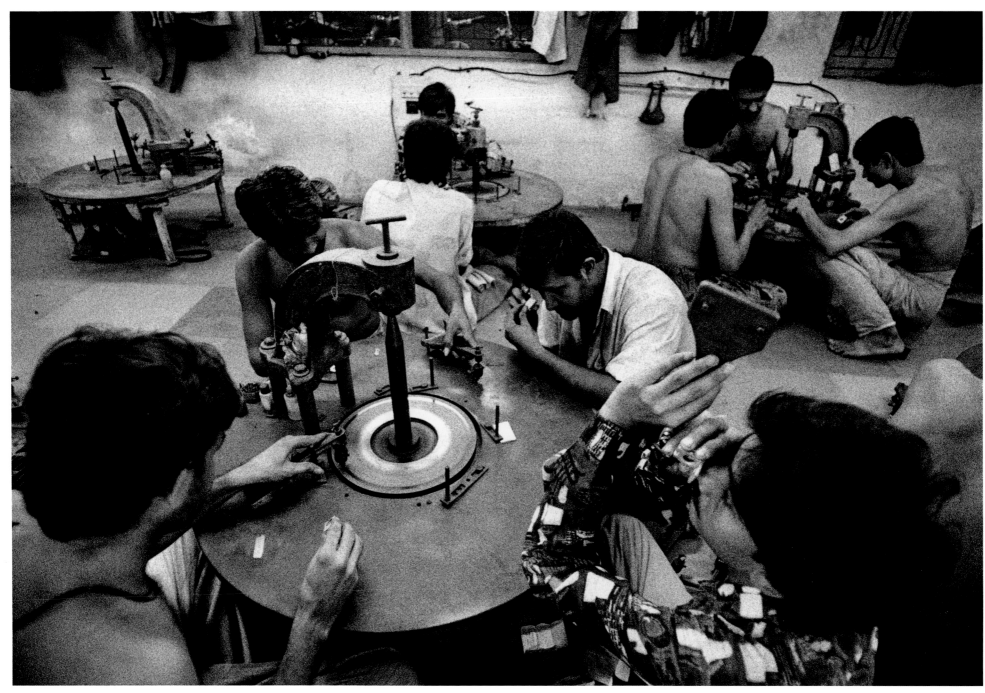

Sebastião Salgado, *Diamond-cutting factory in Surat*, Gujarat State, 1995

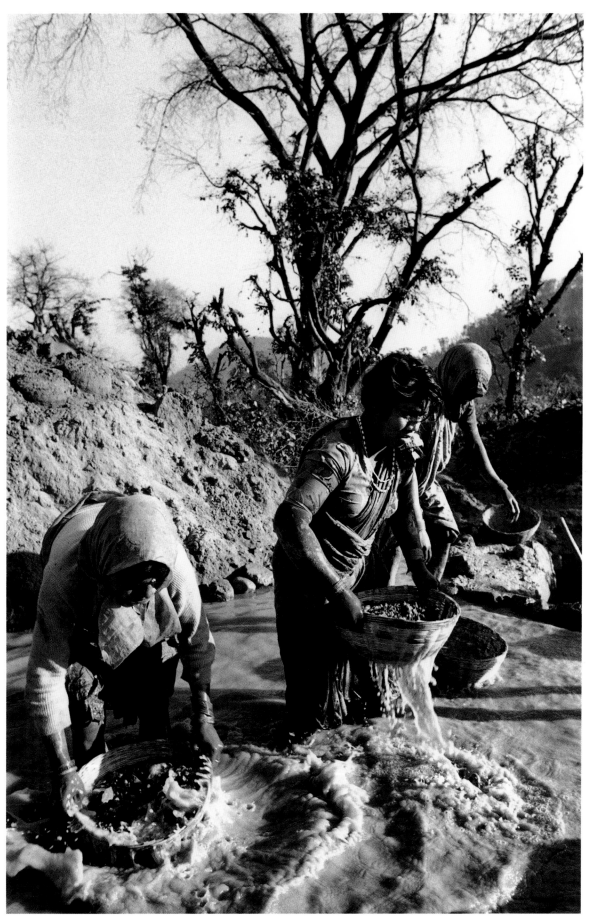

Sebastião Salgado, *Sirsa diamond mines*, Kalinjar, Madhya, Pradesh State, 1996

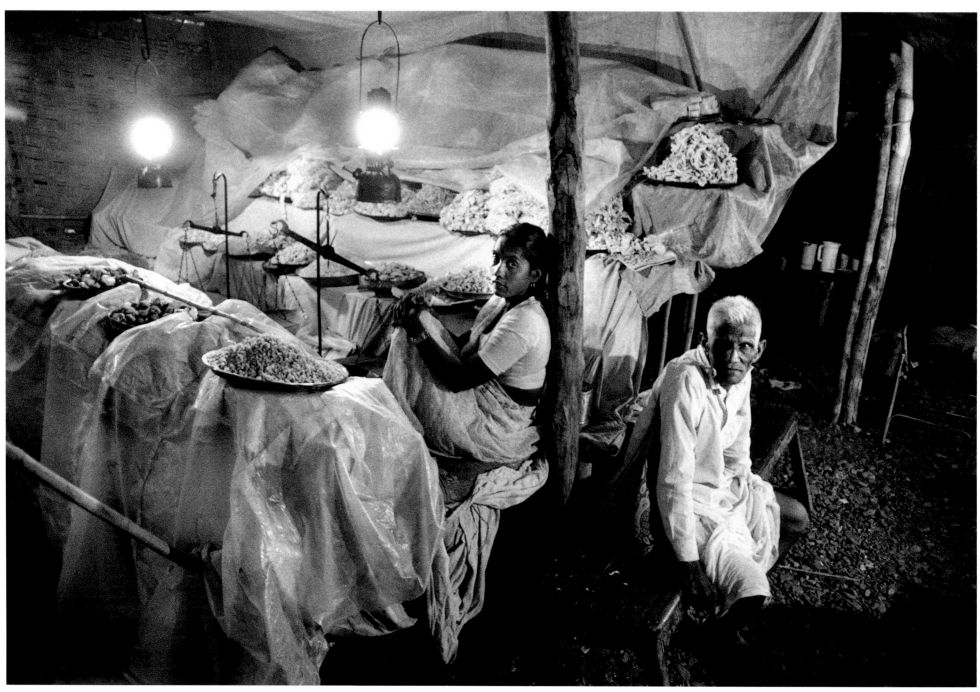

Sebastião Salgado, *Tent where the workers' meals are kept, Sandar Sarovar Dam construction site*, Gujarat State, 1990

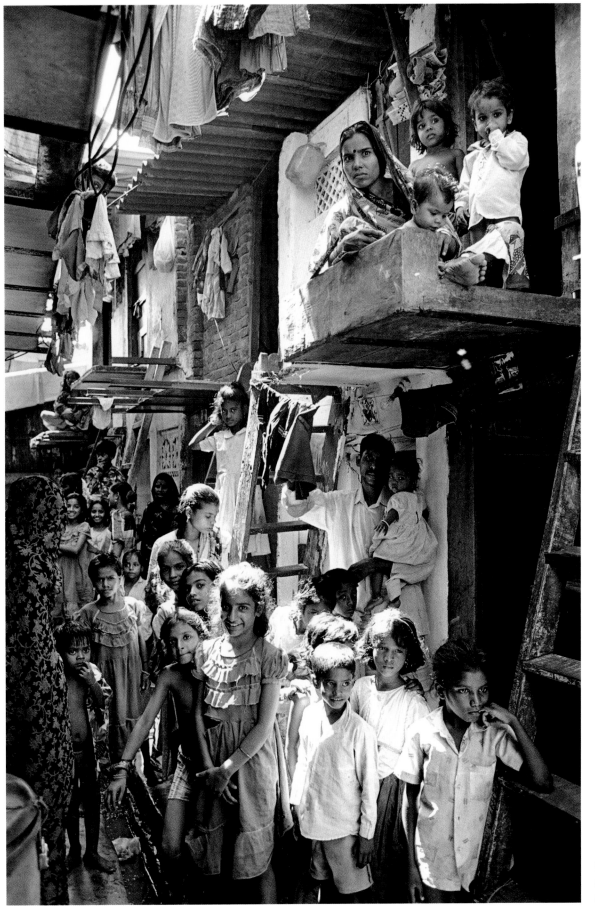

Sebastião Salgado, *The shantytown of Dharavy, one of the two largest shantytowns of Asia*, Bombay, 1995

I love India, not because I culti-
vate the idolatry of geography, not
because I have had the chance to be
born in her soil, but because she
has saved through tumultuous ages
the living words that have issued
from the illuminated consciousness
of her great sons. . . .

—RABINDRANATH TAGORE, 1912

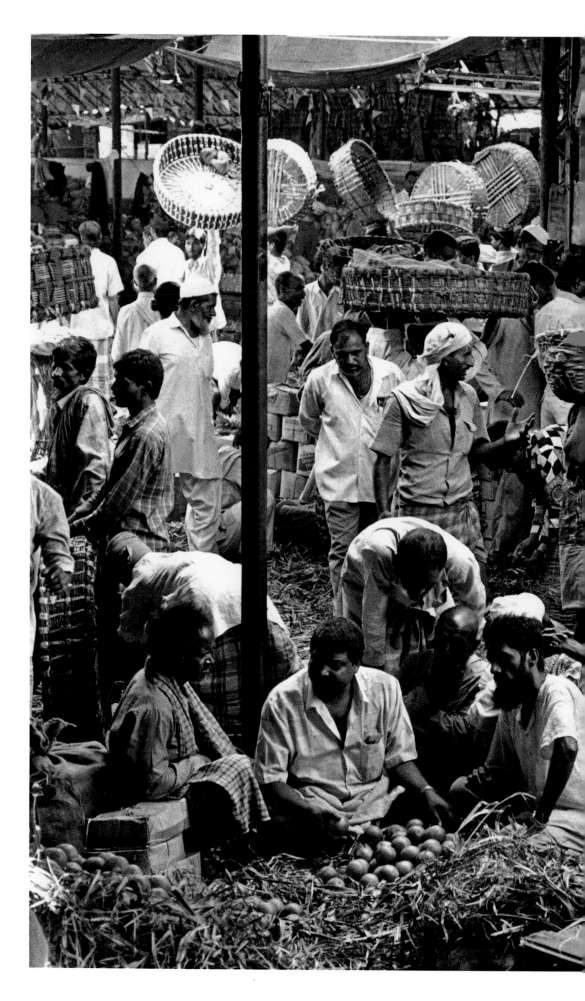

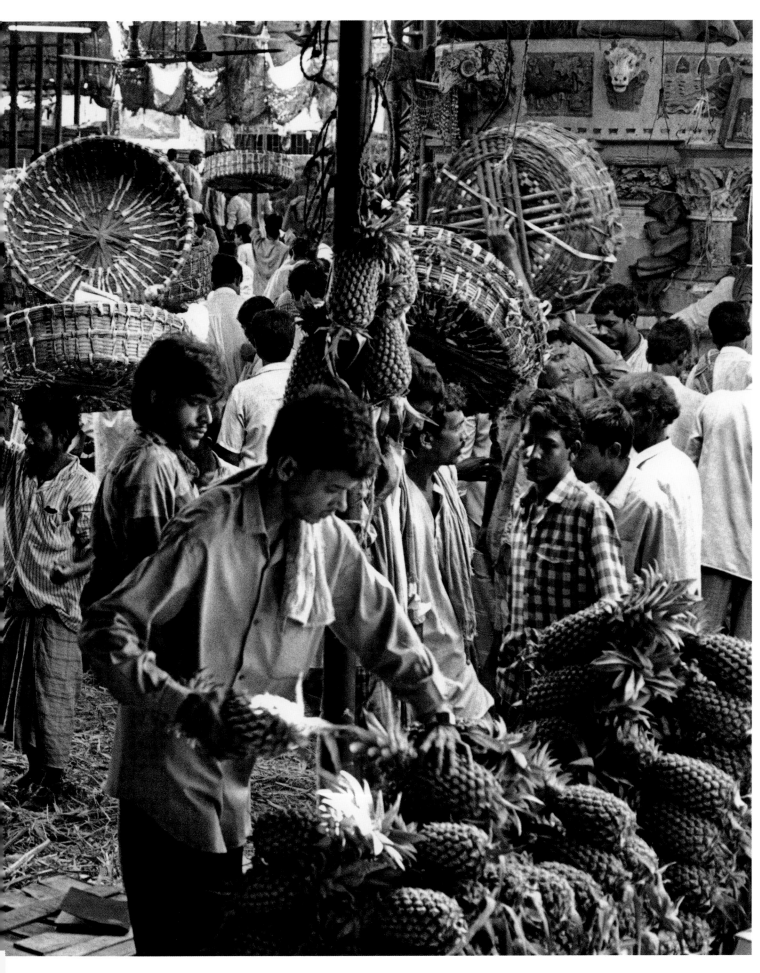

Sebastião Salgado, *The Crawford Market*, Bombay, 1995

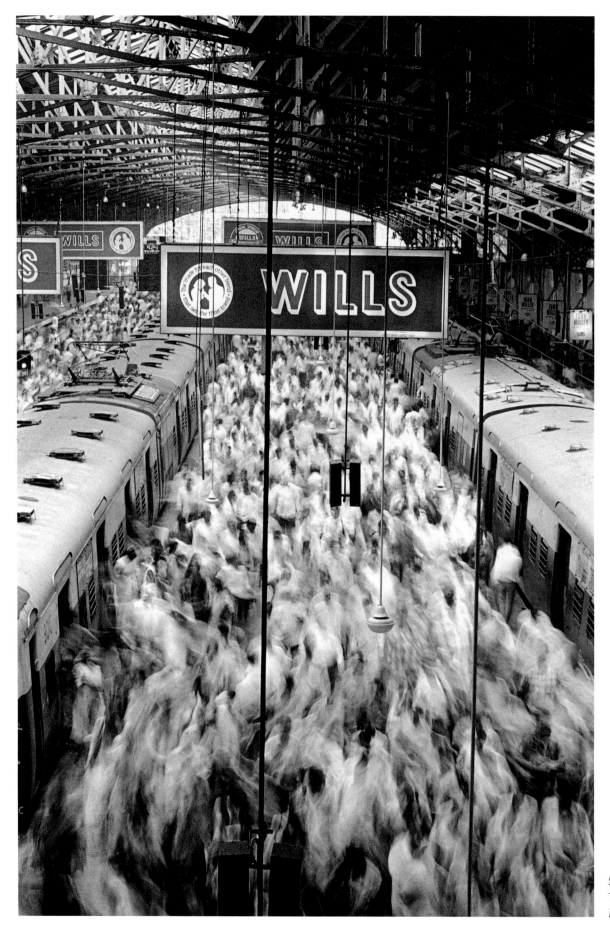

Sebastião Salgado, *Church Gate
Terminus Station of the Western
Railroad Line*, Bombay, 1995

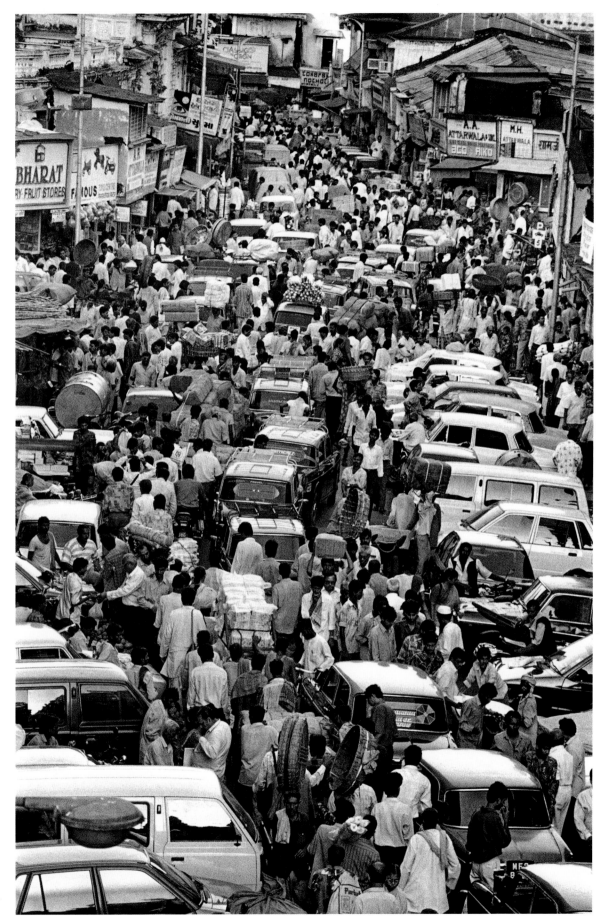

Sebastião Salgado,
*A crowded street of Dava
Bazaar*, Bombay, 1995

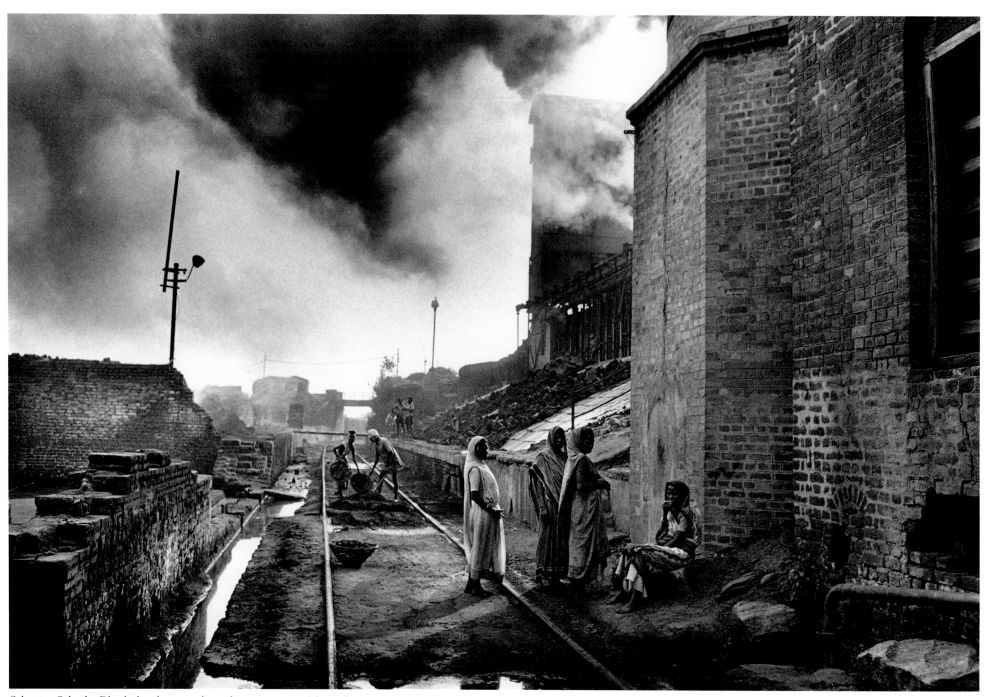

Sebastião Salgado, *Dhanbad coal mines, where a large proportion of the workers are women*, Bihar State, 1989

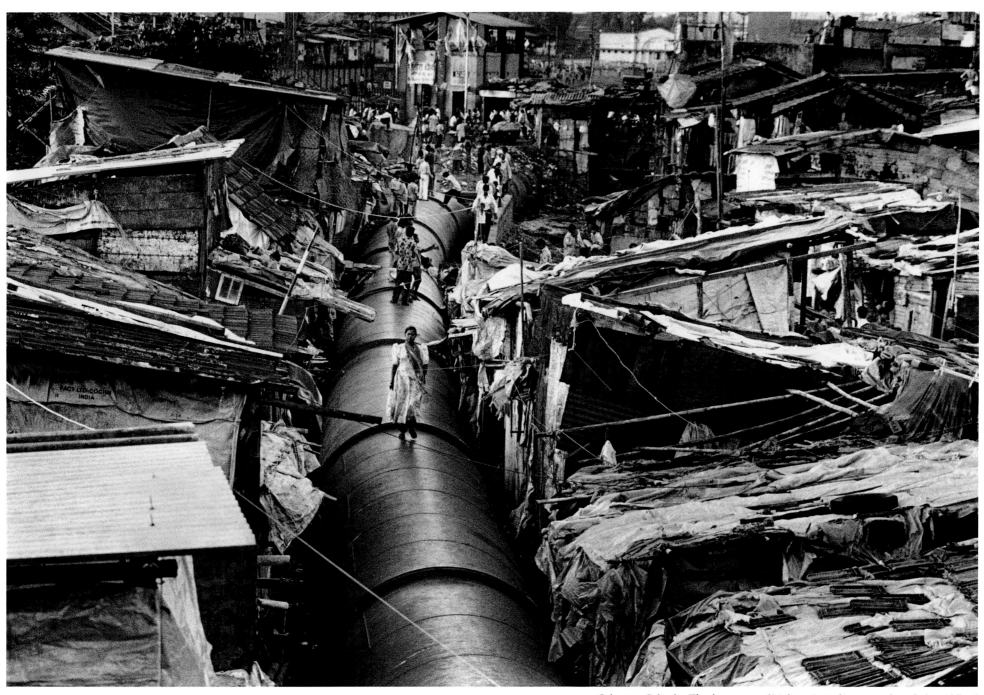

Sebastião Salgado, *The shantytown of Mahim. A pipeline passes through the middle of the slum, bringing drinking water to the rich parts of the city*, Bombay, 1995

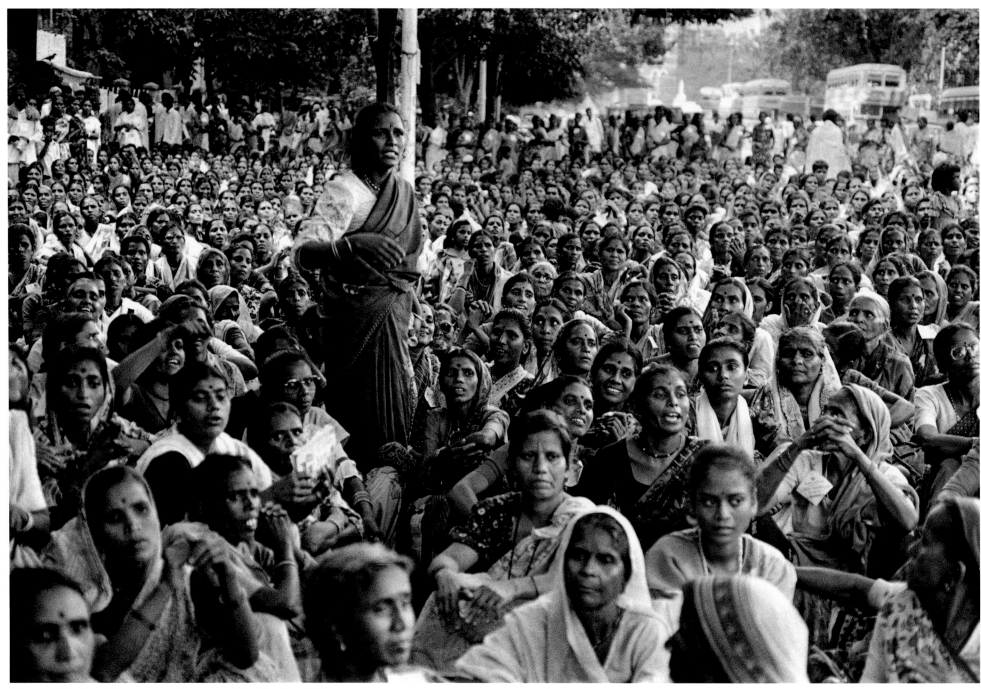

Sebastião Salgado, *A demonstration of women teachers*, Bombay, 1995

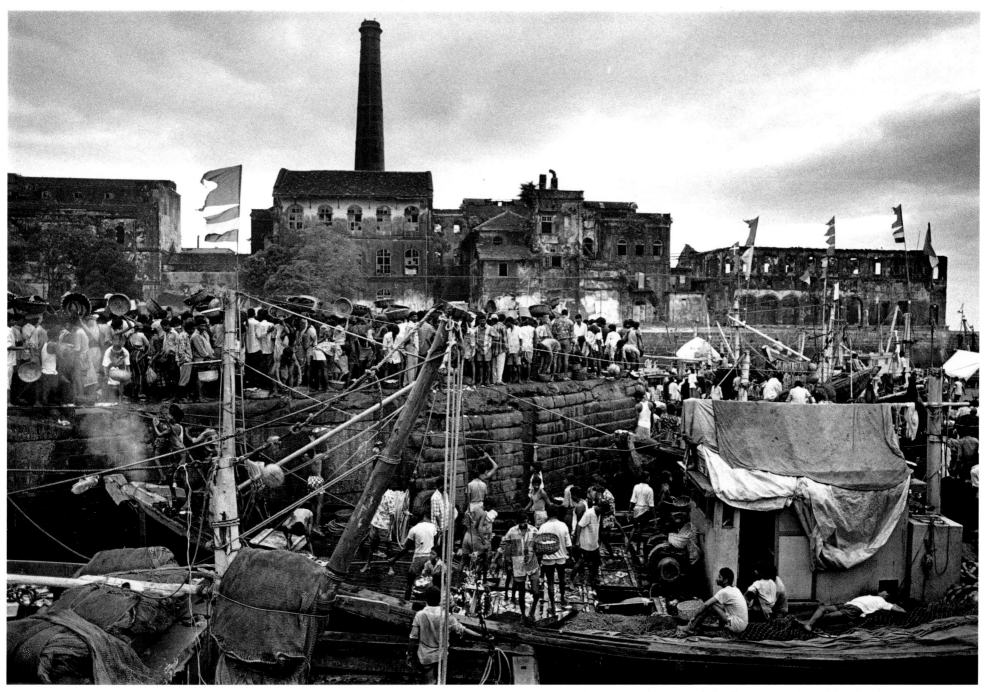

Sebastião Salgado, *Sassoon docks, the main port of arrival for fishing boats to Bombay,* 1995

AFTERWORD

For more than three years, many individuals around the world have been engaged in creating the exhibition and accompanying publication, *India: A Celebration of Independence, 1947–1997*. These devoted participants have included curators, historians, editors, writers, designers, and supporting staff. Most importantly, there are the photographers—more than a score of them in this project, about equally balanced, as it turns out, between those born in India and those whom Victor Anant describes so aptly as "enchanted foreigners." Each of these people is responsible for this project, each offered something of him- or herself that contributed in a vital way to its completion.

There is another individual whose spirit and wisdom pervades these efforts: the remarkable Dorothy Norman. Dorothy's images and words do not appear in the preceding pages, although she is a gifted photographer—as well as a fine writer and editor. Our debt is to her lifelong genius for bringing together ideas, experience, people: her gift of kindling inspiration. Dorothy was devoted to the Indian cause, a close friend both of Jawaharlal Nehru and of his daughter Indira Gandhi—and a witness to that epochal Independence Day, August 15, 1947. She has also been a nurturing spirit through Aperture's forty-five year history, and she was instrumental in the founding of the Alfred Stieglitz Center of Photography at the Philadelphia Museum of Art in 1968. Because of Dorothy, and many other extraordinary factors, both Aperture and the Philadelphia Museum of Art have continued to have a deep-rooted attraction toward India. There was, of course, the irresistible lure of the country's ancient heritage—the arts, literature, and, above all, spiritual gifts to the world. These cast their spell on virtually any inquiring intellect, any seeker of beauty and inspiration. As institutions with a dedication to photography, both the Museum and Aperture also have a more tangible fascination and sympathy with the tumultuous events and challenges of India's contemporary history, captured in imagery that ranks among the most compelling in the medium.

Neither the exhibition nor this book could presume to approach the past fifty years of India's history with anything close to comprehensiveness. Even the most cursory familiarity with India reveals that the country's immensity, variety, and complexity will never be encompassed comprehensively. What we have attempted is to select and in many cases to discover those photographers and those images that provide a glimpse of the human face, the inner culture, of India's past half-century.

There are images here that reveal the genius, devotion, and generosity of Mahatma Gandhi, and the human force that he wove into the quest for freedom; there are moments here, both formal and informal, with the nation's great leaders, Nehru and Indira Gandhi; moments that capture a sense of overwhelming change in economic, social, and cultural life; and moments that are truly, uniquely Indian in their originality and sense of possibility—think, for example, of the photographs here of working children of Rajasthan, seeking control of their own destiny by creating for themselves a surprisingly powerful Children's Parliament.

While we cannot expect to evoke India in more than a sequence of such moments, captured by the camera over the past five decades, it is our hope that we convey here something of the quality that unites India's people—no matter how profound their differences. In the book's Introduction, Victor Anant brilliantly conjures up this quality in his remembered image of a black-skinned ancient in a saffron loincloth, perhaps a holy person or beggar, possessing a humanity that is disciplined to a single, crucial truth: *"Dharam karo."* Do your duty. Your dharma.

Any visitor to India will recognize this as a common rhythm of life, a rhythm manifested in constant generosity, in continued offerings. We witness such offerings at every moment, in every fashion: ritual offerings of *puja*, offerings of prayer to Allah, offerings of charity to the poor, offerings of hospitality and welcome to the visitor. There are offerings of historic import, such as the shelter India offered to the exiled Dalai Lama and his followers, or (earlier in the century) to the millions of refugees seeking haven from the war that gave birth to neighboring Bangladesh.

We hope that the viewer of the images in this exhibition and publication will recognize that this is the true nature of our "celebration": to honor a people who give so liberally of their life and culture, who make an offering to something greater—to work, to family, to a sense of the larger universal order.

In this spirit, we further hope that all who view the photographs in *India: A Celebration* will accept them as offerings by some of the most insightful photographers during the past fifty years. For each of them, as for all who have participated in this effort, India exists, in Cartier-Bresson's poignant phrase, as "a haven for the heart."

ANNE D'HARNONCOURT, George D. Widener Director, Philadelphia Museum of Art
MICHAEL E. HOFFMAN, Executive Director, Aperture
Adjunct Curator, Alfred Stieglitz Center, Philadelphia Museum of Art

1857: The great Sepoy Revolt, or "mutiny" to the British, shakes the British East India Company's rule to its foundations.

1858: The revolt is suppressed, and the British crown takes over India's government. The Governor-General of India is now also called the Viceroy.

1861: An Indian Council's Act leads to Indian involvement in the process of legislation in years to come.

1885: The Indian National Congress is founded, and spearheads the freedom struggle.

1889: Kadambini Ganguly becomes the first woman to address an open session of Congress. In 1886, Anandibai Joshi and she had become the British Empire's first women doctors.

1892: An Indian Council's Act increases nonofficial and Indian participation in the legislatures and introduces indirect elections. Indians are critical of the Act because real power still rests with the Viceroy.

1905: Province of Bengal is partitioned. Indians regard this as an attempt to marginalize the politically assertive Bengalis. Widespread agitation follows, with boycotts and burning of foreign goods.

1906: A Muslim party, the Muslim League, is established in Dacca with encouragement from the British.

1907: The Indian National Congress is split between moderates and extremists. The extremists are expelled.
—An attempt is made on the life of the Lieutenant-Governor of Bengal, underlining the emergence of revolutionary terrorism as an alternative means to freedom.

1909: An Indian Council's Act allows for more Indian participation in legislatures but introduces communal electorates. National leaders oppose this as another attempt to divide the Hindus and Muslims of India.

1911: At a durbar in Delhi, King George V annuls the partition of Bengal. Delhi is made the capital of India.

1914: World War I begins. The efforts by the North America–based Ghadar (Revolutionary) Party to start an uprising in India fail.

1915: Mohandas K. Gandhi returns to India from South Africa, where he had led a successful peaceful-resistance movement against the government. During 1917–18, he provides leadership to peasant movements in Bihar's Champaran and Gujarat's Kheda districts and to textile mill workers in Ahmedabad.

1916: Extremists return to the Congress at its annual session in Lucknow. A pact between the Congress and the Muslim League, known as the Lucknow Pact, is made in an attempt to pave the way for cooperation between the two.

1918: World War I comes to an end.

1919: In March, Gandhi calls for a *satyagraha* (nonviolent protest) against the move to enact the Rowlatt Bills which propose severe curbs on the civil liberties of Indians, with a view to putting an end to terrorist activities.
—On April 13, General Reginald Dyer orders the massacre of Indians protesting at Jallianwala Bagh. Virulent protests explode in most parts of India. Poet Rabindranath Tagore renounces his British knighthood. Stunned by the general climate of violence, Gandhi withdraws his call for agitation on April 18.
—The Government of India Act of 1919 introduces the system of "diarchy" in the provinces. The Governor and the provincial executive are in charge of reserved subjects such as law and order, and accountable to the Viceroy for these, and elected ministers are responsible for subjects such as education and local developmental works. The concessions do not satisfy Indian Nationalists.

1920: The Commmunist Party of India is founded at Tashkent, in Russia, under the leadership of M. N. Roy.
—The Congress, led by Gandhi, in support of the Khilafat Committee, launches a Non-Cooperation movement.

1922: Gandhi withdraws the Non-Cooperation movement after twenty-two policemen are killed in a violent incident at Chauri Chaura in the Gorakhpur district of Uttar Pradesh. The Congress is demoralized by his withdrawal; Khilafat leaders feel let down.
—Gandhi is nevertheless imprisoned in March.
—Thwarted in their attempt to seek a revision of the Congress decision to boycott participation in legislatures set up under the 1919 Act, two stalwarts of the party, Chittaranjan Das and Motilal Nehru (father of Jawaharlal), leave to form their own Swaraj Party.

1924: Gandhi is released from prison on grounds of poor health, and makes up with Swaraj Party leaders.

1927: British government establishes an all-white commission headed by Sir John Simon to study whether India is ready for further constitutional progress, and if so, along what lines.
—The Congress decides to boycott the Simon Commission.

1928: Nationwide general strikes and protest demonstrations greet the Simon Commission's arrival in Bombay on February 3. Jawaharlal Nehru and radical nationalist from Bengal, Subhas Chandra Bose, emerge as important national leaders in the agitation that follows.

1929: Jawaharlal Nehru becomes President of the Congress at its annual session at Lahore. For the first time, the Congress declares that nothing short of Purna Swaraj, or complete self-rule, is its goal, and authorizes the Congress Working Committee to launch a program of Civil Disobedience.

1930: Gandhi starts the Civil Disobedience movement on April 6 at Dandi, in Gujarat, Western India, by initiating a protest against tax put on salt. Jawaharlal Nehru is arrested on April 14, Gandhi on May 4 for defiance of the Salt Act. This becomes a populist movement, with women and children playing important roles.
—Revolutionaries in Bengal raid a police armory in the port of Chittagong, and battle with the army and police on a neighboring hill signifying the resurgence of revolutionary terrorism in Bengal.
—Lord Irwin, the Viceroy, suggests a Round Table Conference and proposes eventual dominion status, or autonomy within the imperial government, for India.
—The first Round Table Conference is held in London in November.

1931: A pact between Gandhi and Irwin is announced on March 5, following Gandhi's release on January 25. The British government agrees to release prisoners, withdraw repressive measures and permit manufacture of salt for consumption in the coastal villages, and the Congress agrees to suspend its Civil Disobedience movement.
—Three revolutionaries, Bhagat Singh, Sukhdev, and Rajguru, are hanged on March 23 for the 1928 assassination of a police officer involved in a *lathi* charge that led to the death of nationalist leader Lala Lajpat Rai.
—Sarojini Naidu becomes the first woman president of the Congress.
—Gandhi sails for London on August 29 to attend the second of the Round Table Conferences.

1932: The government launches an offensive against the Congress by arresting Gandhi on January 4. Savage repression is unleashed on the country.

—The British, pursuing a divide-and-rule policy, announce the Communal Award, which provides for a separate electorate for the Depressed Classes (now known as Scheduled Castes and Tribes) in addition to the existing separate electorates for Muslim, Sikh, and Christian minorities.

—Gandhi begins a fast unto death on September 20 to protest this award. The Poona Pact, signed by him and Dr. B. R. Ambedkar (representing the Depressed Classes), recognizes higher representation in the provincial and central legislatures than under the Britsh award. In turn, Dr. Ambedkar abandons their demand for a separate electorate.

1934: The Communist Party of India is declared illegal.

—Gandhi withdraws the Civil Disobedience movement.

—Jayaprakash Narayan, Acharya Narendra Dev, and Minoo Masani form a Socialist party within the Congress.

—Gandhi resigns from the Congress "only to serve it better in thought, word, and deed."

1935: A Government of India Act in August provides for a federal government in India with provincial autonomy, and expands the franchise to cover one-sixth of the population. The provincial governments are to be headed by prime ministers. Real power remains with the Viceroy and his governors and officials.

1937: Congress sweeps the elections under the 1935 Act. It forms governments in Madras, Bombay, Central Provinces, Orissa, Bihar, Uttar Pradesh and, later, in Assam and the North-West Frontier Province.

1939: Subhas Chandra Bose is re-elected Congress President, despite Gandhi's opposition, for a second term. However, he cannot continue in office and resigns to form the Forward Bloc party.

—World War II breaks out. The Viceroy announces India's participation in the war without consulting Indian nationalist leaders.

—The Congress Working Committee condemns Nazism and Fascism but states that India's participation in the war must be as an independent people. The Viceroy does not accept this, and the elected Congress ministries in the provinces resign. Elected Muslim League ministries continue in office.

1940: The Muslim League, under Mohammed Ali Jinnah, demands a separate state of Pakistan.

1941: Subhas Chandra Bose escapes from his house in Calcutta where he was interned, and reaches Berlin. He broadcasts from there, exhorting Indians to revolt.

—Sir Stafford Cripps comes to India with a draft declaration promising dominion status at the end of the war. Congress leaders reject the proposal.

1942: Congress launches the Quit India movement on August 9. A country-wide upsurge, which follows despite the arrest of the leaders, is repressed.

1943: Subhas Chandra Bose is reported to have reached Tokyo, where he announces a Provisional Government of Free India and the formation of the Indian National Army.

1944: Gandhi is released from prison on May 4.

1946: A British Cabinet Mission arrives in India. Unable to achieve a consensus on a constitutional scheme, it proposes a very loose federal structure with the provinces given wide autonomy. It also proposes the setting up of a constituent assembly and an interim government. However, disagreements between Congress and the Muslim demand for Pakistan stall progress.

—The Muslim League declares Direct Action Day through country-wide demonstrations, which trigger the Great Calcutta Killing. A year of Hindu-Muslim violence starts. The British agree to Jinnah's demand for Pakistan as a separate state. The Congress accepts the Partition of the country.

1947: India becomes independent at midnight on August 15, with Jawaharlal Nehru as the first prime minister.

—Irregular troops from Pakistan invade Kashmir in October. Maharaja Hari Singh of Kashmir signs instrument of accession to India. Indian troops move into Kashmir.

1948: Gandhi is assassinated by a Hindu fanatic on January 30.

—The Communist Party of India adopts an insurrectionary line at its second Congress and intensifies its violent peasant movements in West Bengal and Andhra Pradesh.

—The Government of India announces its industrial policy aiming to develop a mixed economy in India.

1949: The U.N. arranges a cease-fire in Kashmir.

1950: On January 26, India declares itself a republic, with a federal, democratic, and parliamentary constitution with provisions for the underprivileged classes. Dr. Rajendra Prasad becomes the first President of India.

1951: The launching of the first Five-Year Plan (1951–56) inaugurates an era of planned economic development.

—The Communist Party of India returns to the parliamentary path.

1952: The first general elections under the new constitution returns the Congress to power at the Center and in the States.

1954: A Sino-Indian treaty on Tibet delineates "five principles of peaceful coexistence," called Panchasheela.

—A socialistic pattern of society is declared to be India's goal.

1955: India takes the initiative in forming a nonaligned movement of Afro-Asian states at a conference in Bandung, Indonesia.

—Several states enact land-reform legislation.

—The Hindu Marriage Act abolishes bigamy among Hindus.

1956: The Hindu Succession Act grants inheritance rights to women.

—An Industrial Policy Resolution gives the State a major role in the economy to increase the pace of economic growth and accelerate industrialization.

1957: Dr. Sarvepalli Radhakrishnan, eminent philosopher and scholar, becomes President of India.

1958: Jawaharlal Nehru explains the principles of a nonaligned foreign policy in Parliament.

—Nehru pilots a Science Policy Resolution in Parliament.

1959: Tibetans revolt against Chinese rule. The Dalai Lama is given refuge in India. Sino-Indian relations, strained by a border dispute, deteriorate sharply.

1960: Chinese Prime Minister Zhou En-lai visits Delhi. Talks aiming to resolve the India-China border dispute fail.

1962: The India-China border dispute flares up into a military conflict. Following Indian reverses, Krishna Menon resigns as Defense Minister.

1963: Several important central ministers and State chief ministers, belonging to the Congress, resign from office under a plan named after Congress President K. Kamaraj, to work in the party's organization.

1964: Jawaharlal Nehru dies on May 27; Congress names Lal Bahadur Shastri the new prime minister.

1965: An India-Pakistan war ends in cease-fire after twenty-two days of fighting.

1966: India and Pakistan sign a peace treaty at Tashkent under Soviet auspices.

—Lal Bahadur Shastri dies at Tashkent soon after signing the accord. Indira Gandhi is chosen as prime minister.

—The devaluation of the rupee triggers contry-wide criticism.

1967: The Congress suffers a severe setback in the general elections. It loses power in several major states, and has a slim majority to rule at the Center.

1969: Dr. Zakir Hussain dies. Congress splits over the choice of its candidate for a successor. Nationalization of Indian banks is Indira Gandhi's first step into populist economic policies.

—V. V. Giri, Indira Gandhi's candidate, wins the presidential election. A split in the Congress reduces her government to a minority at the Center, but support by the Communists and the Dravida Munnetra Kazhagam, a regional party in Tamil Nadu, keeps it in power.

1971: Indira Gandhi leads her bloc of the Congress to a sweeping victory in midterm parliamentary elections with the slogan "*Garibi Hatao*," or "Banish poverty."

—Ten million refugees from East Pakistan (now Bangladesh) pour into India as the Pakistani army launches a brutal crackdown on the movement for autonomy there.

—India and Soviet Union sign a treaty of peace and friendship.

—India defeats Pakistan and helps in the liberation of Bangladesh.

1972: Indira Gandhi and the new Pakistani Prime Minister Z. A. Bhutto sign the Simla Accord, marking the end of the 1971 war, and saying that the Kashmir dispute should be resolved through bilateral discussions. Following this, 93,000 Pakistani prisoners of war are returned to Pakistan.

1974: India explodes an underground nuclear device.

1975: The Committee on the Status of Women in India submits its report.

—A High Court judgment sets aside Indira Gandhi's election to Parliament. Facing growing discontent, and increasingly the target of an anticorruption movement led by Jayaprakash Narayan, she declares a state of emergency on June 25. She is accused of dictatorial rule with her son Sanjay running the government.

1977: The Congress is trounced in the parliamentary elections of March; both Indira Gandhi and Sanjay are defeated. Non-Communist opposition parties merge to create the Janata (People's) party. Morarji Desai becomes prime minister.

1979: The Janata party's government falls as a rump withdraws support. A new minority government is formed with Charan Singh as prime minister. He resigns shortly afterward, as the Congress withdraws its support from him.

1980: Indira Gandhi returns to power in the midterm elections.

—Sanjay Gandhi dies in an airplane crash.

1984: Indian troops storm into the Golden Temple in Amritsar after bitter fighting to clear it of Sikh militants. There is widespread criticism of this action.

—Indira Gandhi is assassinated by her bodyguards seeking to avenge the Golden Temple action.

—Rajiv Gandhi becomes prime minister amid brutal anti-Sikh riots in many parts of the country.

—A poisonous gas leak from a Union Carbide plant in Bhopal claims thousands of lives.

—Congress under Rajiv Gandhi sweeps the parliamentary elections held in December.

1985: The annual budget inaugurates the process of economic liberalization.

1986: The new education policy, making for changes in the system of education from the primary to the university level, is presented in Parliament.

1989: The Congress, led by Rajiv Gandhi, whose popularity had been undermined by corruption charges against his government, loses the parliamentary elections. A new coalition government takes office with V. P. Singh as prime minister.

1990: V. P. Singh announces his government's decision to implement the controversial report of the Mandal Commission, providing for job reservation for the Other Backward Classes. Violent protests erupt in many parts of India.

—The V. P. Singh government falls on November 7.

—Another minority government is installed under Chandra Shekhar, but does not last. New parliamentary elections follow.

1991: Rajiv Gandhi is assassinated on May 21 while campaigning.

—The Congress emerges from the elections as the largest single party: P. V. Narasirnha Rao becomes the new prime minister.

—The 1991–92 budget initiates liberalization at an unprecedented pace.

1992: Despite low polling, the successful holding of elections in Punjab signifies the waning of secessionist terrorism growing since the late 1970s.

—The destruction of the Babri Mosque by an army of fanatics shocks the country and highlights the diabolical potential of Hindu communal politics that are gathering momentum.

—The detection of a serious bank and share swindle underlines the massive corruption in the country.

1993: The 73rd Constitution Amendment Act reserves one-third of the seats in local bodies for women.

1996: Congress, led by Narasimha Rao, is defeated in the parlimentary elections. The Bharatiya Janata Party, the largest single party, forms government but resigns before facing a vote of confidence as it fails to muster a majority. The coalition United Front Government assumes office under H. D. Deve Gowda as prime minister.

—India refuses to sign the Comprehensive Nuclear Test Ban Treaty.

Chronology compiled by Hiranmay Karlekar.

HENRI CARTIER-BRESSON is one of the world's most renowned photographers. Born in 1908, he studied painting in the 1920s, and turned to photography in the early 1930s. In 1933, he studied film with Paul Strand, and later worked as assistant to Jean Renoir. During World War II, Cartier-Bresson was captured by the Germans and spent three years in prisoner-of-war camps before escaping to join the Paris underground, filming the homecoming of French POWs. In 1947, he founded the Magnum photo agency, along with Robert Capa, David Seymour, and others. His work has since taken him all over the world. A book of his Indian photographs, *Henri Cartier-Bresson in India*, was published by Thames and Hudson in 1987.

MITCH EPSTEIN attended the Rhode Island School of Design before studying with photographer Gary Winogrand at Cooper Union in New York City. He is the recipient of a National Endowment for the Arts fellowship and grants from the New York State Council for the Arts and the Pinewood Foundation. He has had many solo exhibitions in New York City, and his work is included in numerous major photography collections around the world, including the Museum of Modern Art and the Metropolitan Museum of Art, both in New York City, and Paris's Bibliothèque Nationale. Epstein has taught photography at Harvard University's Carpenter Center, and has worked as a cinematographer and production designer for several award-winning films, among them *Salaam Bombay!* and *Mississippi Masala*. Among his books are *In Pursuit of India* (Aperture, 1987) and *Vietnam: A Book of Changes* (Norton/Doubletake, 1996). He currently lives and works in New York City.

KANU GANDHI (1917–1986), a cousin and disciple of Mahatma Gandhi's, joined India's Non-Cooperation movement while still in his teens. Mahatma Gandhi, who generally did not pose for photographers, allowed his cousin to photograph him provided the work was entirely self-financed, and no flash was used. The photographer's proximity to Mahatma Gandhi allowed him to capture rare private and informal moments of his subject's life. While some of Kanu Gandhi's photographs have been published in newspapers and other publications, the vast majority of them have never been seen in public.

WILLIAM GEDNEY (1932–1989) was born in New York City. His first exhibition, "Eastern Kentucky and San Francisco," was presented in 1968 at New York's Museum of Modern Art. He received many awards and fellowships, including a John S. Guggenheim Memorial Foundation grant and a Fulbright fellowship (for his work in India, where he lived for many years), as well as a grant from the National Endowment for the Arts. Gedney also worked as a professor of photography at Cooper Union and at Pratt Institute, both in New York City, until 1989, the year of his death.

HARRY GRUYAERT, originally from Belgium, has during the course of his career worked in many countries throughout the world. His photographs have been widely published, in such magazines as *Zoom* and *Photo* (France), *Stern* (Germany), and *Actuel Fotografi* (Sweden). His "Rencontres Indiennes" (*Double Page*, no. 17) appeared in 1982. Gruyaert's work has been presented in numerous exhibitions, most recently at 1996's "Dijon vue par . . . " at the Dijon Palais des ducs de Bourgogne, among many other shows. He has published two books: *Morocco* (Schirmer Art Books, 1990) and *Lumière Blanche* (Centre Nationale de la Photographie). A member since 1981 of the prestigious Magnum photo agency, Gruyaert currently lives in Paris.

A political activist and journalist as a youth in India in the early 1940s, SUNIL JANAH began to photograph while on writing assignments for a leftist newspaper. At the center of India's political and cultural activity, Janah photographed the most significant events in the country during its transition from British rule to an independent nation, the famines of 1943-45, massive political rallies and protests, and the devastations of India's Partition. His photographs of the people, industries, temple sculptures, and leading exponents of Indian classical dance, of Gandhi, Nehru, and their contemporaries are records of the India of those times. Janah's studio in Calcutta became a gathering place of important political figures, intellectuals, artists, and filmmakers of the day. It was a stopover for such celebrities as Martha Graham, V. S. Naipaul, Yehudi Menuhin, Jean Renoir, and Margaret Bourke-White.

THOMAS L. KELLY has lived in Nepal for the past eighteen years, working as a photographer and documentary filmmaker. In 1993, he was a recipient of a Threshold Foundation grant to document child prostitution throughout South Asia. Kelly's work has been widely published in such publications as

GEO, *Natural History*, and *Smithsonian*. Three books of his photographs have been published by Abbeville Press: *The Hidden Himalayas* (1987), *Kathmandu: City on the Edge of the World* (1989), and *Tibet: Reflections from the Wheel of Life* (1993). Kelly has had major exhibitions of his work in Asia and in Europe.

American photographer CHARLES LINDSAY's photographic work often addresses the links between culture and nature. His first book, *Mentawai Shaman: Keeper of the Rain Forest* (Aperture, 1992) chronicles the photographer's experiences living with a tribal healer and hunter over the course of eight years. Lindsay's work has appeared in numerous international publications, including the *New York Times Magazine*, *Natural History*, and *GEO*. His work has also been featured on National Public Radio and on CNN International. His most recent book, *Turtle Islands: Balinese Ritual and the Green Turtle*, was published by Takarajima in 1996.

MARY ELLEN MARK has achieved worldwide fame through her numerous photoessays and portraits in such journals as the *New Yorker*, the *New York Times Magazine*, *Harper's Bazaar*, the *London Sunday Times Magazine*, and many others. She is the recipient of several awards and grants, including a John Simon Guggenheim fellowship, three fellowships from the National Endowment for the Arts, and a World Press Award for Outstanding Body of Work Throughout the Years. She has published eleven books, among them *Mother Teresa's Mission of Charity in Calcutta* (Friends of Photography, 1985), and *Indian Circus* (Chronicle and Takarajimasha Inc., 1993). A retrospective of her work entitled "Mary Ellen Mark: Twenty-five Years" is currently touring internationally.

Magnum photographer STEVE McCURRY has traveled and worked extensively in India over the past eighteen years. He is the winner of many photography awards, including a Robert Capa Gold Medal from the Overseas Press Club for his coverage of the war in Afghanistan; the Olivier Rebbot Award for his work on the Philippine revolution; and several first-places in the World Press Photo Awards. McCurry has been a contract photographer for *National Geographic* for more than fifteen years and has produced more than eighteen stories for the magazine, as well as working free-lance for many other publications. He has published two books, *The Imperial Way* (1985), and *Monsoon* (1988), and is currently working on a book chronicling his experiences in Afghanistan.

Originally from southern Italy, DARIO MITIDIERI has lived and worked for the past fifteen years out of London. He has contributed to many publications, including Britain's *Sunday Telegraph*, *The Independent Magazine*, and the *London Sunday Times Magazine*, as well as Germany's *Stern* and *Das Magazine*. He has worked on photography projects on subjects around the world, ranging from China's Tienanmen Square massacre in 1989, the fall of the Communist regime in Albania in 1992, and the refugee crisis in Rwanda in 1994, to the "Children of Bombay"—a project that was presented as an internationally traveling exhibition and a book of the same title, published in 1994. Among other honors, Mitidieri has received a W. Eugene Smith Memorial Grant in Humanistic Photography, the Visa d'Or at the International Festival of Photojournalism in Perpignan, and the European Publishing Award for Photography. He has had numerous solo exhibitions around the world.

ROBERT NICKELSBERG lives in New Delhi. Since 1988, he has been covering the six countries of South Asia—Pakistan, Afghanistan, India, Sri Lanka, Nepal, and Bangladesh—for *Time* magazine, and working for other Western publications. Nickelsberg has been witness to many of India's social upheavals, crises, and human suffering spurred by clashes between individuals, historical biases, and cultural traditions.

Born in Calcutta, PRASHANT PANJIAR is a self-taught photographer whose work has appeared in numerous publications in India, including *Patriot*, *Link*, and *India Today*. His books *The Survivours: Kampuchea 1984* (Patriot Publishers), and *Malkhan: The Story of a Bandit King* (Lancers) were both published in 1984. His photographs have been included in exhibitions throughout India, and a solo show entitled "Kampuchea Lives Again" was presented in 1984 in Delhi and Calcutta. He currently works as Associate Editor (Photography) and a contributing photographer at New Delhi's *Outlook* magazine.

SWAPAN PAREKH, born in 1966, studied photojournalism and documentary photography at New York's International Center of Photography. His photographs have appeared in such international publications as *Time*, *Life*, *U.S. News and World Report*, *American Photo*, *Der Spiegel*, and *El Pais*. He has won many awards and prizes, including: First Prize in the Spot News Picture category by the World Press Photo Foundation, Award of Excellence in Magazine News Picture category at

"Picture of the Year" competition, Washington D.C., three awards from Nikon International, and the Young Photographer's award at Photosynkria '96 in Greece. Parekh is represented by the Black Star Photo Agency, and lives in Bombay.

RAGHU RAI was born in the town of Jhhang, now in Pakistan. He started photographing in the early 1960s, and began by working as staff photographer at the *Hindustan Times* and the *Statesman*. He joined the Magnum photo agency in 1977, and worked as the picture editor for *India Today*, India's leading news magazine, from 1982–1990. His photographs and photoessays have appeared in numerous publications, including *Time*, the *New York Times*, *Paris Match*, *National Geographic*, and *GEO*, among several others. Since 1971, Rai has held solo exhibitions in major cities throughout the world. The winner of many Nikon Photo Contest international Awards, Rai has also received the "Padamshree," one of India's highest civilian awards. He has served on the jury for World Peace Photos of the Year a number of times. Rai has produced more than seven books of photography, on subjects ranging from India's Sikhs, Mother Teresa, and Indira Gandhi, to studies of Calcutta and Delhi. Rai is currently working on two new books, one on the master musicians of India, the other on Jainism.

SANJEEV SAITH's photographs have been published in several books and journals, and exhibited at galleries in India and the U.K., and are included in several collections, among them: the National Gallery of Modern Art in New Delhi, and London's Photographer's Gallery. Saith has also worked as a cameraman on such films as *Vivekananda* (1994), and *Everest* (1985), which received the National Book Award for best adventure-documentary. Books of his photographs include: *A Journey Down the Ganga* (1989), *Kashmir* (with Marie D'Souza and others, 1990), and *Ganga* (1995). Saith has also edited solo and collective photography projects, and conducts workshops to promote photography as a way of seeing. He lives in New Delhi.

Brazilian photographer SEBASTIÃO SALGADO is a world-renowned exemplar of the tradition of "concerned photography." Salgado has been awarded virtually every major photographic prize in recognition of his accomplishments, from institutions in France, Germany, Holland, Spain, and the United States. He has received the W. Eugene Smith Grant in Humanistic Photography, and was twiced named

Photographer of the Year by the International Center of Photography in New York. He has covered major news events all around the world—from the attempted assassination of Ronald Reagan and the wars in Angola and the Spanish Sahara, to the taking of Israeli hostages in Entebbe. Among Salgado's many published books are *An Uncertain Grace* (Aperture, 1990), and *Workers: An Archaeology of the Industrial Age* (Aperture, 1993).

KETAKI SHETH, originally from India, studied photography and communication arts at New York University and at Cornell University. Her work has been exhibited throughout the world, in India, the U.K., Germany, and the U.S.A. In 1993, she was awarded the Sanskriti National award for her contribution to Indian photography. Since 1990, she has worked as contributing photographer to Berlin's *Die Tagerzeitung*.

DAYANITA SINGH studied visual communication at the National Institute of Design in Ahmedabad, before traveling to New York to attend the International Center of Photography's program in photojournalism and documentary photography, and interning with photographer Mary Ellen Mark. Singh's work has been published internationally in many magazines and journals, including *Time*, *Newsweek*, the *Washington Post*, the *Philadelphia Enquirer*, the *New York Times*, Britain's *Independent*, the *London Times*, and many others. She has received awards from the Alliance Française, the Andreas Franic Foundation, and elsewhere. Her projects include a range of topics, from "Children and Widows of the 1984 Riots" and "Prostitutes in Bombay and Madras" to "Bollywood" and "The Ms. India Beauty Pageant." For her most recent project, she has been photographing upper-class families in the urban centers of Delhi and Bombay to document current socioeconomic changes that are influencing and transforming the Indian family.

PAMELA SINGH was born in 1962 in New Delhi, India. She was educated in Jaipur, India, and attended New York's Parsons School of Design, and the American College in Paris, as well as taking workshops at New York's International Center of Photography. Singh worked in Africa for five years as a camerawoman on documentary films. Her work has been distributed throughout the world through Gamma Press Photos. Singh has worked extensively in Southeast Asia and Europe. For the past three years, she has been working on a long-term photography project entitled "Indian Women," studying the role of women in today's changing India.

A documentary photographer and printmaker, ROSALIND SOLOMON studied with Lisette Model. She has worked extensively in India since 1971. Her solo exhibition "Rosalind Solomon, Ritual" at New York's Museum of Modern Art included a series of her India images. She has been given fellowships from the American Institute of Indian Studies, Art Matters, Inc., and the National Endowment for the Arts. Her India works were organized by the International Center of Photography at George Eastman House, which showed and toured them to several venues, including the American Museum of Natural History of the Smithsonian Institution in Washington, D.C.; the exhibition also traveled to many cities in India. Solomon has also worked in Peru, Zimbabwe, South Africa, the southern United States, and elsewhere. She lives in New York City.

Born in Navsari, India, the daughter of a self-taught photographer, HOMAI VYARAWALLA was one of the first Indian woman photojournalists to document Indian life. Her work was first published in 1938 in the *Bombay Chronicle*, and later in major foreign publications. Vyarawalla was given weekly assignments from the *Illustrated Weekly of India*, and during World War II covered every aspect of wartime activities during the late 1930s and early 1940s. In 1942, she began work as an assistant photographer at the *Times of India* in New Delhi, where the headquarters of the Far Eastern Bureau of the U.K. publicity office were located. A contributor also to *Time* and *Life* magazines, Vyarawalla worked until 1967 for the British Information Services. She remained a free-lance photographer until 1970. She currently lives in Vadodara, near Bombay.

ALEX WEBB began working as a professional photojournalist in 1974. His photographs have appeared in such publications as *GEO*, and the *New York Times Magazine*, and in exhibitions at the Fogg Museum in Boston and the Walker Art Center in Minneapolis. Webb has been a member of the Magnum photo agency since 1976.

ACKNOWLEDGMENTS

The Philadelphia Museum of Art and Aperture are deeply grateful to the many people whose help made this publication and exhibition possible. Foremost are the photographers, whose images of India in these pages and on the walls of the exhibition provide such extraordinary insight into the people and culture of India. Raghu Rai gave generously of his time and his invaluable expertise; through his guidance our attention was drawn to many of the talented emerging photographers working in India today. Victor Anant not only contributed a powerful essay to this book, but gave his advice and unfailing encouragement to the project as a whole. Henri Cartier-Bresson was most collaborative, and devoted much time to selecting the photographs from his remarkable body of Indian work.

From the earliest stages of "India: A Celebration of Independence," Professor John Kenneth Galbraith offered his counsel and encouragement. U.S. Ambassador to India Frank G. Wisner recognized the significance of the book and exhibition from the outset, and generously provided his personal support and the support of his office to ensure that the project would be seen throughout India. Our thanks to William V. Parker, Counsellor for Cultural Affairs at the United States Information Service, and to Usha Balakrishnan of the U.S.I.S. in Delhi, who was very helpful in coordinating the exhibition's placement at Indian venues. Special thanks are also extended to Ashis and Swapna Gupta and to Patwant Singh, who generously gave their support and guidance to the project from the beginning.

A number of photographic archives contributed images to this project; special thanks are extended to the George Arents Research Library for Special Collections at Syracuse University, the Special Collections Library at Duke University, Autograph Photos, and the Hulton Getty Picture Collection. Purvi Shah was most helpful with the text research for the book, and Udayan Gupta and Zettie Emmons kindly offered their informed evaluation of the project as it developed.

Dorothy Norman, who played an important role in the founding of the Alfred Stieglitz Center at the Philadelphia Museum of Art, has sustained a profound commitment to the culture and people of India for more than fifty years. Her enduring love of India was one of the factors that helped to bring this extraordinary project to life.

THIS PUBLICATION OF
INDIA: A CELEBRATION OF INDEPENDENCE
WAS MADE POSSIBLE THROUGH
A GENEROUS GRANT FROM
EASTMAN KODAK COMPANY.

THE EXHIBITION AND WORLDWIDE TOUR OF
"INDIA: A CELEBRATION OF INDEPENDENCE"
WOULD NOT HAVE BEEN POSSIBLE
WITHOUT THE GENEROSITY OF
FORD MOTOR COMPANY.

Air transportation for "India: A Celebration of Independence" has been provided by
AIR INDIA,
the official airline for the publication and exhibition.

Accommodations throughout the project have been generously provided by the
TAJ GROUP OF HOTELS.

"INDIA: A CELEBRATION OF
INDEPENDENCE, 1947–1997"
EXHIBITION SCHEDULE
(as of March 15, 1997):

PHILADELPHIA MUSEUM OF ART,
July 6–August 31, 1997

ROYAL FESTIVAL HALL, LONDON,
November 28, 1997–January 18, 1998

VIRGINIA MUSEUM OF FINE ARTS, RICHMOND
May–June, 1998

INDIANAPOLIS MUSEUM OF ART,
September 4–November 15, 1998

KNOXVILLE MUSEUM OF ART,
December 18, 1998–February 28, 1999

A sister show will travel throughout India:

NATIONAL GALLERY OF MODERN ART, NEW DELHI,
October 4–November 12, 1997

NATIONAL GALLERY OF MODERN ART, MUMBAI,
December 1–December 31, 1997

VICTORIA MEMORIAL MUSEUM, CALCUTTA,
January 24–February 24, 1998

LALIT KALA AKADEMI,
CHENNAI,
April, 1998

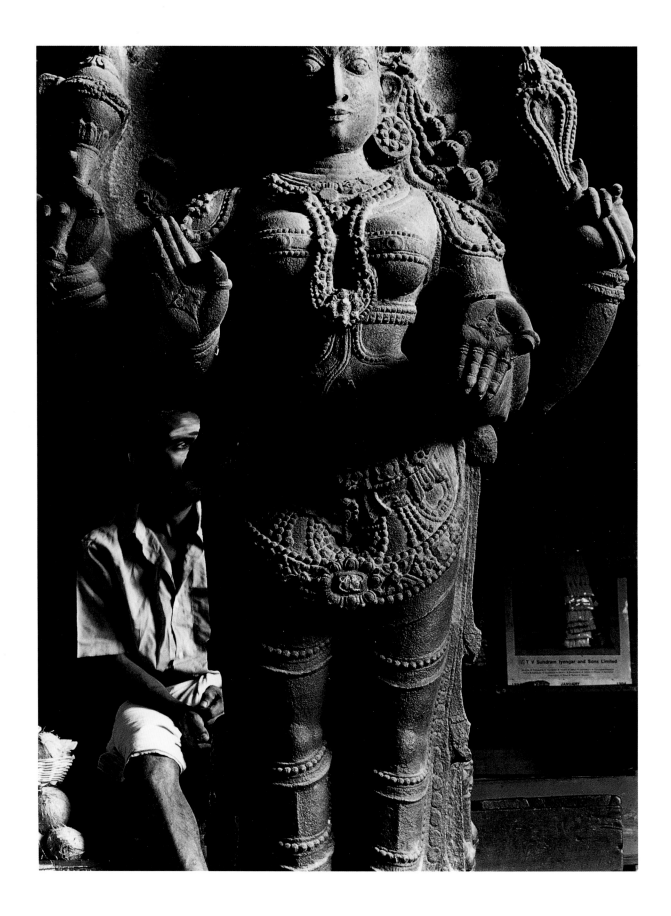

Charles Lindsay, *Stone Temple Goddess of Fertility*, Madurai

Library of Congress Catalog Card Number: 96-80164
Hardcover ISBN: 0-89381- 695-7 Paperback ISBN: 0-89381-718-X

Book design by Wendy Byrne
Jacket design by Peter Bradford/Danielle Whiteson
Printed and bound by Arti Grafiche Motta, Milan, Italy
Separations by Sele Offset

The staff at Aperture for *India: A Celebration of Independence, 1947–1997* is:
Michael E. Hoffman, *Executive Director*
Diana C. Stoll, *Editor*
Shona Gupta, *Project Coordinator*
Stevan A. Baron, *Production Director*
Michael Lorenzini, *Assistant Editor*
Helen Marra, *Production Manager*
Sarah Gray, Amy Schroeder, *Editorial Work-Scholars*
Shona Curtis, Katie Warwick, *Production Work-Scholars*

Aperture Foundation publishes a periodical, books, and portfolios of fine photography to communicate with serious photographers and creative people everywhere. A complete catalog is available upon request. Address: 20 East 23rd Street, New York, New York 10010. Phone: (212) 598-4205. Fax: (212) 598-4015.

Aperture Foundation books are distributed internationally: in Canada: General Publishing, 30 Lesmill Road, Don Mills, Ontario, M3B 2T6. FAX: (416) 445-5991; in the United Kingdom: Robert Hale, Ltd., Clerkenwell House, 45-47 Clerkenwell Green, London EC1R OHT. FAX: 171-490-4958; in continental Europe: Nilsson & Lamm, BV, Pampuslaan 212-214, P.O. Box 195, 1382 JS Weesp., Netherlands. FAX: 31-294-415054.

For international magazine subscription orders for the periodical *Aperture*, contact Aperture International Subscription Service, P.O. Box 14, Harold Hill, Romford, RM3 8EQ, England. Fax: 1-708-372-046. One year: £29.00. Price subject to change.

To subscribe to the periodical *Aperture* in the U.S.A. write Aperture, P.O. Box 3000, Denville, NJ 07834. Tel: 1-800-783-4903. One year: $44.00.

First edition
10 9 8 7 6 5 4 3 2 1